Experience Printmaking

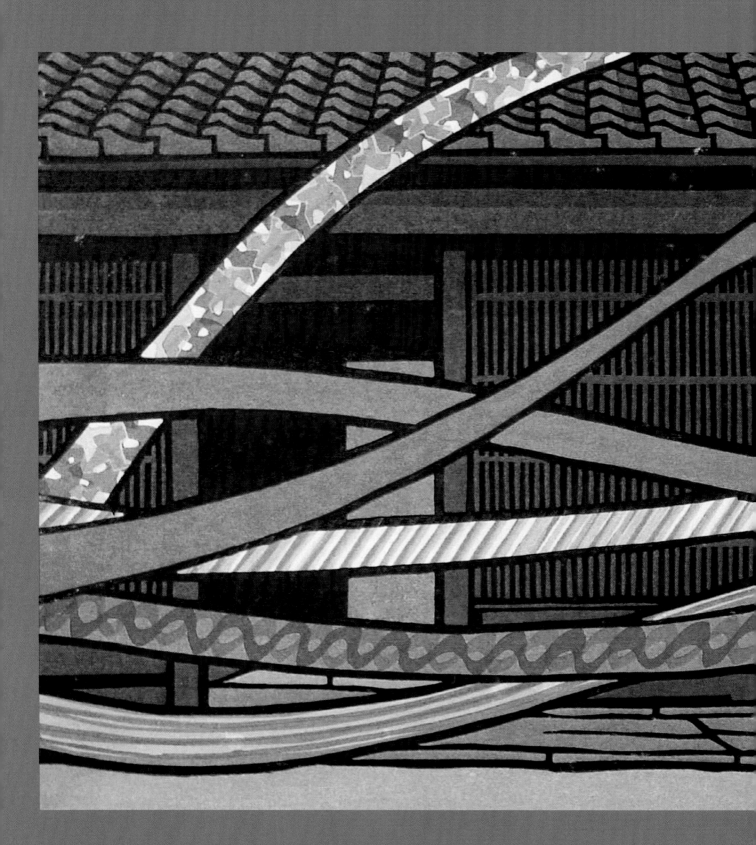

Experience
PRINTMAKING

Donna Anderson

Davis Publications, Inc.
Worcester, Massachusetts

Front cover: Barbara Hepworth, *Genesis*, 1969. Lithograph on paper.

Back cover: Student work, Kim Wolforth, *Rita;* Student work, Kelly Burke, *Tree of Life.*

Half title: David Gamble, *Ysolina* (detail), 1996. Lithograph.

Title page: Katsuyuki Nishijima, *Dyes in Kyoto.* Woodblock print.

Publisher: Wyatt Wade
Acquisitions Editor: Jane McKeag
Editor: Reba Libby
Photo Acquisition: Donna Young, Lydia Keene-Kendrick
Art Direction: Douglass Scott, WGBH Design
Layout: Books By Design, Inc., Victoria Hughes Waters

Acknowledgments
Special thanks goes to David Coen who gave direction to my ideas and helped put hundreds of years of printmaking into only nine chapters. I also thank my wonderful husband, Bob Anderson, for patiently reading countless versions about each process. I have an overwhelming appreciation for the people at Davis Publications for their continued support and resourcefulness in the task of creating a textbook to cover so much information in the allotted space. Jane McKeag was a wonderful editor, coming into a project after it had already begun and making wonderful suggestions. Reba Libby kept me on schedule so that my book would come out on time. Donna Young and Lydia Keene-Kendrick found all the pictures that I wanted to use for examples. And thank you to publisher Wyatt Wade for his patience in listening to me complain about needing a printmaking book until he suggested that I write it.

Special Thanks to Contributing Editors and Consultants
Phyllis Ball, Farragut High School, Knoxville, Tennessee
Nicole Brisco, Pleasant Grove High School, Texarkana, Texas
Julia Dyche, Shenandoah High School, Shenandoah, Iowa
Lynn Felts, Winfield High School, Winfield, Kansas
Beth Ford, Flowerree Galetovic, Bearden High School, Knoxville, Tennessee
Christine Harness, Retired Art Educator, Knoxville, Tennessee,
Andrea Haury, Karns High School, Knoxville, Tennessee
Pilar Hernandez, North Springs High School, Sandy Springs, Georgia
Ron Hickman, South Doyle High School, Knoxville, Tennessee
Suzanne Jack, Hardin Valley Academy, Knoxville, Tennessee
Lee Ann Jenkins-Freels, South-Doyle High School, Knoxville, Tennessee
Judy Jorden, Retired Art Educator, Knoxville, Tennessee
Linda Kieling, Rosemont Ridge Middle School, Westlinn, Oregon
Shannon McBride, Lakeridge High School, Lake Oswego, Oregon
Nick Madden, Chattahoochee High School, Alpharetta, Georgia
Judi Morgan, St. Georges School, Spokane, Washington
Dr. Fred Patterson, Art Supervisor, Knox County Schools, Knoxville, Tennessee
Matt Phillips, Roswell High School, Roswell, Georgia
Dr. Emily Ruch, Creative and Performing Arts High, Memphis, Tennessee
Ken Schwab, Leigh High School, San Jose, California
Bill Shinn, Karns High School, Knoxville, Tennessee
Rhonda Test, Hawaii Preparatory Academy, The Big Island of Hawaii
Charlotte Turner, Centennial High School, Roswell, Georgia

About the Author
Donna Anderson has an M.S. in Art Education from the University of Tennessee where she studied printmaking with Byron McKeeby. Her undergraduate work was done at Middle Tennessee State University with printmaker Larry Brooks. As an art teacher in Knox County Schools for 34 years, she covers all types of printmaking in her classes. She has won numerous awards including Knox County Teacher of the Year for 1997, Tennessee Art Educator of the Year for 2003 and National Secondary Art Educator for 2008. She has traveled to Japan as a Fulbright Memorial Teacher Scholar and as a Fulbright Scholar to Egypt and Israel. She is still teaching and lives in Knoxville, Tennessee.

Library of Congress Control Number: 2009926194
Printed in the United States of America
ISBN: 978-0-87192-982-2

10 9 8 7 6 5 4

Contents

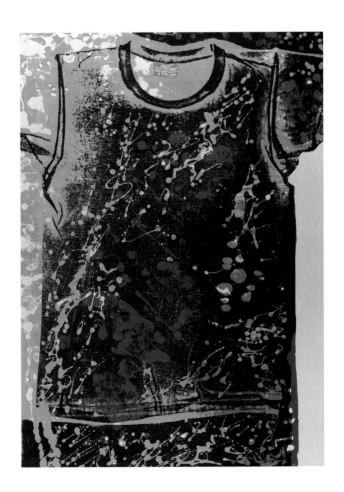

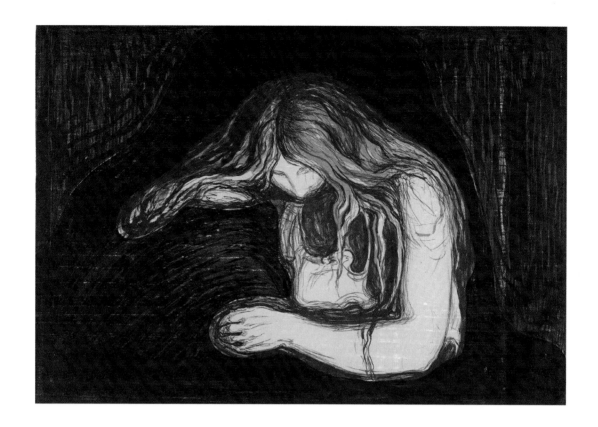

Studio Handbook

Owner's Manual for Experience Printmaking

To get the most out of any tool, it is valuable to understand its key features and intended uses. In detailing the unique design and features in this textbook, the following will help make *Experience Printmaking* the most valuable tool in your printmaking studio.

These opening pages give you a **visual and verbal overview** of the concepts covered in the chapter.

Build your printmaking vocabulary. Key terms are highlighted and defined the first time they appear. These and other terms are also defined in the Glossary.

These headings, which divide large ideas into **manageable, easy-to-follow concepts,** are ideal for quick reference and review.

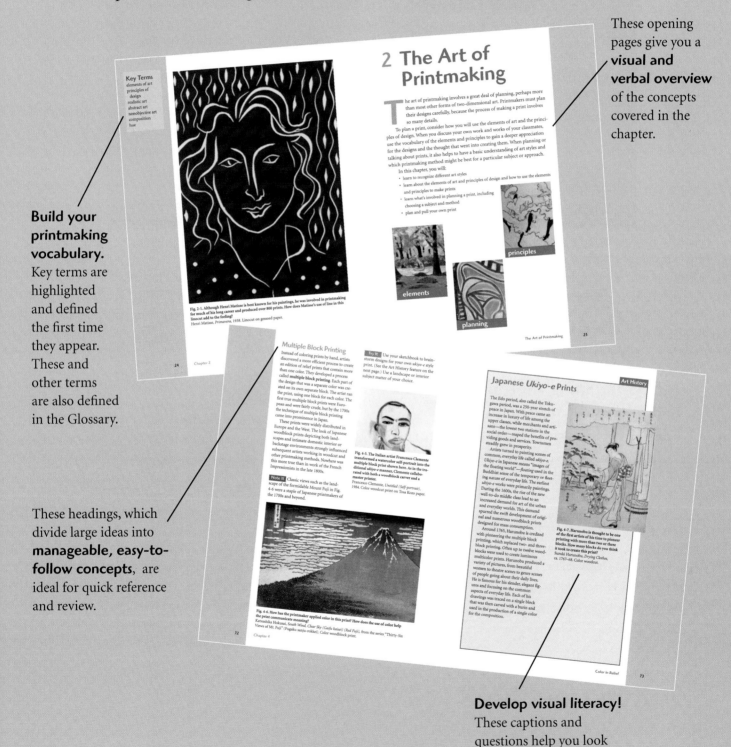

Develop visual literacy! These captions and questions help you look more closely at the artwork.

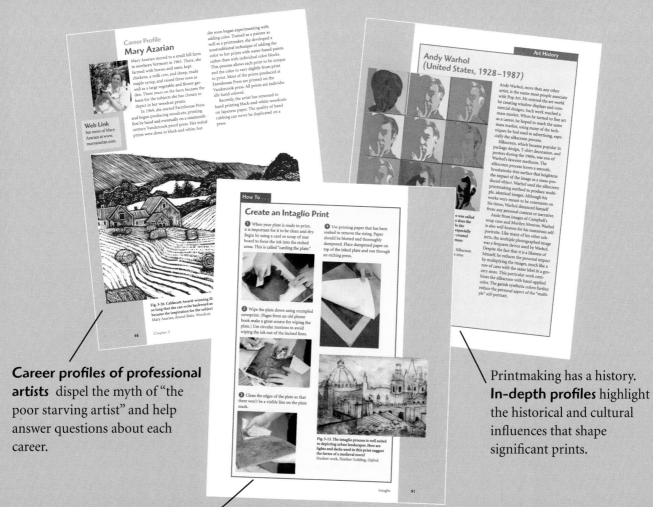

Career profiles of professional artists dispel the myth of "the poor starving artist" and help answer questions about each career.

Printmaking has a history. **In-depth profiles** highlight the historical and cultural influences that shape significant prints.

These illustrated, **step-by-step How To's** will help you master fundamental techniques and skills.

Samples of **student artwork** in each chapter encourage peer sharing and critique.

Don't miss the **Handbook** for detailed instructions on printmaking procedures, troubleshooting, tips for making a clean print, and more!

Fig. 1-1. What things do you notice first about this print? What feelings does it communicate?
Janet Fish, *Tropical Still Life*, 1992. Silkscreen.

1 What Is Printmaking?

Printmaking is both a technical and a creative process in which artists explore ideas and subject matter. Like drawing, painting, or photography, printmaking is a form of communication. However, printmaking has its own processes and techniques.

What do you think of when you hear the word *print*? In printmaking, a print is not a reproduction, or copy, of an original. Each print is an *original*, handmade work of art, created by pressing paper against an inked surface, or in the case of silkscreen, pushing ink through a screen onto paper or other surface. Printmakers make prints working alone or with assistants. They use one or more of four methods developed over centuries of experimentation and technical advances.

Among art media, printmaking past and present has provided a special opportunity for communicating all kinds of information. That information includes messages, symbols, and announcements. It includes views of the world and its people, places, and things. It also includes abstract explorations. Because prints can have many originals, the printmaker has the ability to share his or her approved works with many more individuals than is possible for even the fastest draftsperson or painter.

method

In this chapter, you will:

- learn the basic principles and terminology of printmaking
- learn the four major methods of printmaking
- learn about the uses of prints in the past and the present
- begin to experiment with printmaking

design

process

Prints and the Printmaking Process

Like photographs, prints can be produced over and over. But a print should not be confused with a photograph, nor should printmaking be confused with photographic reproduction. A **reproduction** is a copy of an original piece of artwork, such as a painting, that is printed, or reproduced, many times by means of a commercial photographic process. That's how most of the artworks shown today on calendars and in magazines and books are replicated.

The plate. As with the other media, the printmaking process begins with a **design**, or plan, for how the print will look, and with the **plate**, the inked surface from which a print is transferred to paper, or "pulled."

Because all printmaking follows from a working design, some basic skills in drawing are essential. These skills, grounded in both observation and practice, include the ability to understand things like composition, body and facial proportions, perspective, and basic color theory. For more on these concepts, see Chapter 2, "The Art of Printmaking," and the Handbook at the end of this text.

Most printmakers work out their initial designs on paper using pencil, pen, or paint. The process of getting a design from the paper onto the printing plate is called *transferring a design*. You will learn more about the transfer process, too, in Chapter 2.

The impression. The first print that is pulled from an inked plate is called the **impression**. The impression lets the printmaker see what the plate design looks like. The printmaker uses the impression as reference and may make some adjustments to the plate before making more prints.

The edition. After the printmaker decides that the impression is satisfactory, the plate is considered final. The printmaker produces any number of impressions

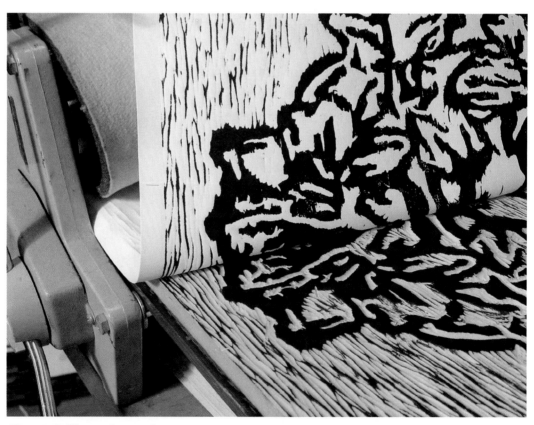

Fig. 1-2. Pulling an impression.
Printer pulling impression from plate.

by hand, signing and numbering them in a group called an **edition**. Each print shows two numbers. The second number tells you how many prints have been made. The first number tells you which number out of the whole edition a print is. The eleventh print in an edition of fifty would be numbered "11/50."

Note It Once the edition is printed, the artist might change the design and continue working the plate. However, prints pulled from such a subsequent *state*, or version of the plate, would constitute a separate edition.

Try It Each print that an artist signs and numbers is an original work of art. What information can you learn from looking at the print in Fig. 1-4?

Fig. 1-3. This original print was created using black and white stamping with an accent color in the background.

Student work, Jing Jie Jiang, *Jiang*.

Fig. 1-4. The lines and shapes in this print make symbolic reference to the land and humans' spiritual relationship to it. What symbols can you identify?
Jaune Quick-to-See Smith, *Cahokia*, 1989. Lithograph.

Printmakers and Prints

The story of printmaking is a story of design, technology, and communication. It is also a story of personal expression, innovation, and collaboration.

From the earliest recorded human experience, prints have been made to document and communicate information. Original paper prints in China and Europe functioned to illustrate religious manuscripts, as did those by medieval artists in northern Europe. The early printmakers printed designs on both paper and textiles for use in religious services. These artists were among the first to experiment with woodblock printing. After Johannes Guttenberg invented movable type in 1440, books became much easier to produce. Books needed illustrations, and therefore the need for woodcuts and engravings increased dramatically.

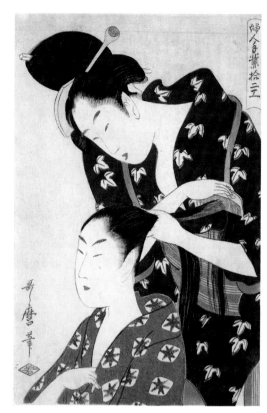

Fig. 1-6. The prints of Utamaro and other Japanese printmakers were prized by collectors and studied by the French Impressionists, whose own works came to be influenced by Japanese designs.
Kitagawa Utamaro, *Combing Hair*, ca. 1800. Color woodcut.

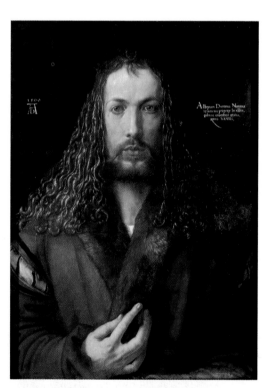

Fig. 1-5. Dürer was one of the key figures in the early history of printmaking.
Albrecht Dürer, *Self-Portrait at 28*, 1500. Oil on wood.

Renaissance artist Albrecht Dürer was a master in woodcuts. His cut lines are incredibly fine and give his prints depth and shading. He massed fine lines together to produce prints that look more like pen and ink drawings than woodcuts. He and Andrea Mantegna used prints to tell stories and explore representations of the human figure. They brought the art of wood carving and wood engraving to new heights.

Over time, prints stopped being seen as simply a way to illustrate texts. Instead, people began to value prints as works of art. Artists in Europe, who traditionally earned a living from commissions on portraits, began to create prints for sale to the public. They also used this **medium** as a forum for personal expression and experimentation.

With the development of multiple block printing, Japanese artists of the 1700s and 1800s perfected the art of the woodcut after its spread to Japan from Europe (via China). Multiple block printing will be discussed in Chapter 5. Japanese printmakers in turn influenced printmakers in Europe, from Goya in Spain to Daumier and Toulouse-Lautrec in France.

Note It Early printing methods were also used for illustrating herbal, scientific, and engineering information—even for making items like maps and playing cards.

Try It Draw the animal of your choice and create a print design based on your drawing. How will you simplify the lines in your design?

Fig. 1-7. Dürer first drew the rhinoceros in pencil. Later, he created the woodcut from which the print was pulled. The print reverses the drawing.
Albrecht Dürer, *The Rhinoceros*, 1515. Woodcut.

Printmaking in the Modern Era

In the modern era, artists as different as Edward Hopper, M. C. Escher, Käthe Kollwitz, and Chuck Close continued to explore traditional printmaking methods.

African American artists such as Henry Osawa Tanner, William H. Johnson, Romare Bearden, Charles White, and Elizabeth Catlett rose to prominence in the field of printmaking. In the 1950s, artists at the forefront of Pop Art and abstraction developed new methods of printmaking.

Try It Can you create a collage and then turn it into a silkscreen print?

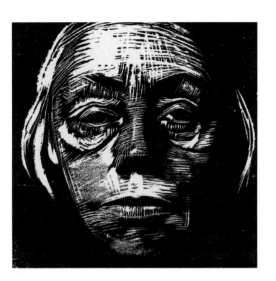

Fig. 1-8. Käthe Kollwitz produced numerous self-portraits that record the passing of time. Imagine how your own self-portrait might affect a viewer some years from now.
Käthe Kollwitz, *Self-Portrait*, 1923. Woodcut.

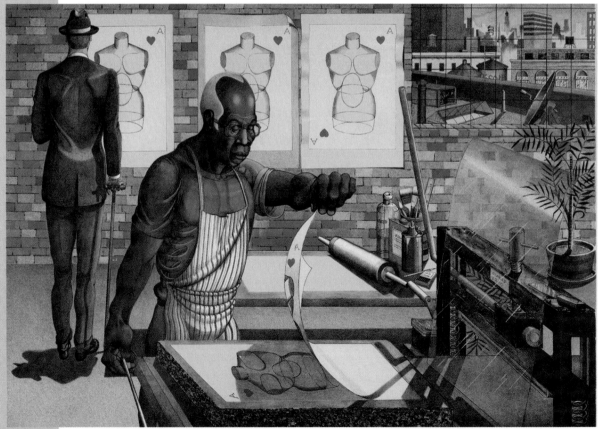

Fig. 1-9. Artist and teacher Robert Blackburn, the subject of the print shown here, started a major printmaking workshop in New York City and collaborated with major artists of the twentieth century.
Ron Adams, *Blackburn*, 2002. Color lithograph.

Fig. 1-10. Eduardo Paolozzi, both a sculptor and printmaker, produced collage-based silkscreens that were instrumental in shaping the Pop Art style. His creations started as unrelated collages and images, which he then rearranged into unified designs.

Sir Eduardo Paolozzi, *7 Pyramide in form einer achtelskugel*, 1967. Color screenprint.

Printmaking Today

Artists use prints to record experience and to communicate ideas and information for personal expression or social commentary. Today, prints are created for more varied artistic and commercial purposes, and by a more diverse body of artists, than at any time in history. Most prints are created by using a press, either by an artist working alone or in a team with a printer. Prints come in all sizes.

Commercial Printmaking

Most commercial printmaking relates either to advertising or to product design. The use of original prints in books, calendars, and posters continues today but is limited to short-run editions created mostly for collectors. Otherwise, the images you see in the printed materials you read are not prints but reproductions, created by a process called *photo offset*.

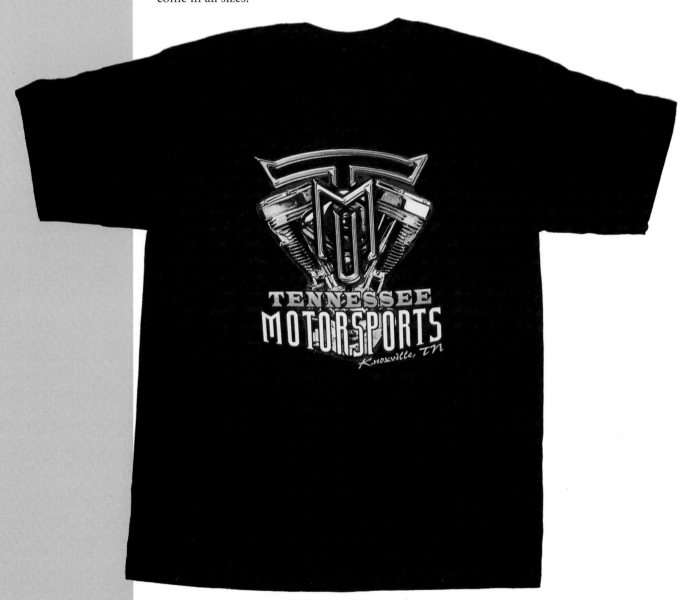

Fig. 1-11. Silkscreened T-shirts are one of today's most popular examples of commercial printmaking. Look in your closet or drawer at home. You probably own clothing that a printmaker helped create.
Silk-screened T-Shirt.

Fig. 1-12. How would you compare and contrast this print to the one in Figure 1-19? Kate Shepherd, *Baudelaire (Blue Sea)*, 2007. Aquatint and line etching.

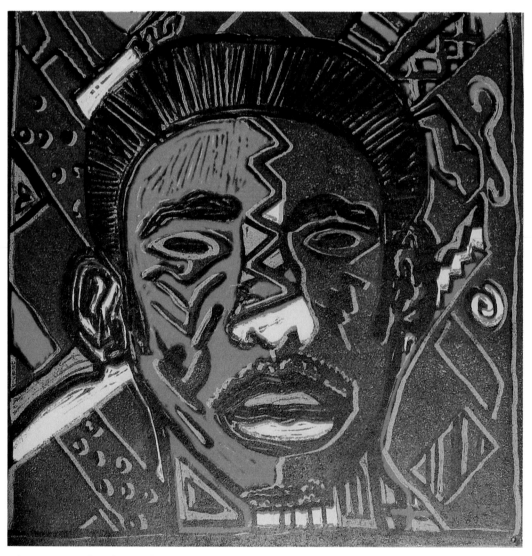

Fig. 1-13. How has this student artist included symbols in his self-portrait? Student work, Lloyd Collins, *Self-Portrait*.

Methods of Printmaking

Before you continue to the next chapters in this book, which provide an in-depth exploration of printmaking, let's get an overview of the four major methods, or processes, of printmaking. Later, when you read about each method in detail, you will learn how printmakers combine methods and add embellishments. The four methods are:

- relief
- intaglio
- silkscreen
- planographic

Relief

In **relief** printmaking, the artist carves into a plate to remove the areas that will not print, leaving only the raised area to be inked and printed. Relief prints create a reverse, or mirror image, of the plate design. Most relief plates are made from wood or linoleum. As the artists carves the image for a relief print, the gouge leaves cut marks; this method of carving gives a distinct character to the printed image.

Intaglio

In the **intaglio** printmaking method, lines are engraved or cut with an etching needle or etched with acid. This process is done on the surface of a metal plate, usually copper or zinc. The plate is then dipped in an acid bath, causing the incised lines to be permanently "etched" in the metal. Then the plate is inked, the ink fills the lines etched into

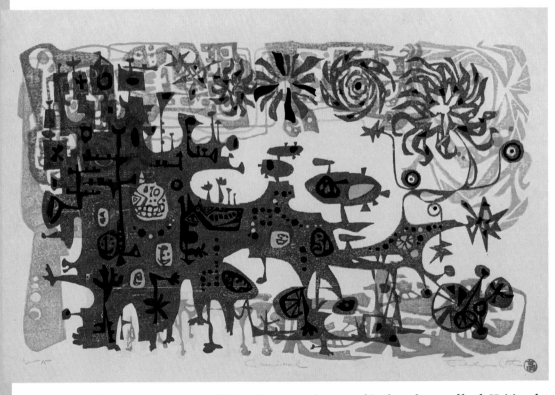

Fig. 1-14. African-American artist Eldzier Cortor was interested in the cultures of both Haiti and Mexico. Some of the designs in this relief suggest symbols of those cultures.
Eldzier Cortor, *Carnival*, 1960. Woodcut.

the plate. The inked lines are pressed against the paper. Like relief prints, intaglio prints create a mirror image of the plate design.

Note It *Relief* means "the elevation above a flat surface." In relief printmaking, the inked areas are raised above the carved lines. In intaglio, the lines are cut *into* the plate and then filled with ink. Intaglio became a very popular method of printing during the Renaissance. Artists achieved increasingly complex effects of detail, tone, and shadow.

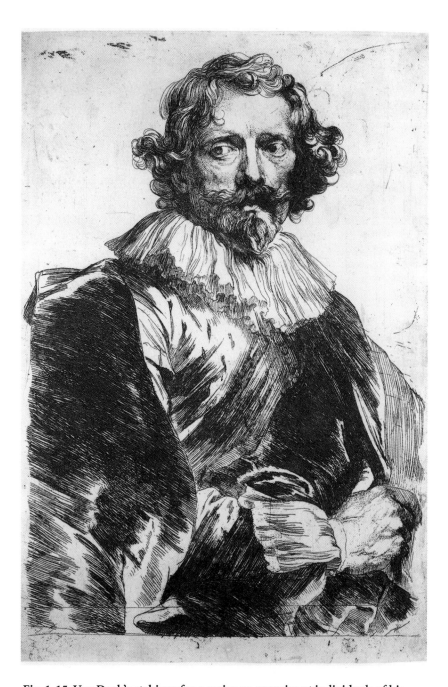

Fig. 1-15. Van Dyck's etchings for a series on prominent individuals of his time served to promote his skills as a draftsperson and printmaker. This print is based on a drawing done in black chalk. What does the print communicate about Lucas Vorsterman, van Dyck's fellow artist?
Anthony van Dyck, *Lucas Vorsterman*, from *The Iconography*, ca. 1626–36. Etching.

Silkscreen

Silkscreen is also called *screen printing* and *stencil printing*. The artist pushes ink through a screen or screens onto paper to create an image. The artist uses stencils to block out areas and determine where the ink will go. Areas that are not blocked by the stencil receive the ink and are produced directly on the paper below. This is the process that was used to create the T-shirt design shown in Fig. 1-11.

A fine art print created by this process is called a *serigraph*. Serigraphy is characterized by a graphic boldness that emphasizes shapes and color contrasts.

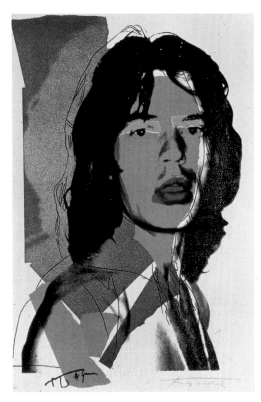

Fig. 1-16. Andy Warhol took many of his own photographs of world celebrities. The photos frequently found their way into his silkscreens.
Andy Warhol, *Mick Jagger,* from portfolio of 10 screenprints, 1975. Screenprint.

Planographic

The process of printing from a flat surface is called *planography*. In **planographic** printing, the image to be printed is placed directly on the surface of the plate. In this way planography differs from the other printing methods, in which the image is carved, etched, raised, or made with a stencil.

There are two types of planographic printing. In *lithography*, the artists uses a greasy crayon or other chemically reactive substance to create an image on a stone, paper, or metal plate. The plate is treated with a chemical, which causes the ink to be attracted to the greasy areas and repelled by the non-printing areas. In *monotype*, the ink is applied on a surface and then printed with a press. Usually, only one print is made, which accounts for the term *monotype*— the prefix *mono-* means "one." Lithographs and monotypes produce mirror images of the surface design.

Fig. 1-17. In planographic printing, the design is printed directly from a surface design. What does this print communicate?
Student work, Kelsey Ryon, *January.*

Printmaking Methods

	Relief	Intaglio	Silkscreen	Planographic
Print names and plate materials	woodcut wood engraving linocut collagraph	engraving drypoint etching aquatint mezzotint	serigraph screen print	lithograph monotype
Plate materials	plank wood (woodcut) end grain wood (wood engraving) linoleum (linocut) found objects (collagraph)	zinc copper plastics	paper silk nylon synthetics	limestone metal paper plastic glass
Tools	gouges knives brayers	etching needle acid grounds	knives glue tusches squeegee	litho crayon tusche paint crayon d'arche
Type of press	baren wooden spoon etching press	etching press	screen	litho press (for stone lithogra- phy) etching press
Area that prints	area above surface	area below surface	open areas of stencil	surface design
Method example				

Mixed Methods

Some printmakers make hand additions to their prints. Other printmakers combine printmaking methods to develop particular subjects or motifs.

Fig. 1-18. This print was made by silkscreening over a lithograph impression. Why do you think an artist might want to combine methods?
Frank Stella, *The Butcher Came and Slew the Ox.* Hand-colored and collaged with lithographic, linoleum block, and screen printings.

Digital Printmaking

Let's turn from traditional printmaking methods to digital. Do digital prints relate to the printmaking methods explored in this chapter? Actually, they do, and they don't. That's because a **digital print** is technically a photograph, not a print, and digital printmaking a photographic, or reproductive process.

But that doesn't mean digital processes don't have a place in printmaking using traditional methods. Many of today's printmakers incorporate digital technology. You'll learn about using digital processes for design of a print in a later chapter.

Fig. 1-19. Colored pencil is one way to add color to a relief print. The embellished print created in this manner would constitute an edition of one.
Student work, embellished print.

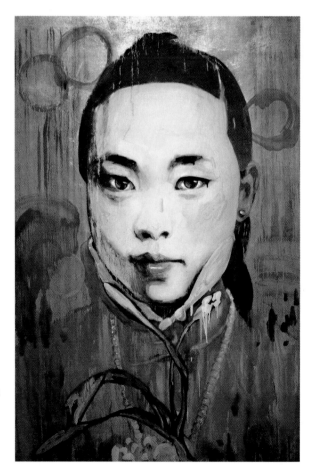

Fig. 1-20. Many of Hung Liu's prints begin with a digital base. Then the artist adds layers working in mixed media.
Hung Liu, *Narcissus 4*, 2007. Mixed Media.

Make a Chop

You can use a chop for your personal symbol to identify your artworks and to sign your prints. A chop is a small seal, stamp, or impression that identifies the artist and can be printed or embossed at the bottom of a print. Chops were introduced into Japan from China in 701 CE. A chop can be made from clay, wood, rubber, or linoleum. Chops may vary in complexity from just the initials of the maker to complex visual symbols.

A simple chop may just include your initials. The image becomes more complex if you consider your personality, likes, dislikes, beliefs, and interests. As you create your chop, think about what you want viewers to know about you. What images and symbols will represent you in your chop?

Think about images or symbols to express who you are. Consider your interests, cultural background, or talents.

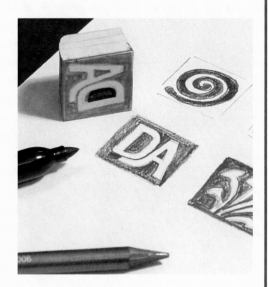

❶ Draw some sketches of your ideas. The size of the chop will be one inch square, so draw several one-inch squares on your paper and fill them in with sketches.

❷ After you have explored the different ideas and have decided on your final design, use an ebony pencil to fill in the areas that will print. The unfilled areas will be cut away.

❸ Use a square gum eraser as your plate, or stamp. A relief print is a *mirror image* of what is on the plate. When you transfer your drawing onto your eraser, you will *offset* it. In order for you to chop the print correctly, you will need to *offset* the ebony drawing onto the chop. Do this by pressing the chop onto the completed drawing. When you lift the chop the image will be on the printing surface.

❹ Carefully draw over the offset image with a marker. The surface is now ready for cutting.

❺ Now cut away the unfilled areas that will not print. When you have finished cutting, your chop is ready to use.

Hatch Show Print

"Letterpress printing" is a term for printing text with movable type. The raised surfaces of the metal letters are inked, then pressed against paper or a smooth surface to obtain an image in reverse. William H. Hatch (1833–1896) ran a print shop in Prescott, Wisconsin, with his two sons, Charles R. and Herbert H. In 1875, William moved his family to Nashville, where Charles and Herbert founded CR and HH Hatch, later called Hatch Show Print.

From their very first print job, the Hatch brothers achieved the artistic balance between type size and style, vertical and horizontal layout. They made posters for the circus, minstrel shows, vaudeville acts, and carnivals.

The mid-1920s to the 1950s was a golden era for country music and the printmakers who advertised for them.

Fig. 1-22. The classic letterpress poster style can still be used to proclaim just about any event or bit of news. How effectively does this birth announcement printed by Hatch serve its purpose?
Birth Announcement for Duke Rainier Rayburn, 2007.

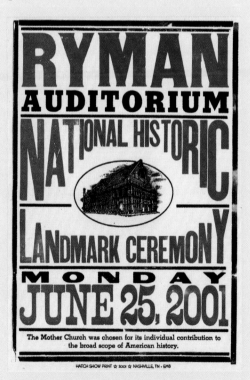

Fig. 1-21. Hatch Show Print is an old-fashioned letterpress print shop, based in Nashville since 1879.
Ryman National Historical Landmark Ceremony, 2001.

Hatch also captured the feel of jazz and blues in the work they did for the great entertainers of the day: Cab Calloway, Bessie Smith, Duke Ellington, and Louis Armstrong.

The openness to Southern culture and advertising helped Hatch Show Print survive the comparatively lean years after 1952. While other letterpress printmakers found it hard to compete with offset printmaking, Hatch could turn to country music for continued support. The company also embraced newer forms of entertainment such as all-star wrestling and rock and roll. Today, Hatch Show Print cranks out posters for contemporary performers from Keith Urban to Margaret Cho. The traditional look of letterpress printing endures in these posters.

Studio Experience
Stamped Print

In this Studio Experience, you will create a stamped relief print using a design of your choice. The process requires only the eraser on the end of a pencil, printing ink, and some paper.

Before You Begin

Think about the design you would like to present. Work out the composition in your sketchbook or on other paper. After your design is complete, draw it lightly with a pencil on your paper. Consider the colors you will use.

You will need
- sketch paper
- 9" x 12" white paper for printing
- water-based block printing ink in assorted colors

Create It

1. Experiment with designs on sketch paper and choose a final design to develop as a print.

2. Draw your design on paper and choose your ink colors.

3. Put small amounts of ink onto a piece of Plexiglas. Mix the ink to get exactly the colors you want in your print. Roll the ink into a small area so that the ink is flat.

4. Press the eraser into the ink and then onto the paper. Continue stamping until the print is complete.

Fig. 1-23. Stamping the print.

Check It

Are you pleased with your stamped print? If you were to create a second impression, what changes would you make in your design?

Sketchbook Connection

Keeping a sketchbook is a great way to practice drawing and to explore designs that you might later use for prints. Sketches, like photos, can capture the world as you see it, giving you visual records of what you see and think. Carry your sketchbook with you, and use it frequently.

Fig. 1-24. Stamped prints are suitable for just about any subject, from abstract designs to self-portraits. How is the stamping in this print applied to suggest hair texture, skin tones, and background? Student work, MacKenzie May, *MacKenzie.*

Rubric: Studio Assessment

4	3	2	1
Planning • Composition • Reflection/Evaluation			
Strong design and composition that addresses complex visual and/or conceptual idea.	Composition clearly shows intention and attempt to balance/unify design but unsuccessful.	Composition is awkward but shows some purpose.	Weak composition lacks evidence of intention or consideration. Haphazard.
Media Use • Craftsmanship			
Successful experimentation and/or risk-taking with media. Neat execution. Exhibits intent while recognizing own limitations.	Reasonable risk-taking in application of media. Above-average rendering with slight deficiencies evident in final project.	Normal use of media in project. Shows some area of skill in a limited area.	Poor or wasteful use of media/equipment. Unable to recognize own ability, hindered by limitations.
Craftsmanship • Synthesis • Reflection/Evaluation			
Critically reflects on, evaluates, and determines prints in terms of learned concepts and techniques. Freely shares ideas, takes active interest in others; eagerly participates in class discussions. Works independently and remains on-task.	Adequately reflects on, evaluates, and determines prints in terms of learned concepts and techniques. Shares ideas, shows interest in others; participates in class discussion. Works independently and remains on-task.	Inadequately evaluates prints; poorly reflects on learned concepts and techniques. Little interest in sharing ideas or listening to others, reluctant to participate in class discussions. Needs coaxing to work independently and remain on-task.	Little or no attempt made to reflect on and evaluate prints using learned concepts and techniques. Indifferent to the ideas of others; not willing to participate in class discussions. Does not work independently, behavior disruptive.

Career Profile
Katsuyuki Nishijima

Web Link
See more of
Katsuyuki Nishiji-
mas prints at
www.yoseido.com.

Katsuyuki Nishijima is a printmaker who produces woodblock prints. Art galleries in Japan and in the United States carry his work, and his prints are enjoyed by collectors all over the world. Born in Japan, he was trained at the Mikumo Publishing House in Kyoto. During this time, he had both solo and group shows.

His work is somewhat like the traditional ukiyo-e woodblock style. Nishijima's prints represent a simple, calm, and quiet picture of the landscapes and architecture of Japan. His prints show quiet streets, entrances to small shops or restaurants, a small boat in a harbor. Although he draws scenes that would normally be filled with people, his streets and landscapes are deserted. He has become a very popular artist with the public, who buy his prints in three sizes—small, medium, and large. He also makes small limited editions, which are of more interest to the serious collector.

Fig. 1-25. This print is from a series of town views, here emphasizing fabrics being dried after dyeing. What effect does leaving people out of the scene have on the viewer?
Katsuyuki Nishijima, *Dyes in Kyoto*. Woodblock print.

Chapter Review

Recall Explain the four methods of print-making.

Understand Describe the process involved in creating an edition of prints.

Apply Which printmaking process would be best to produce the following images: (1) a detailed drawing, (2) a poster design, (3) a photographic image? Explain your choices.

Analyze Look at the Andy Warhol print, *Mick Jagger* (Fig. 1-16). Why might this image work best as a silkscreen, rather than a relief, intaglio, or planographic print? How has the artist used blocks of color? What parts are emphasized by these areas? Would the same image be possible in a woodcut? Why or why not?

Synthesize Create a poster that illustrates the four different processes of printmaking. Describe each method and draw or paint a design that could be produced in that process.

Evaluate Look again at the Japanese wood-cut in Fig. 1-6. What moment in time is depicted? How well do you think the print succeeds as a visual record?

Writing About Art

Choose an image from this chapter to write a four-sentence paragraph in which you explain what the print communicates to you. What does the print express, and how does it make you feel? Remember to begin your paragraph with a clear topic sentence. The second, third, and fourth sentences should include statements that support the thesis.

For Your Portfolio

As you create editions of prints, it's a good idea to keep them together. Placing a sheet of waxed paper between each print in your portfolio will keep your prints in the best condition and ensure that ink is not offset, or smudged, from print to print.

Keeping all your prints together in your portfolio will eventually give you the opportunity to compare your ideas and craftsmanship from edition to edition.

Fig. 1-26. How has the stamping technique been used in this print?
Student work, Jason Gaus, *Tools of the Trade.*

Key Terms
elements of art
principles of
 design
realistic art
abstract art
nonobjective art
composition
hue

Fig. 2-1. Although Henri Matisse is best known for his paintings, he was involved in printmaking for much of his long career and produced over 800 prints. How does Matisse's use of line in this linocut add to the feeling?
Henri Matisse, *Primavera,* 1938. Linocut on gessoed paper.

2 The Art of Printmaking

The art of printmaking involves a great deal of planning, perhaps more than most other forms of two-dimensional art. Printmakers must plan their designs carefully, because the process of making a print involves so many details.

To plan a print, consider how you will use the elements of art and the principles of design. When you discuss your own work and works of your classmates, use the vocabulary of the elements and principles to gain a deeper appreciation for the designs and the thought that went into creating them. When planning or talking about prints, it also helps to have a basic understanding of art styles and which printmaking method might be best for a particular subject or approach.

In this chapter, you will:

- learn to recognize different art styles
- learn about the elements of art and principles of design and how to use the elements and principles to make prints
- learn what's involved in planning a print, including choosing a subject and method
- plan and pull your own print

principles

elements

planning

Art Styles

Traditional two-dimensional works are drawn, painted, or printed in a realistic or representational style called **realistic art**, in which objects are drawn as they appear in life. This style has come to be called Realism. Renaissance artists painted in the **classical** style. Figures and architecture are rendered with attention to proportion and balance. The classical ideals of beauty were first established by the ancient Greeks and later rediscovered by Renaissance artists.

In **abstract art**, a modern development of the late 1800s and early 1900s, the subject is often stylized or loosely interpreted in a way that avoids literal representation.

However, the object may still be recognizable. Abstract art is a major part of today's visual experience.

Abstract works may or may not suggest recognizable subjects. **Nonobjective art**, on the other hand, does not present images that are realistic or in any way representational. The image is not likely to be apparent to the viewer. A nonobjective work can look like nothing more than lines, shapes, or colors. Knowing the differences between realistic, abstract, and nonobjective works will give you the vocabulary to discuss these styles. Becoming familiar with the different styles will help you form your own stylistic preferences when you are choosing subjects and designs for your own prints.

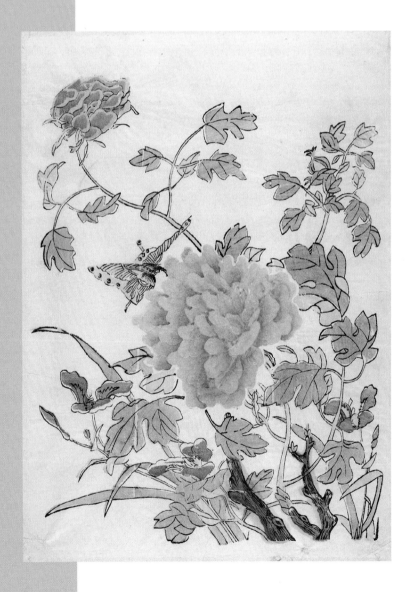

Fig. 2-2. Botanical prints such as this Chinese example from the 1700s are both faithful to reality and designed to please the eye. China, *Peonies and Butterfly*, c. 1650. Color print.

Fig. 2-3. In abstract designs, the world can be both as you've seen it and as you've never seen it before. What makes the print shown here abstract?
Edgar Degas, *Foret dans la montagne (Forest in the Mountains)*, c. 1890. Monotype.

Try It Locate examples of realistic, abstract, or nonobjective prints throughout this book.

Note It Abstract art can purposely confuse the distinction between geometric and natural shapes. In its handling of light, forms, and spatial effects, abstract art can surprise the viewer. It can also defy traditional use of color that is faithful to nature, and instead include color that is unexpected, or even shocking.

Fig. 2-4. In nonobjective art, the subject has disappeared completely or is so heavily altered that it seems to represent nothing with which the viewer is familiar. The style grew out of twentieth-century modernism and abstraction.
Elizabeth Murray, *Untitled,* 1982. Screenprint.

Composing Your Prints

When we talk about the way an artwork looks, we talk about its composition. **Composition** refers to the arrangement and relationship of the different parts that make up a whole image. In art, composition includes the elements of art—the composition's individual parts—and the principles of design, or the organizing effects a composition achieves. The elements of art are *line, shape, form, color, value, texture,* and *space*. The principles of design are *balance, movement, repetition, contrast, emphasis, pattern, proportion,* and *unity*. Learning to use the elements and principles results in stronger images that will convey your ideas to the viewer.

The Elements of Art and Principles of Design

Elements of Art	Principles of Design
line	balance
shape	movement [rhythm]
form	repetition
value	contrast
color	emphasis
space	pattern
texture	unity and variety
	proportion

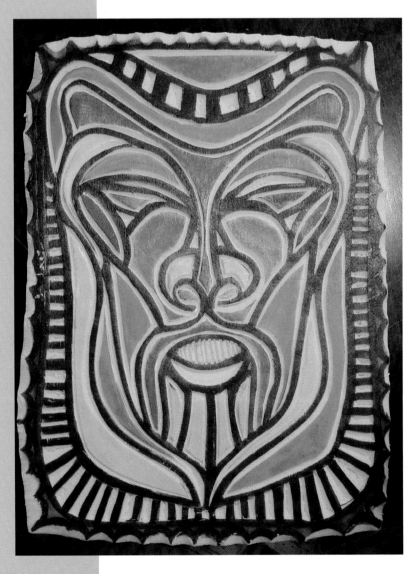

Fig. 2-5. Choose the printmaking processes that best suit your desired results. A relief process was used to create this print.
Teacher-made example, Donna Anderson, *Mask Colors.*

Planning a Design

When thinking about a design, consider what printmaking method you will be using. A design that has drawn or fine lines might work out better as an intaglio or lithograph. A design that incorporates more solid shapes might best be rendered using a stencil process.

Contemporary artist Claes Oldenburg compares the process of making a print to preparing a pizza: "You start with a white sheet of paper—that is, the 'dough'—to which you add layers of images: cheese, mushrooms, sausage bits, tomato paste, immersed in overprinted inks. In the end, the 'pizza' is 'editioned'—that is, sliced and distributed for consumption."

How To . . .

Transfer a Design

It's easy to transfer a drawing from a paper surface to another surface such as a linoleum block. In the carbon paper transfer technique, you trace your drawing with carbon paper under your drawing and on top of the block.

1 Place your drawing over the carbon paper, on top of the surface you will transfer the design to, such as a linoleum block.

2 Use a ballpoint pen to trace over the lines on the drawing. Press down on the lines.

3 Lift the paper occasionally to check the tracing. When complete, remove the sketch. Your drawing is transferred.

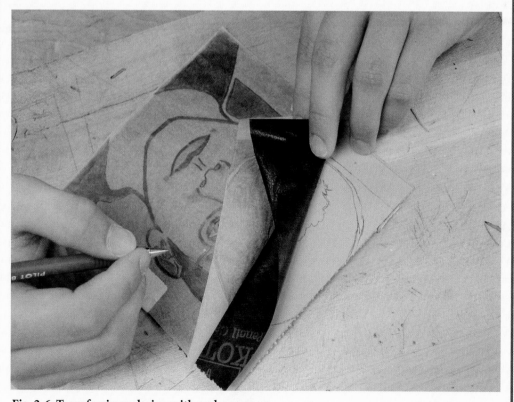

Fig. 2-6. Transferring a design with carbon paper.

The Elements of Art

The **elements of art** are the visual components of an image. They are all real things that can be seen in your prints. Think of them as the materials you will use to compose your designs.

Line and Shape

The first time you picked up a crayon as a child, you began to make lines. A line by definition is a single moving point, but line in art is much more versatile. When the artist Paul Klee described his abstract designs he spoke of "taking a line for a walk." Printmaking is well suited to such explorations of line.

Lines can be combined to create *geometric shapes* such as squares, triangles, and circles. They can also be used to create *organic shapes*. Organic shapes have irregular edges.

Lines can define the shape of an object, creating a representational object that is visible to the viewer, or lines can be put to nonobjective purposes. Lines can lead the viewer's eye through a work of art, or to its center of emphasis. Lines are most interesting in compositions that use a variety of line types.

In his relief print *Type A*, Chris Brady incorporates only one line that is extended for the entire length of the football-field-length linocut. The artist says that "it carves its way through the darkness of the blocks."

Note It If lines are placed very close together, they make an area look darker. When lines are spaced apart, an area looks lighter.

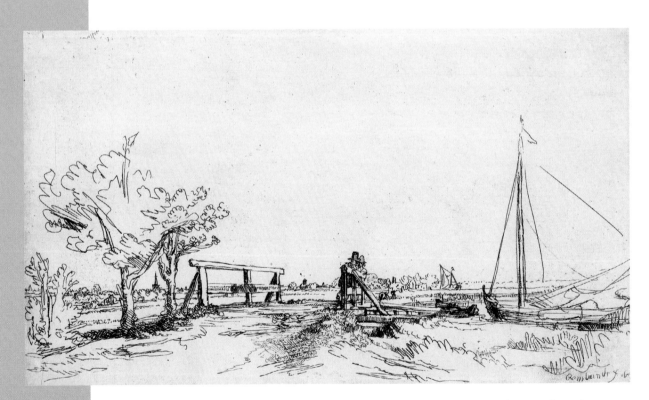

Fig. 2-7. Where do you see lines placed closer together and farther apart in this intaglio print?
Rembrandt Harmensz van Rijn, *Six's Bridge*, 1645. Etching.

Fig. 2-8. Notice the organic shapes created as the line in this print snakes its way along, doubling back and back again upon itself.
Chris Brady, *Type A*, panel 24.

Fig. 2-9. What kinds of shapes do the lines in this print define?
Ed Ruscha, *Your Space #1*, 2006. Sugar lift flat bite and hard ground etching.

Suggested Form

Just as a shape is a two-dimensional object, a *form* is three-dimensional. Artists use value, perspective, crosshatching and other means to suggest form in a two-dimensional artwork. As with shape, form can be geometric or organic. A sphere or cylinder is geometric, and an apple or a pumpkin is organic.

Texture is the way an object feels or looks like it might feel to the touch. Textures can be soft or rough or anything in between. Most textures in prints are implied. *Implied* texture is texture that is suggested by the artist but not actually present to the touch. The print may show a rough object, such as tree bark, but the actual surface of the print is smooth. Texture that you can touch, or *actual texture*, is less common in printmaking, although many contemporary printmakers include it by adding collage or other embellishments to prints.

Fig. 2-10. What suggested forms and textures do you see in this print?
Student work, Sam Hill, *Chess Pieces*.

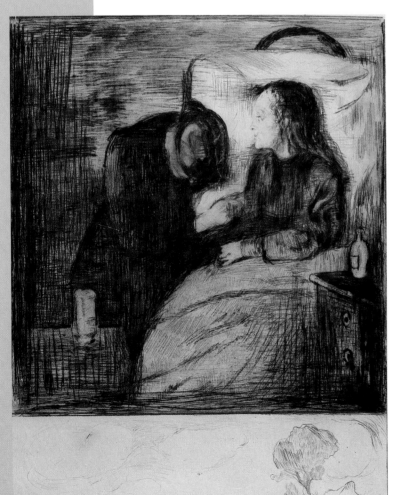

Fig. 2-11. Edvard Munch used the intaglio method to create this print based on one of his paintings. What implied forms and textures can you identify in this print? How is space suggested in the print?
Edvard Munch, *The Sick Child*, 1894. Drypoint, roulette, and burnisher on copper.

Fig. 2-12. The artist has used an image of an engine and played with the black and white areas to indicate positive and negative space. How does this create interest and excitement in the print? How might planning have played an essential part in this print's successful execution?
Student work, Justin Trammel, *Negative Space.*

Space refers to the area around and between shapes and forms. *Positive* and *negative* space is sometimes referred to as figure/ground. Most often, the object is the positive space, and the area around it is the negative space.

Note It Perspective is an aspect of space. It is used to give the impression of distance and relative sizes of objects. Objects are often overlapped or shown in different sizes depending on their location in the composition, an effect called *casual perspective.* Linear perspective is a second type of perspective effect. In *linear perspective,* space is organized by relating objects to a single vanishing point on the horizon.

Try It Black-and-white relief prints rely heavily on the effective use of space. Draw a design to be printed as a single-color relief. Make sure to clearly define the positive and negative space to be shown in the print.

Fig. 2-13. What textures do you see in this lithograph?
Ed Ruscha, *A Columbian Necklace . . . ,* 2007. Four-color lithograph.

Color and Value

Value is an element of art that refers to the lightness or darkness of the surface. Different methods of printmaking rely on different techniques to create value. Line can be used to create value in an artwork as well.

Like painters and photographers, printmakers think about *color* all the time, especially color combinations and schemes. A color combination refers to a grouping of two *complementary* colors, such as orange and blue. A color scheme refers to the overall plan for color in a print. Will you use warm colors such as red, yellow, and brown? Or will you use cool colors such as green, blue, and gray? Or will you combine warm and cool colors?

The name for a color is **hue**. Adding white to a hue creates a *tint* and adding black to a hue produces a *shade*. Artists also create mood in the way they choose their colors.

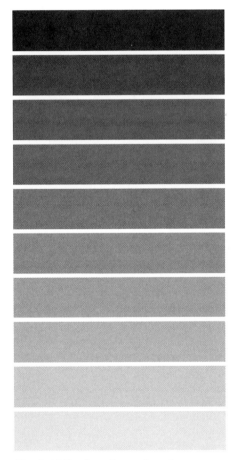

Fig. 2-14. In the value scale, values range from black to white, with gray values in the middle.

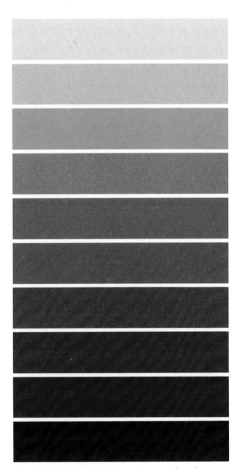

Fig. 2-15. In this color value scale, the tints appear above the central hue, and the shades appear below.

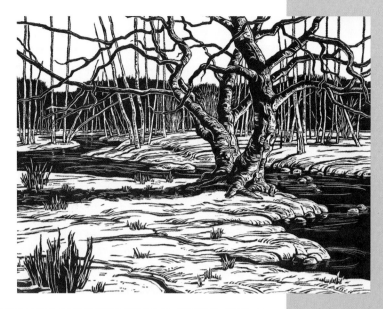

Fig. 2-16. This black-and-white print creates a stark high contrast vision of winter.
Margaret Adams Parker, *Winter Shadows*, 2007.
Woodcut.

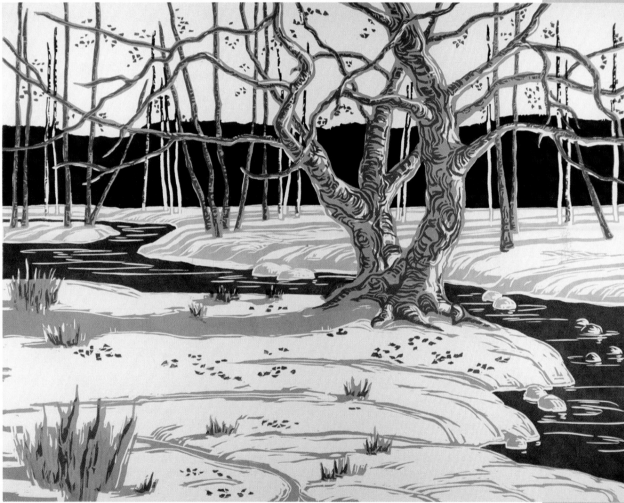

Fig. 2-17. How do the tints in this six-color print make the scene appear softer, more tranquil?
Margaret Adams Parker, *Winter Stream*, 2007. Woodcut.

Israhel van Meckenem

You have learned that a woodcut is a relief print. Everything except the design is cut away, leaving the raised surface. In contrast to the relief print is the intaglio process. A design is cut into a metal plate with a tool called a burin. The plate is inked, and the ink is held in the grooves while the surface ink is wiped away. A piece of dampened paper is forced into the incised lines to pick up the ink.

As was the case with woodcuts, engraving was brought to a high level of sophistication during the 1400s by German artists. One such artist was the engraver Israhel van Meckenem, who apprenticed with his father and learned the crafts of goldsmithing and engraving. His first works were copies of his father's engravings, as well as those of other accomplished engravers of the period. One of these artists is known only as Master ES (active from the 1450s through the 1470s, Upper Rhine). Producing in his lifetime no fewer than 624 individual plates, he was the most prolific engraver of the Renaissance in the north.

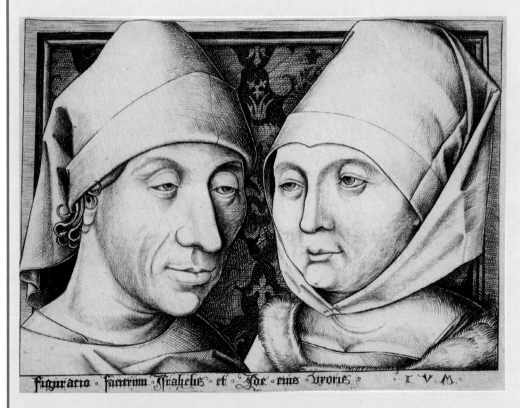

Fig. 2-18. In northern Europe, no one made more metal engravings than Israhel van Meckenem. He depicted himself and his wife in this double portrait. Where can you identify dark and light values? Where do you see texture?
Israhel van Meckenem, *Self-Portrait with His Wife Ida*, c. 1490. Engraving on paper.

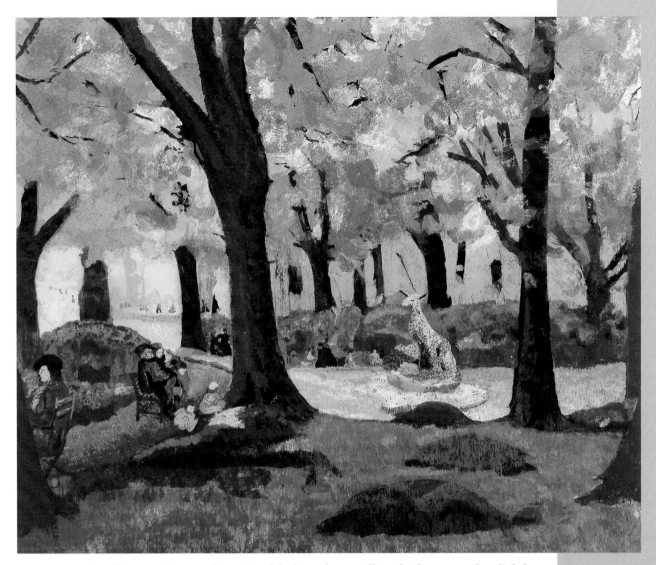

Fig. 2-19. In this silkscreen, the artist has printed darker colors or allowed colors to overlap slightly to create the dark areas of the image.
Loïs Mailou Jones, *A Shady Nook, Le Jardin du Luxembourg, Paris,* 1991. Color screen print.

Note It Color works differently in different methods of printmaking. In silkscreen, the artist can print darker colors and overlap them slightly to create the dark areas of the image. Colors tend to lay down more "flatly" than in relief, intaglio, and lithography, with each new color addition blocking out, or laying over, the area of color printed beneath it.

The Principles of Design

While the elements of art are things you can always see in a print—lines, shapes, colors, and so on—the **principles of design** are not always present. Rather, they are effects that can be achieved through the way you use the elements of art in your prints.

Fig. 2-20. What kind of balance does this print achieve?
Eldzier Cortor, *Dance Composition #35*, not dated (early 1990s). One-color aquatint and line etching.

Balance

Balance is a feeling of equilibrium among the elements in a work of art. It can be symmetrical, asymmetrical, or radial. *Symmetrical balance* is formal balance. It occurs when both sides of a picture are exactly or almost exactly the same. *Asymmetrical balance* uses size or color to balance a design; both sides of the design are not the same. The third kind of balance, *radial balance*, is like a circle. The design comes from the center and moves out to the edges.

Fig. 2-21. This painter and printmaker usually works in a realistic style. Her figures are carefully studied. Would you say the forms and figures are proportional?
Paula Rego, *Mr. Rochester*, 2002. From *The Guardians*, a suite of nine lithographs.

Proportion

Proportion has to do with the way forms and figures relate to one another. When objects in an image are proportional, they have a harmony that is realistic and true to life. Representational images depend on proportion.

Note It *Scale* has to do with showing things larger or smaller than their actual size, but with their individual parts in proportion.

Fig. 2-22. Claes Oldenburg's sculptures usually begin as drawings and prints. What purpose is served by the inclusion of the skyscraper tip on the sidewalk in this print?
Claes Oldenburg, *Proposal for a Colossal Monument in Downtown New York City: Sharpened Pencil Stub with Broken-off Tip in Front of the Woolworth Building*, 1993. Etching.

Pattern, Rhythm, and Movement

Pattern in print design can be used to develop a sense of rhythm and movement, forming an arrangement of elements that creates a sense of direction or visual action. In the artwork *Racing*, by Sybil Andrews, notice how the artist uses the repeated stylized image of the horse and the rider to move your eye to the horse in the lead. The race around the track is intensified by the curved fencing in the bottom left-hand corner of the picture.

Note It Optical movement is the movement of the viewer's eye over the artwork, or the movement in a design that seems to play optical tricks. The Op Art style capitalizes on this effect of visual perception.

Fig. 2-23. How does this print achieve pattern, rhythm, and movement?
Sybil Andrews, *Racing*, 1934. Linoleum cut.

Fig. 2-24. How does this print achieve rhythm and movement?
Student work, Cher Norville, *Zebra*.

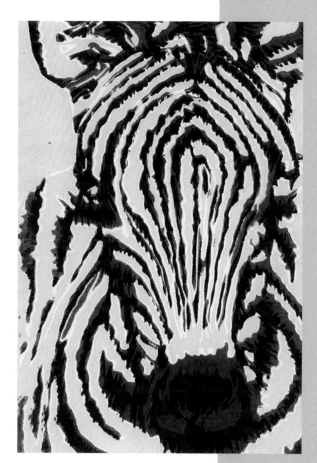

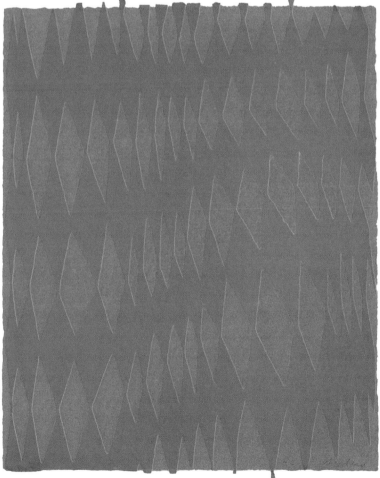

Fig. 2-25. How do the colors move your eyes across this print? Do you think it would work as well with other colors? Kate Shepherd, *Rondeau*, 2005. Pigmented linen blownout on pigmented linen-cotton base sheet.

Unity, Variety, and Repetition

When the design of a print has variety and a balanced composition, it has *unity*. The printmaker has pulled the image together into a single whole. When you look at a unified composition, everything is visually in the right place.

Try It Experimenting with the printmaking process can result in some exciting artwork. Planning is important, but it is also important to realize that not every effect in a print can be planned. Serendipity, or a happy accident, often occurs. Sometimes it reveals new and exciting images.

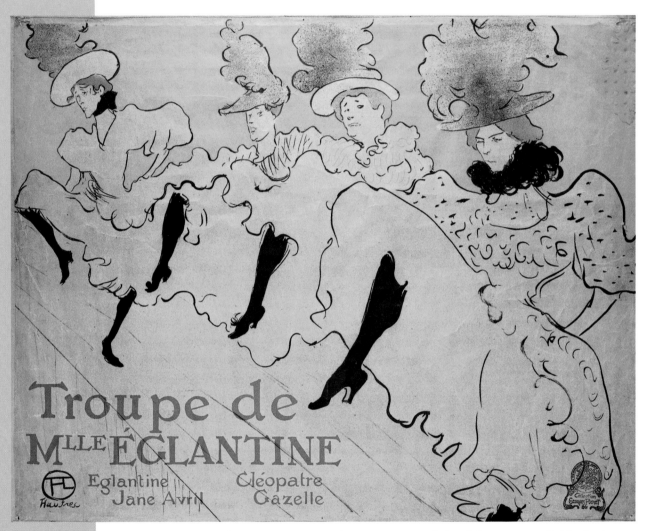

Fig. 2-26. In printmaking, composition is the arrangement of visual elements in a finished print. Henri de Toulouse-Lautrec, *La Troupe de Mlle. Eglantine,* 1896.

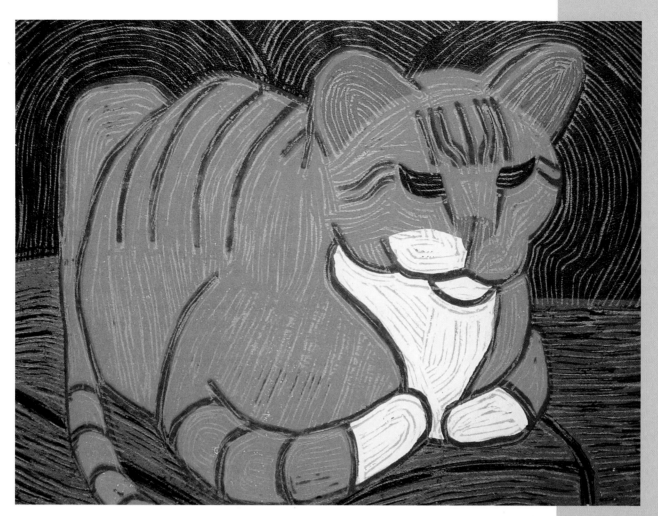

Fig. 2-27. Notice how the student has unified this work with the addition of white highlights.
Student work, John Carlisle, *Toby*.

Studio Experience
Repeated Pattern Print

Before You Begin

Pattern is another of the principles of design that lends itself to printmaking. It can be fun to experiment with creating a repeated pattern. The pattern can develop as you experiment or can be planned, as seen in the photos, to create a pattern within a pattern. Design your image so that a new pattern emerges as the squares touch when printing. Consider how you would like your picture to look.

You will need
- foam cut in 3" squares
- utility knives
- block printing ink
- brayers
- 18" x 24" paper

Create It

1. Sketch some basic designs that you might like to use for your pattern. Think about how your pattern will fit together. Transfer your design to the block.

2. Carefully carve. When cutting into the foam, angle the X-acto knife and cut down one side of a line, then angle the knife in the other direction to cut along the same line. Using the knife in this manner gives you a V-cut that will be easier to control in executing the design. Remember to cut away only the areas that will remain white, or the color of the paper, and to leave raised the areas that you want to print with color.

3. To ensure that your pattern will match, choose one corner that will be the center of your design. Measure up on either side of this corner so that the design will match each time it is turned. On the back of the block put a dot on your center corner so that you will not be confused and turn the block the wrong way when printing.

4. Roll ink onto the block and press against the paper. Turn the 3-inch square one-quarter turn each time it is printed, which will allow a new pattern to emerge.

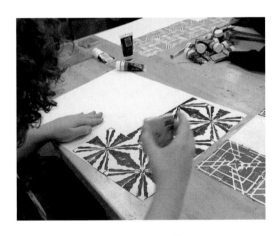

Safety Tip Use care in handling utility knives or any sharp tools.

Check It

Discuss the studio with your classmates. Which designs did you find most interesting? Experiment with your design. Try blending different colors, overprinting, and maybe even offsetting one color onto a new printing block. By cutting the inked areas, you can create a reverse image that can be cut and printed to give a new effect.

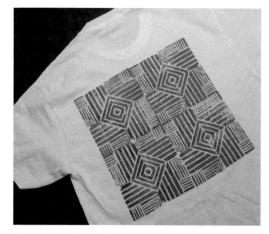

Fig. 2-28. The student who created this design liked it so much she printed it on a T-shirt with textile ink.
Student work, Charlene Dickson, *Geometric Blue*.

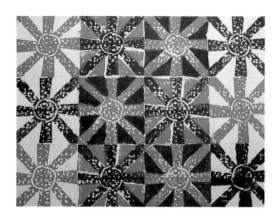

Fig. 2-29. The repeated pattern in this print was accomplished using the same block in two different colors. To add color in the white areas, the student cut a triangle of foam and carefully positioned it in each area.
Student work, Jason Gaus, *Repeat in Violet and Pink*.

Rubric: Studio Assessment

4	3	2	1
Planning • Design • Placement			
Obvious evidence of thinking and decision-making.	Design clearly shows evidence of purpose.	Design is awkward but shows some purpose.	Weak design lacks evidence of intention or consideration.
Effective use of class time; demonstrates clear focus and intent throughout design process.	Reasonable use of class time.	Limited exploration of concept. Limited use of class time.	Haphazard. Off-task for majority of class time.
Media Use/Technique • Technical skills • Safety			
Successful application of technical skills.	Most technical aspects are used well.	Limited use of techniques with some success.	Poor or wasteful use of media/equipment.
Effective display of safety when handling media/equipment.	Reasonable display of safety evident when handling media/equipment.	Possible safety violation.	Lacks awareness of tools/media techniques. Blatant disregard for safety.
Craftsmanship • Pattern • Placement			
Excellent quality in execution of design. Free from mistakes that distract from the unity of the whole.	Demonstrates above average execution of design with slight deficiencies evident in final project.	Needs a lot of touch-up work. Artist should pay more attention to details.	Work has many problems with the look because it has been put together too fast with little or no attention to detail.
Works independently and remains on task.	Needs minimal supervision following instruction.	Needs coaxing to work independently and remain on task.	Does not work independently; exhibits disruptive behavior.

Career Profile
Red Grooms

Red Grooms, whose given name is Charles Rogers Grooms, was born in Nashville, Tennessee. He started taking private art lessons at the age of ten. While still attending Hillsboro High at the age of seventeen, he had an exhibition of his paintings in a Nashville Gallery. After high school he studied for a short time at The Art Institute of Chicago and then completed his studies back home at Peabody College. After college he moved to New York, where he has remained and continued his work. With over forty years as a printmaker, he is also a painter, sculptor, filmmaker, and performance artist. His printmaking is often quite different from the norm. Many of his prints are three-dimensional. His ideas come from his surroundings.

He gives this explanation about the print *Dalí Salad*. "One of the reasons I picked Dalí is because Dalí is an atypical man in the print field. He both exploited and has been exploited in printmaking. That's both the joy and the danger of printmaking. And somehow Dalí became a subject I wanted to deal with. I like this print very much." Grooms used actual vegetables from the supermarket in modeling the pieces of the salad. The butterflies placed on the subjects' hands and arms evoke the fantastical world of Surrealism, the prevailing style of Dalí's abstract artistic productions. Grooms continues to produce interesting and innovative artworks.

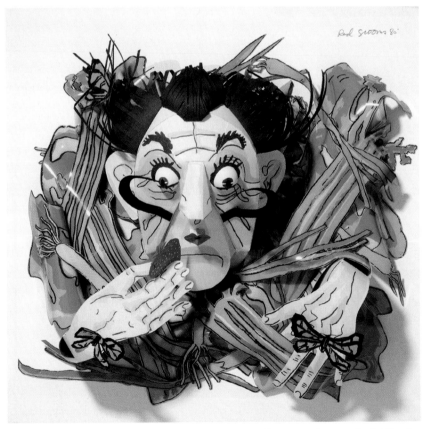

Fig. 2-30. The salad parts of this 3-D print were silkscreened onto vinyl. The face and hands were created and printed as lithography on paper. All of the elements were cut out and then assembled under a plastic bubble.
Red Grooms, *Dalí Salad,* 1980. Print.

Chapter Review

Recall Name the elements of art and the principles of design.

Understand How do the elements of art relate to the principles of design?

Apply Use line to create a drawing that has areas of light and dark value.

Analyze Look again at *Dalí Salad* by Red Grooms (fig. 2-30). What elements and principles can you identify in the print?

Synthesize Look again at the black-and-white print emphasizing space in Fig. 2-12. How could you change the print to emphasize a different principle of design?

Evaluate Look at the print by Munch in Fig. 2-11. Notice the landscape with tree indicated in the bottom portion of the print. Why might Munch have included the landscape at the bottom of the interior scene? Is the combination effective? How does the print succeed as a whole?

Writing About Art

Search in magazines or online for images that reflect the elements and principles of art. Find several examples that reflect any one element or principle (line, shape, repetition, etc.) and write a paragraph describing the element or principle that they share.

For Your Portfolio

You can show some variety in your portfolio by creating the same image in several different medium. Try making a dry point, a relief print, and a silkscreen using the same picture. It might be interesting to combine two of the processes.

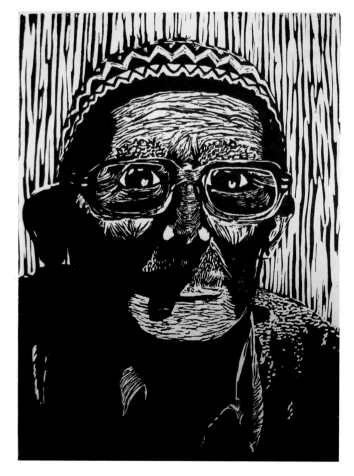

Fig. 2-31. This student print has a strong use of line to portray the age of the subject. What elements and principles can you identify in the print?
Student work, Jordan Swan, *Alzheimer's.*

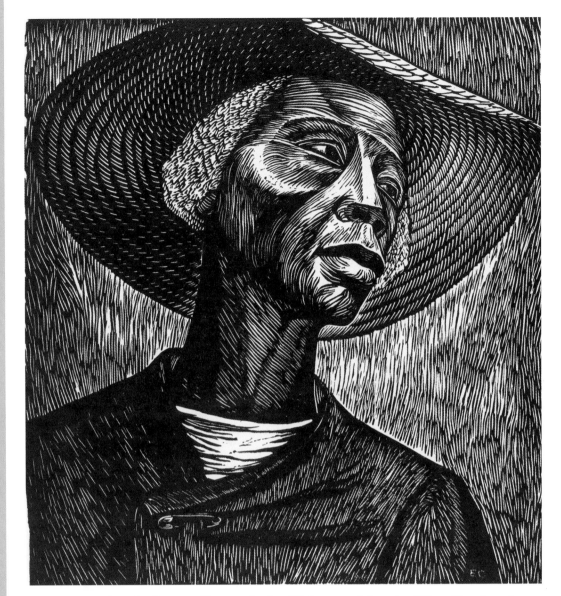

Fig. 3-1. Notice how the figure and hat are sized to fill the area of the print. What effect does that have on you, the viewer?
Elizabeth Catlett, *Sharecropper,* 1952. Linocut.

3 Basic Relief

Have you ever used a stick to make marks in sand, mud, or wet cement? If so, then you have already experimented with creating a design that is cut into a surface material. This is exactly what artists do when they carve relief prints.

For centuries, carved or engraved woodblocks were the easiest and least expensive method of creating illustrations for printed books. Later, artists created relief prints as works of art in themselves. Today, many artists and illustrators continue to work in this basic method.

In this chapter, you will learn:

- the types of relief prints
- the characteristics of relief prints
- the process of making a relief
- how to make your own relief print

linocut

relief

woodcut

The Print in Relief

The relief print is based on a centuries-old production method. Relief plates carved from wood are called woodcuts and wood engravings, depending on the tool used in carving. The primary relief methods used by artists throughout history are the woodcut, the engraving, and the linoleum cut, or linocut.

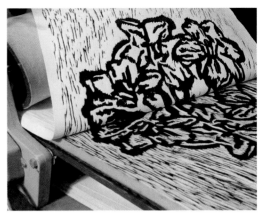

Fig. 3-2. Relief plate and print.

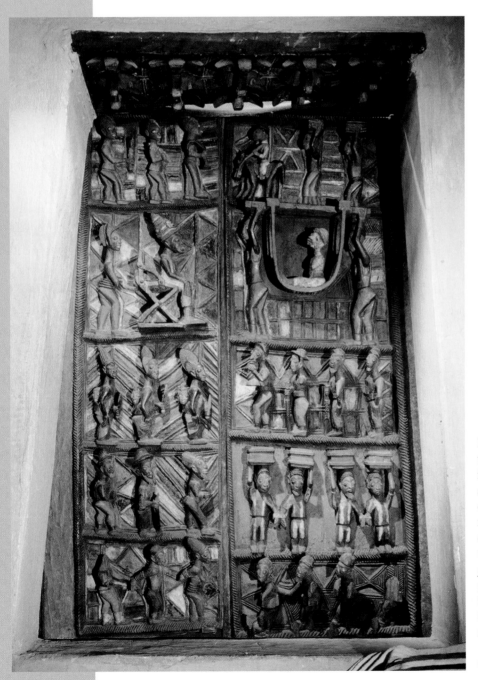

Fig. 3-3. The design carved in this door stands out in relief from the background. In the same way, a relief is the part of the print design that is raised above the carved areas of the plate.
Olowe of Ise, *Doors from palace at Ikere-Ekita.* Central panel depicts the reception by the king (Ogoga of Ikere) of Captain Ambrose, 1st British official to visit the area in 1895, late 19th century. Carved wood.

The term *relief* originates with *relief sculpture*, in which forms project outward from a background or surface. As explained in Chapter 1, relief printing results from a process of subtraction in which material is removed from the plate with a sharp tool, leaving negative spaces that are below the surface.

When the plate is inked, only the surface material takes the ink to create the positive shapes or spaces on the printed design. The removed areas below the surface do not take ink and when the print is pulled they are left as light, or negative, spaces.

Fig. 3-5. Fingerprints and handprints, in which the raised lines on the surface of the skin are replicated, have been described as the "essence" of relief printmaking. The tegata, or hand-shape prints, of Sumo wrestlers, can be valuable collectibles.
Ozeki Konishiki, *Tegata Sumo Japan Wrestling.* Tegata handprint.

Note It Recall the concept of positive and negative space from Chapter 2. Successful relief prints depend on an understanding of the uses of positive and negative space.

Try It Use ink and paper to print your fingerprint. Which lines on the print are the positive spaces and which are the negative?

Fig. 3-4. Transferring images from carved and inked wooden blocks to paper, as in the print shown here, the Chinese created some of the earliest known reliefs.
Vaishravana with attendants, from Cave 17, Mageo, near Dunhuang, Gansu province, China, Five Dynasties, 947 CE. Woodblock print on paper.

Woodcut

The **woodcut** is the oldest and most common type of relief print. The artist draws a design on a smooth plank of wood and then carves it with a special sharp tool called a **gouge**. The artist pushes the gouge away to make the carving. This is the method artist Albrecht Dürer used in the 1500s to create the intricately detailed woodcut shown in Fig. 3-9.

Fig. 3-6. In woodcut, cuts in the wooden plank are most easily made with the grain. Cutting against or across the grain is more difficult.

Safety Tip Be sure to use a bench hook whenever you use carving tools (see page 58) in woodcut or linocut. A bench hook will keep your wood plank or linoleum block steady so that it won't move during carving. Just as important, be sure to keep your hands behind the cutting blade to avoid injury.

Fig. 3-7. Woodcuts allow the image to be unified by using the cut lines to carry the viewer's eye throughout the picture. The cut lines connect all the parts of the image. Vija Celmins, *Ocean Surface Woodcut*, 1992. Woodcut.

Fig. 3-8. How does your eye move through this field? What is the artist trying to say about this country scene? Mary Azarian, *Haying*. Woodcut.

Albrecht Dürer

During the 1400s, German artists developed the relief printing medium of woodblock prints to a great level of sophistication. The process, which originated in Asia, flourished during the sixteenth century in Germany, particularly in the art of Albrecht Dürer. Dürer is considered the greatest artist of the Renaissance in the north, on a par with Leonardo da Vinci and Michelangelo.

After studying goldsmithing, woodcutting, and painting, Dürer began to travel around Europe, to Italy and the Netherlands. In Italy he learned about humanism and the Renaissance ideals of Italian artists and philosophers, who believed that the artist was more than just a craftsman. Like the Italian Renaissance artists, he believed in the genius of the artist and his importance to society. Learning from Italian artists, Dürer was the first German artist to study anatomy.

Although Dürer was also well known as a painter, it was his prints that made him wealthy. His early woodcuts were illustrations for books. By the late 1490s he was producing his own books, which he had written and illustrated with his own drawings. Because of the volume of illustrations he had to produce, Dürer probably did not cut his own block, but made sure the block cutter stuck close to his drawing.

Fig. 3-9. This print was developed as an illustration for a commentary on the Book of John. How does the artist give 3-D form to the figures in this woodcut? Albrecht Dürer, *Four Horsemen of the Apocalypse*, ca. 1497–98. Woodcut.

Wood Engraving

Wood engraving, like woodcut, involves removing material so only the part that is left takes the ink and is printed.

In wood engraving, the artist uses a sharp tool called a **burin** (also called a *graver*) to engrave a line below the surface of the plate. The burin has a V-shaped tip that creates clean, strong edges for printing.

Wood engravings are done using an end cut of wood, rather than the wooden plank used in woodcut. The end cut would be similar to a horizontal slice of a tree trunk. Because there is no grain, the cuts are easier to make and to control.

First developed by the English printmaker and illustrator Thomas Bewick, by the early 1800s wood engravings had found significant commercial uses. Wood engraving as a printmaking method is not as common now as it was in earlier times. Today, wood engraving is done mainly as an artistic process, rather than for making multiple copies.

Note It Wood engraving provided an excellent method for making popular illustrations, and thus wood engraving contributed to the nineteenth-century rise of illustrated magazines that reached a large public.

Fig. 3-10. The end grain, or crosscut, of wood is used in engraving because the grain does not resist or guide the cut in any one direction.

Fig. 3-11. In this hand-colored woodcut, the artist signed, numbered, and chopped her work on the print itself. This is done when prints bleed, or go all the way to the edge of the paper.
Student work, Katie Buchanan, *Spring Flowers*.

Fig. 3-12. Northern European artist Lucas Cranach the Elder used a burin in the wood engraving process which has a V-shaped tip that creates clean, strong edges for printing.
Lucas Cranach the Elder, *St. Christopher*, 1509. Chiaroscuro woodcut.

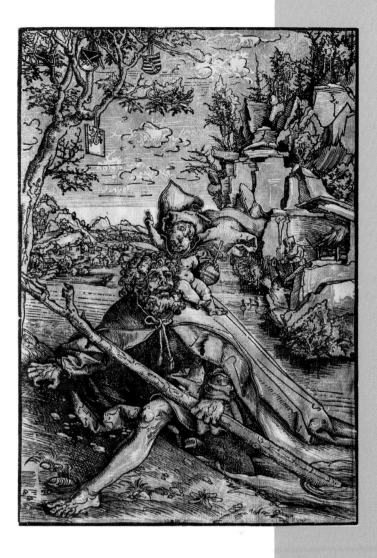

Fig. 3-13. How effectively does this engraving describe the hound?
Thomas Bewick, *A Hound*, from *History of British Birds and Quadrupeds*. Engraving.

Linocut

Linoleum is another material artists use to make relief prints. With the development of linoleum in the 1800s, artists found a material that could be carved like wood but with a bit less effort, because the substance is softer than many woods and contains no grain. The print resulting from the process of printing from linoleum block is called a **linocut**. Today, many artists and illustrators continue to carve prints in linoleum.

Safety Tip Remember to use a bench hook to keep your wood plank or linoleum block steady so that it won't move during carving.

Fig. 3-14. Carving the linoleum block.

Fig. 3-15. What elements and principles can you identify in this print? How do they work to communicate the subject of insects in the garden?
Pablo Picasso, *Young Pigeon*, 1939. Linocut.

Fig. 3-16. In what ways is this print surreal? Student work, Laura Aghagian, *World Hunger*.

Fig. 3-17. The artist used the cut marks in this linocut to create interest. Notice the curved line across the forehead, which pulls your eye around the face. What other ways has the artist used the cut lines to create visual interest? Samella Lewis, *I See You*, 2005. Linocut.

Fig. 3-18. This Egyptian artist uses the manner of cutting to create pattern and movement. Sareya Sedky, *Egyptian Mother and Child.* Linocut.

Line

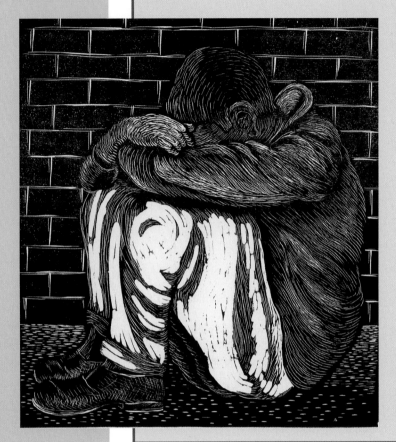

In the image *Youth*, by Margaret Taylor Burroughs, line plays a prominent role. The cut marks in the jacket are placed next to each other to show the creases and shadows in the sleeves, back, and collar.

As you look at the print, notice that the artist has used line to contour the figure's head and hands. You can even see that lines shape the shoes of the figure.

To create focus on the subject, the background of the picture is very minimal. The artist uses simple shapes and marks to imply the brick wall and floor so that the figure is the main point of the print.

Fig. 3-19. African-American artist Margaret Taylor Burroughs often depicts young people in her prints. How does the artist create emphasis in this design? Margaret Taylor Burroughs, *Youth*, 1953. Linoleum cut.

Relief Carving Tools and Techniques

Both woodcuts and linocuts make use of the same carving techniques. You need only a few basic tools, such as a burin and a gouge, to carve woodcuts and linoleum cuts. The tip of a burin is solid and pushes through the wood. The gouge has a blade that is in a U- or V-shape and cuts the plate and removes the linoleum or wood. The groove cut by the gouge is in a U- or V-shape also.

Gouges. The two specific types of blades in gouges used in relief carving are the V-gouge and the U-gouge—each gouge named for the shape of the cut it creates.

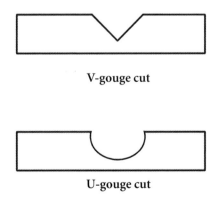

V-gouge cut

U-gouge cut

Fig. 3-20. Both V- and U-gouges come in several different sizes to meet the needs of the artist.

Fig. 3-21. A relief design can be as simple or complex as you wish. The dark areas of this print were printed from the inked, raised surface of a carved linoleum block.
Student work, Kim Wolforth, *Rita*.

Ink and Print a Relief Print

After you have carved your relief plate, gather all your paper and materials together. Be sure that the area in which you will print is clean and free of any of your carving scraps. Any debris that gets into the ink can cause white spots and ruin the ink coverage.

You will need a brayer, ink slab, ink, relief plate, and printing paper.

❶ Squeeze out a portion of ink onto the ink slab. The ink should be about the size of a quarter.

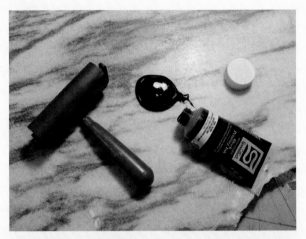

❷ Pick up some of the ink with the brayer.

❸ Roll the ink out in a small area so that it looks like the surface of an orange peel. The surface should be evenly pebbled and you should hear a small swishing sound as you roll the brayer.

4 Lift the brayer at the end of each roll so that the ink is distributed around the entire brayer. (If the brayer is rolled back and forth, it will have ink only on one side.)

5 Begin to roll the ink onto the printing plate. Be sure to roll ink over the entire surface. The ink will be shiny so that you can tell which parts are covered. Angle the plate in the light to check for any missed areas. Be sure ink is rolled all the way to the edge of the plate.

6 Center the plate on the printing paper. Carefully turn the plate over so that the paper is up. Run the plate through a press or burnish the back of the paper with a baren or other object, such as a wooden spoon, to produce the print. Carefully pull the paper away from the plate to reveal the printed image. Check to see if any changes need to be made to the plate. If you are happy with the results, continue printing an entire edition. Be sure to sign, number, and title your edition of prints.

Expressive Possibilities

The German Expressionists and the modern and contemporary artists who followed have made fruitful use of the relief medium. The Expressionist print in Fig. 3-22 is abstract. It takes liberties with reality, but is still representational of a person.

Note It While wood engraving, woodcut, and linocut are the major techniques for relief printing, they are not the only techniques. *Collagraph* and *embossing* are additional methods of relief printing that you'll learn more about in Chapter 9, Mixed Methods and New Directions.

Try It What models might you have access to among your own family and friends? Develop a print based on a portrait of someone you know. Your print might be based in observational drawing or on a photograph. What can you say about a person in a relief print?

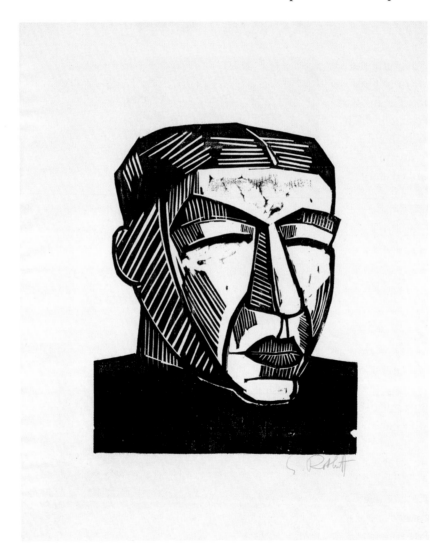

Fig. 3-22. This artist's mother modeled for the portrait in this print. Would you say this is a realistic or abstract work? Why?
Karl Schmidt-Rottluff, *Mother* from the portfolio *Ten Woodcuts*, 1916, published 1919. Woodcut.

Fig. 3-23. What does this print show? Why is relief an effective method for this design?
Leonard Baskin, *View of Worchester,* 1953. Wood engraving.

Fig. 3-24. Notice the movement in this image and the way the student has used cut lines. Do you think this enhances the design?
Student work, Ian Turner, *Dandelions.*

Studio Experience

Self-Portrait Linocut

Self-portraits are a good way to think about who you really are. It's an opportunity to consider what you like to do and what you want to become. A self-portrait also gives you the opportunity to decide how you want to look and how your clothing can reflect your personality.

When drawing your self-portrait, use a mirror, not a photograph, to view your own image. Drawing from a photograph only gives you a two-dimensional view of yourself. Drawing using a mirror allows you to see exactly how your eyes look and how different they are when you laugh. You can easily change your expression in a mirror, something that you cannot do with a photograph. As you draw, you can experiment with expression and make changes in how much or how little of your face shows in the picture. Sometimes it is more interesting to zoom in on your face. Unless you are having yearbook pictures made, the entire face doesn't always need to be in the picture.

Before You Begin

Using a mirror, study your expressions. Choose an expression and decide what parts of your face to focus on for your self-portrait. You will draw yourself, using only black and white. There should be as much black as there is white in the image. Remember, when transferred to the linoleum, the white areas of the design will be cut away.

You will need
- drawing pencil and eraser
- mirror
- 8½" x 11" paper
- marker
- carbon paper
- ballpoint pen
- masking tape
- 6" x 6" linoleum piece
- linoleum cutters
- brayers
- water-based block printing ink
- printing press

Create It

1. On an 8½" x 11" piece of paper draw a 6" x 6" square. Draw your self-portrait in this square.

2. Cut out the square of paper. Lay carbon paper on the 6" x 6" linoleum piece (carbon-side down) and then place the drawing on top. Use masking tape on two sides to keep it in place. Trace the design completely with the ballpoint pen. Remove the carbon paper and drawing from the linoleum. Trace the carbon line on the linoleum with the marker so it is more visible.

3. Using a gouge, carefully cut away the white areas you do not want to print. Use a brayer to apply water-based block printing ink to your plate.

4. Put a piece of paper on top of the plate and, with the paper up, run the print though the press. After checking for any needed changes, print your edition. Don't forget to title, sign, and number your edition.

Safety Tip To keep your linoleum from shifting when you are cutting it, be sure to use a bench hook. Be sure to keep your hands behind the cutting blade to avoid injury.

Check It

Did you pick an interesting expression? What part of your face did you focus on and why? What could you have done differently?

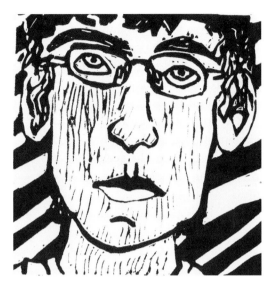

Fig. 3-25. Experiment with composition. Sometimes it is more interesting to zoom in on your subject.
Student work, Josh Galyon, *Self-Portrait.*

Journal Connection

I AM

I am (*two special qualities about yourself*)
I wonder (*something you are actually curious about*)
I hear (*sounds you enjoy*)
I see (*your favorite sights*)
I want (*an actual desire*)
I am (*repeat the first line*)

I imagine (*a place or situation other than here*)
I feel (*feelings you experience in your daily living*)
I touch (*or influence someone or something*)
I worry (*something that makes you sad*)
I cry (*something that makes you sad*)
I am (*repeat the first line of the poem*)

I understand (*something you know is true*)
I say (*something you believe in*)
I dream (*something you hope for*)
I try (*something you really make an effort to do*)
I hope (*something you actually hope for*)
I am (*repeat the first line of the poem*)

adapted from Suzi Mee
—Teachers and Writers Collaborative

Rubric: Studio Assessment

	4	3	2	1
Composition				
	Excellent quality in concept and execution.	Demonstrates an above average approach in concept and execution.	Work reflects some effort, student simply follows instructions.	Concepts are simple and tend to be trite. Weak composition, haphazard.
Media Use/Technique • Technical skills • Procedures				
	Followed all directions and used creative license where appropriate to make a striking piece.	Most technical aspects are used well. Reasonable display of safety evident when handling media/equipment.	Limited use of techniques with some success. Possible safety violation.	Poor or wasteful use of media/equipment. Lacks awareness of tools/media techniques. Blatant disregard for safety.
Craftsmanship • Printing • Edition				
	Excellent quality in execution of design. Neat, crisp edges, solid layer of ink, no smudges or fingerprints.	Demonstrates above-average execution of design with slight deficiencies evident in final project. Good layer of ink, but some smudges on edges.	Needs a lot of touch-up work. Artist should pay more attention to details. Edges are smudged, ink is uneven.	Work has many problems with the look because it has been put together too fast with little or no attention to detail.

Career Profile
Mary Azarian

Web Link

See more of Mary Azarian at www. maryazarian.com.

Mary Azarian moved to a small hill farm in northern Vermont in 1963. There, she farmed with horses and oxen, kept chickens, a milk cow, and sheep, made maple syrup, and raised three sons as well as a large vegetable and flower garden. These years on the farm became the basis for the subjects she has chosen to depict in her woodcut prints.

In 1969, she started Farmhouse Press and began producing woodcuts, printing first by hand and eventually on a nineteenth-century Vandercook proof press. Her initial prints were done in black and white, but she soon began experimenting with adding color. Trained as a painter as well as a printmaker, she developed a nontraditional technique of adding the color to her prints with water-based paints rather than with individual color blocks. This process allows each print to be unique and the color to vary slightly from print to print. Most of the prints produced at Farmhouse Press are printed on the Vandercook press. All prints are individually hand colored.

Recently, the artist has returned to hand printing black-and-white woodcuts on Japanese paper. The quality of hand rubbing can never be duplicated on a press.

Fig. 3-26. Caldecott Award–winning illustrator Mary Azarian says she has been doing woodcuts for so long that she can write backward as easily as forward. Her years living on a farm in Vermont became the inspiration for the subjects she has addressed in her relief prints.
Mary Azarian, *Round Bales*. Woodcut.

Chapter Review

Recall Explain the two primary types of relief printing.

Understand Describe the process involved in creating a relief print.

Apply Develop a drawing design that will reproduce successfully as a relief print.

Analyze Look at *The Sharecropper*, by Elizabeth Catlett (Fig. 3-1). What lines do you notice, and how are they combined by the artist to create rhythm and movement?

Synthesize Think about another piece of artwork that you have created, such as a drawing or a painting. How would you change the image to create a successful relief print?

Evaluate Look back at the engraving by Thomas Bewick in Fig. 3-13. How does the engraver create movement and interest in the print? How well do you think this print succeeds in a realistic style?

Writing About Art

Look at the prints of different faces in this chapter. How has the process of relief printing contributed to the expression and feelings conveyed in the image? Choose two of the faces and compare and contrast the way the artist has chosen to represent them. Write a paragraph about the ideas you considered.

For Your Portfolio

Use your portfolio to develop a series of prints. When you are developing your portfolio, it is a good idea to have images that show your ability to develop a theme. Consider a series of self-portraits.

Fig. 3-27. For this print, the student took advantage of subject matter readily available in the art room. Look around. In what ways do you consider your surroundings when looking for subject matter?
Student work, Ben Innes. *Printing.* Linocut.

Fig. 4-1. This woodcut by Helen Frankenthaler has the same "abstract landscape" quality that viewers have identified in the artist's paintings. Would you say this work is nonobjective, or merely abstract?
Helen Frankenthaler, *Savage Breeze.*, 1974. Woodcut, printed in color on cream and brown pink, smooth, laid handmade Nepalese paper (laminated).

4 Color in Relief

Using color is an exciting way to develop your print designs. Print-makers use color in all mediums, including intaglio, lithography, and silkscreen. The oldest method of printing in color, however, is the relief print, specifically the color woodcut.

In the last three hundred years, both woodcuts and wood engravings have evolved to unexpected levels of beauty and complexity. Early woodblock prints were made with black ink, but in the 1700s, artists in Japan perfected the technique of carving woodblocks to make prints with more than one color.

Woodblock reduction prints take skill in planning and carving. The invention of linoleum block printing one hundred years ago has allowed artists to make linocut reduction prints more easily. Both woodcut and linocut reduction prints remain extremely popular today.

In this chapter, you will learn:
- how printmakers past and present have added color to relief by various techniques
- how to plan and make a reduction print

reduction

multiple block

embellishment

Hand Additions

Many early relief prints were hand colored. The oldest prints with color were created by adding hand coloring to the print, rather than printing blocks in successive states with different colors or by reducing the block between printings.

Artists today continue to create relief prints and add color **embellishment** with watercolor, pencil, or other additions. Chapter 9, Mixed Methods, includes examples of such prints. You will have the opportunity to embellish your relief prints with these or other media.

Note It With the embellishment method, each print is unique, so a series of prints cannot form a uniform edition.

Try It Add hand embellishments in pencil or watercolor to one of your own single-color prints. How will you use color?

Fig. 4-2. Hand-colored block prints such as this example were used to illustrate the first printed books. What does this print have to say about its subject, Alexander the Great? *Hartlib's Alexander. Alexander Seated on Throne. Germany, 15th century. Woodcut.*

Fig. 4-3. Note the large size of this print as noted in the credit dimensions. How would you describe the printmaker's use of color in this print?
Jim Dine, *The Woodcut Bathrobe*, 1975. Woodcut with hand coloring.

Fig. 4-4. The relief print shown here was embellished with colored pencil. How did the student plan the color additions?
Student work, Ashley Stanford, *I'm a Star.*

Multiple Block Printing

Instead of coloring prints by hand, artists discovered a more efficient process to create an edition of relief prints that contain more than one color. They developed a process called **multiple block printing**. Each part of the design that was a separate color was created on its own separate block. The artist ran the print, using one block for each color. The first true multiple block prints were European and were fairly crude, but by the 1700s the technique of multiple block printing came into prominence in Japan.

These prints were widely distributed in Europe and the West. The look of Japanese woodblock prints depicting both landscapes and intimate domestic interior or backstage environments strongly influenced subsequent artists working in woodcut and other printmaking methods. Nowhere was this more true than in work of the French Impressionists in the late 1800s.

Note It Classic views such as the landscape of the formidable Mount Fuji in Fig. 4-6 were a staple of Japanese printmakers of the 1700s and beyond.

Try It Use your sketchbook to brainstorm designs for your own *ukiyo-e* style print. (See the Art History feature on the next page.) Use a landscape or interior subject matter of your choice.

Fig. 4-5. The Italian artist Francesco Clemente transformed a watercolor self-portrait into the multiple block print shown here. As in the traditional *ukiyo-e* manner, Clemente collaborated with both a woodblock carver and a master printer.
Francesco Clemente, *Untitled (Self-portrait)*, 1984. Color woodcut print on Tosa Kozo paper.

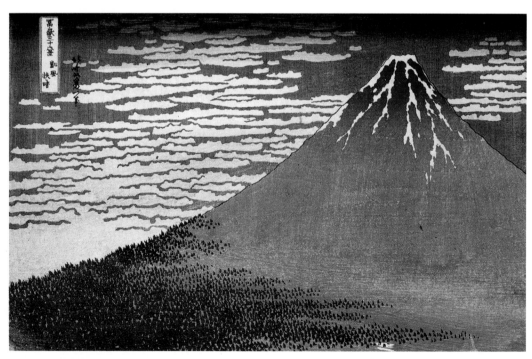

Fig. 4-6. How has the printmaker applied color in this print? How does the use of color help the print communicate meaning?
Katsushika Hokusai, *South Wind, Clear Sky (Gaifu kaisei) (Red Fuji),* from the series "Thirty-Six Views of Mt. Fuji" (Fugaku sanju-rokkei). Color woodblock print.

Japanese *Ukiyo-e* Prints

The Edo period, also called the Tokugawa period, was a 250-year stretch of peace in Japan. With peace came an increase in luxury of life among the upper classes, while merchants and artisans—the lowest two stations in the social order—reaped the benefits of providing goods and services. Townsmen steadily grew in prosperity.

Artists turned to painting scenes of common, everyday life called *ukiyo-e*. *Ukiyo-e* in Japanese means "images of the floating world"—*floating* used in the Buddhist sense of the temporary or fleeting nature of everyday life. The earliest *ukiyo-e* works were primarily paintings. During the 1600s, the rise of the new well-to-do middle class lead to an increased demand for art of the urban and everyday worlds. This demand spurred the swift development of original and numerous woodblock prints designed for mass consumption.

Around 1765, Harunobu is credited with pioneering the multiple block printing, which replaced two- and three-block printing. Often up to twelve woodblocks were used to create luminous multicolor prints. Harunobu produced a variety of pictures, from beautiful women to theatre scenes to genre scenes of people going about their daily lives. He is famous for his slender, elegant figures and focusing on the common aspects of everyday life. Each of his drawings was traced on a single block that was then carved with a burin and used in the production of a single color for the composition.

Fig. 4-7. Harunobu is thought to be one of the first artists of his time to pioneer printing with more than two or three blocks. How many blocks do you think it took to create this print?
Suzuki Harunobu, *Drying Clothes,* ca. 1767–68. Color woodcut.

Reduction Prints

The most efficient process for making relief prints that contain more than one color is the **reduction print**. To make a reduction print, the artist prints the uncut linoleum with the first color. After that color is printed, that part of the linoleum is cut away so that the addition of the next color does not cover the first. Then the artist prints the second color and carves away the design. The linoleum is reduced with each step, until by the time the print is finished, only the linoleum design for the last color remains on the plate.

Fig. 4-8. Compare this image to the black-and-white relief in Fig. 3-1. How does the addition of color change the print?
Elizabeth Catlett, *Sharecropper*, 1952. Color linocut on cream Japanese paper.

Fig. 4-9. This student created a little more interest in his single color print by printing it twice. He printed the image first with white ink and then rolled the plate with black ink and printed it on top. He moved the print over a little so that both colors would show.
Student work, Alan Sudlow, *Mom's Scottie.*

Fig. 4-10. How does this color woodcut seem to blend a traditional Japanese feeling with a more modern style?
Milton Avery, *Birds and Sea,* 1955. Woodcut on paper.

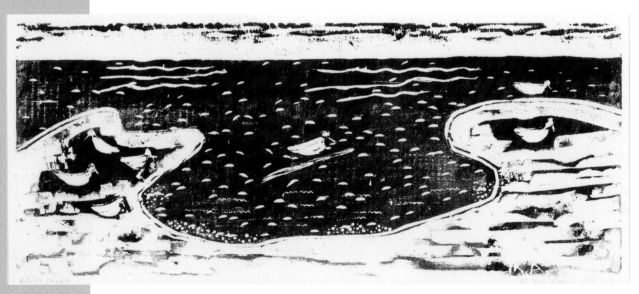

Color and Shape

Color and shape are key to relief prints and to reduction prints in particular. You can experiment with applying color to the shapes cut in each step. Using geometric shapes that complement each other or that create sharp angles can lead to inventive results.

In the linocut in Figure 4-11, the many cubes are made of parallelograms of different shapes, sizes, and colors. The cube forms rest against background tints and shades selected for maximum contrast. Note how they are carefully fitted within the frame of the print. The repeated shapes and colors, while all of a single palette, suggest a universe of unlimited variety.

Fig. 4-11. Why do you think the kind of design shown here might be called "conceptual"? How might the cubes have been arranged differently while still fitting within the allotted frame?
Sol LeWitt, *Distorted Cubes (B)* from *Distorted Cubes (A-E)*, 2001. Linoleum cut.

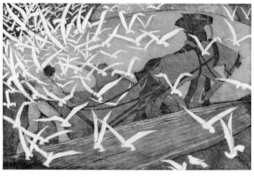

Fig. 4-12. This linocut has more than six colors. Can you find how many there are?
Ethel Spowers, *Birds Following a Plough*, 1933. Linocut.

Note It In reduction printing, each color printed is allowed to dry entirely before the next color is printed.

Try It Practice working monochromatically to get the feel of reducing and over-printing values.

Safety Tip Just as important as keeping your hands from the front of a carving blade, take care when changing the blades in a linoleum cutter. A dull blade can cut you as easily as a sharp one.

Fig. 4-13. Picasso was one of the first artists to explore linoleum reduction printing. How are the lines and shapes in this still life a good choice for a linocut?
Pablo Picasso, *Nature Morte au verre sous la lampe (Still Life with Glass under the Lamp)*, 1962. Linoleum cut, printed in color.

Make a Reduction Print

Use a linoleum plate to make your own reduction print. Use up to four colors in your design. Before you begin, design and paint a template of how you want your print to look.

1 Draw your design the size it will be in the finished print. Use water-based paint and brushes to add the colors you have chosen for the different areas of your print. Paint each section evenly so it will look like the finished product.

2 Cut out the design. Transfer the design to the linoleum plate using carbon transfer process described on page 29 in Chapter 2. Trace the carbon lines with a Sharpie or other permanent marker. Make certain that you can see the lines; you will be cutting these lines as the print progresses.

3 Roll out the lightest color first, usually white or yellow, on the linoleum. Pull the number of prints that will be in the edition. Each color needs to dry overnight before the next color is applied, because water-based ink is being used.

4 Using the V-shaped gouge, outline the areas of the design that are the color of the ink you just printed. Use your original painted design to check that you are cutting the correct area. Use the U-shaped gouge to cut and remove these areas inside the outlined areas.

5 Roll the next color on the linoleum. It is a good idea to mark TOP on the back of the linoleum so that the color will be printed in the right direction. Line the piece of linoleum up with the

edges of the print you made of the first color. Lay the linoleum down on top of the last color. Turn the plate over so that paper is on top before running it through the press.

6 Remove the paper from the plate and you will see that your print now has two colors. To further reduce the plate, repeat the process.

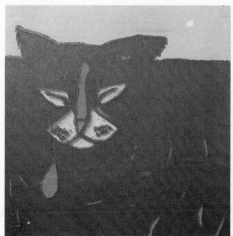

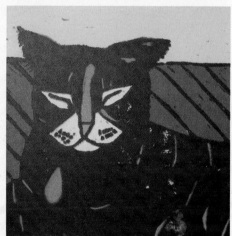

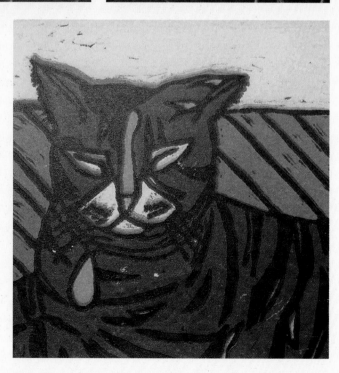

Fig. 4-14. Student work, Jessica Fachman, *Cat*.

Process Books

A **process book** is a book that visually explains reduction printing. It also serves as a document for display of the entire print-making project. You can use your process book to explain the printing process to anyone who views it.

Try It Use a print size that will fit easily on a uniform paper size—say, a 6" x 6" design on 8½" x 11" paper. Measure and use a pencil to mark a 6" x 6" area on a sheet of paper. Sketch a design for a reduction print to use several colors.

Fig. 4-15. Examples of process books show the steps in making a reduction print. The covers are made from papers created with the shaving cream method of printing. Do you think you would like to try this method?

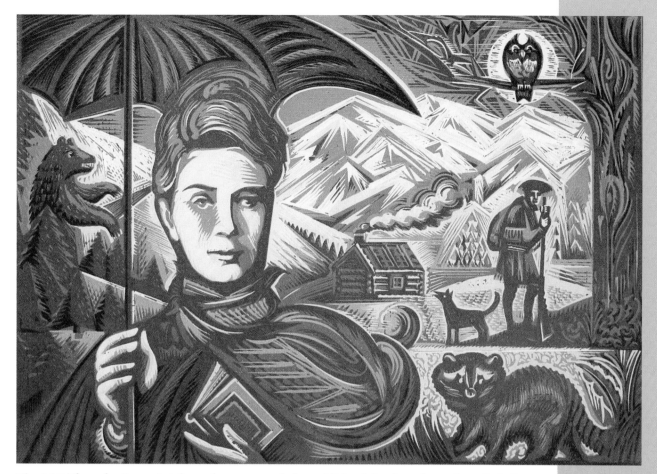

Fig. 4-16. The reduction print shown here was made for a children's book on the explorer Isabella Bird. How does the relief print capture some of her story in a series of carefully planned designs?
Stephen Alcorn, *Isabella Bird, Rockie Mountain Explorer,* 1991. Relief-block print (reduction print).

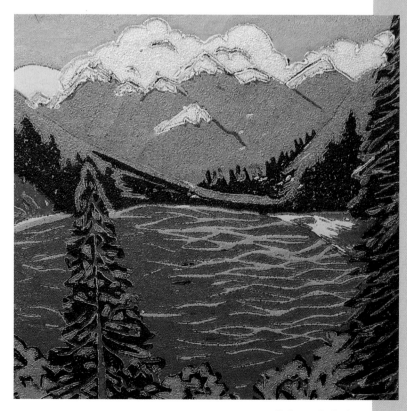

Fig. 4-17. Student work, Jill Pierce, *Mountain Air.*

Studio Experience
Reduction Print and Process Book

In this Studio Experience you'll create your own numbered edition of a five-color reduction print. Your edition will have five prints. Also, at each stage during the reduction process, you will make one extra print, which will go into a process book. The process book will show how you arrived at your final reduction print.

Before You Begin

Look at examples of multicolor linoleum prints. Think about what kind of image you would like to make. Draw your image flatly, without shading. Each color in the print will be solid and flat. Plan to use at least five colors in this design. What colors will you use?

You will need
- 8½" x 11" paper
- pencils
- waterproof markers
- scissors
- masking tape
- paint and paintbrushes
- carbon paper
- battleship linoleum
- linoleum cutters
- brayers
- water-based block printing ink
- printing press
- cover stock or another heavy paper
- chip board, mat board, or cardboard

Create It

1. Draw your design in a 6" x 6" space so it will be the size of the finished print. Use water-based paint and brushes to add the colors you have chosen for the different areas of your print. Paint each section evenly so it will look like the finished product.

2. Cut the painted design along the outside edges so that it is exactly 6" x 6." Lay carbon paper on the linoleum and then the painted design on top. Use masking tape on two sides to keep it in place. Trace the design completely. Remove the painted design and keep it handy. Trace the carbon lines with a Sharpie or other permanent marker. The lines need to be visible because you will be cutting them as the print progresses.

3. Roll out the lightest color first, usually white or yellow. Charge the linoleum and position the square on the right side of the horizontal 8½" x 11" sheet of paper. With the paper up, run the print through the press. Proceed to print 10 more papers the same way. This will give you a final edition of 5 prints and a copy of each printing step for your process book. Allow the papers to dry overnight before the next color is applied.

4. Wipe and dry to clean the plate. Then make your first reduction on the linoleum. Using the V-shaped gouge, outline the areas of the design that have the color of the ink you just printed. Use your original painted design to check that you are cutting the correct area. Use the U-shaped gouge to cut and remove the areas inside the outlined spaces.

Fig. 4-18. How does this student's work show a successful process of reduction? How does the design lend itself to the reduction method?
Student work, Katie Boehr, *Purple Flower.* Five steps to make a five-color print.

5. Roll the next color on the linoleum. It is a good idea to mark TOP on the back of the linoleum so that the color will be printed in the right direction. Line up the linoleum plate with the edges of the first print. Lay the linoleum down on top of last color. Run through the press. Then remember to save one print to use for your process book.

6. After completing this run, clean the linoleum as described in the Student Handbook. Cut your second color away. Refer to your design often when you are outlining the areas to be cut with the V-shaped gouge. After outlining, remove the areas with the U-shaped gouge.

Check It

Continue printing and cutting until the print is finished. Be sure to save one print as each color is added for your process book. When you are finished, you should have six completed prints with five colors on each. Five will be signed and numbered as part of the edition and one will go in your process book. Your process book should also have four other prints: one with four colors, one with three colors, one with two colors, and one with one color.

Sign your edition of five prints with a pencil. Use an edition number on each. See Student Handbook for detailed instructions on signing and numbering a print and on making the pages and covers for your process book.

Rubric: Studio Assessment

	4	3	2	1
Composition				
	Strong composition that addresses complex visual and/or conceptual idea.	Composition clearly shows intention to convey idea.	Composition is awkward but shows some purpose.	Weak composition that lacks evidence of intent or consideration/haphazard.
Procedures • **Transferring Image** • **Printing**				
	Excellent procedural processes. Exhibits technical excellence. Closely followed demonstrated procedures.	Reasonable use of materials and processes. Followed demonstrated procedures with few omissions.	Normal use of processes, some mistakes in procedure.	Poor or wasteful use of media/equipment, procedures not followed.
Craftsmanship • **Printing** • **Edition Quality**				
	Excellent, neat execution. Good ink coverage and registration with no smudges. Includes edition numbers and signature.	Above-average printing with slight deficiencies evident in final project. Complete edition.	Shows some area of skill in a limited area. Irregular registration with smudges and poor ink coverage.	Unfinished edition. Lack of registration. No edition numbers or signatures.

Career Profile
Elizabeth Catlett

Elizabeth Catlett is well known for her interest in issues involving women, race, and ethnicity. A former college professor, master sculptor, painter, printmaker, and activist, she was born in the United States, a descendant of emancipated slaves. Catlett grew up in Washington, D.C. She made art from a very young age, and although her family was poor, her mother made sure she had whatever art supplies she needed. Looking back, Catlett credits her mother with helping her become an artist.

She attended Howard University after she was refused admission to Carnegie Institute of Technology because of her race.

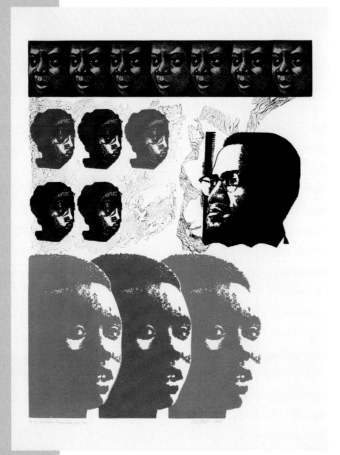

She earned her first master of fine arts degree in 1940 from the University of Iowa, where she had gone to study painting with regionalist painter Grant Wood. His teaching dictum was "paint what you know best." He helped her to deal with her own background. She married a fellow classmate, printmaker Charles White. Receiving a Rosenwald Fellowship Award was a turning point in Catlett's life. She went to Mexico and studied at the famous Taller de Grafica Popular (Graphic Arts Workshop). She worked with artists such as Diego Rivera. At this time she divorced Charles White and married Mexican artist Francisco Mora. She became the first woman professor of sculpture at the Universidad Nacional Autónoma de México.

Elizabeth Catlett is a master artist who has expressed themes of racial injustice, the struggle for civil rights, and the life and history of African-American people in her art. Many of her works recognize the hard work and sacrifice of the African, African-American, and Mexican women. She states, "I have always wanted my art to service my people—to reflect us, to relate to us, to stimulate us, to make us aware of our potential."

Her work has won acclaim in Mexico and the United States and is found in major collections in both countries, including the Institute of Fine Arts in Mexico, the Museum of Modern Art in New York, Library of Congress, Schomburg Collection, the High Museum in Atlanta, the Metropolitan Museum, and the Studio Museum of Harlem in New York City. Elizabeth Catlett has received numerous awards and honors, including the Women's Caucus for Art and an international peace prize.

Fig. 4-19. Elizabeth Catlett is a master artist who has expressed themes of racial injustice, the struggle for civil rights, and the life and history of African-American people in her art. What does this reduction print communicate? Elizabeth Catlett, *Malcolm X Speaks for Us,* 1969. Linoleum cut.

Chapter Review

Recall What is a reduction print?

Understand What is the difference between reduction prints and multiple block prints?

Apply Look back at the reduction print by Sol LeWitt in Fig. 4-11. Plan your own conceptual art print using organic or geometric shapes and forms. How will you repeat shapes and forms? How will you vary them? Plan your print as a reduction using four or more colors.

Analyze Look book at the block print by Harunobu in Fig. 4-7. How did the printmaker balance the composition? How did he create movement and interest?

Synthesize Plan a multiple block relief print for a theater or movie poster. What will you show in your design? Begin with pencil thumbnails, then use color pencil to develop your design as a series of sheets. What colors will you use, and how will you apply them? Will your design include letters? If so, how will you use them?

Evaluate Look again at the student reduction print in Fig. 4-20. How well unified is this design? How successful do you think this print is?

Writing About Art

What did you learn in making a reduction print? Create a list of the things you found difficult, helpful, or even surprising in developing your reduction print. Write a paragraph, based on the list, that provides a clear artist's statement of the experience of making your reduction print.

For Your Portfolio

When including prints in your portfolio, it's a good idea to place wax paper between each print. Diverse media have different degrees of dampness and another work might damage your prints.

Fig. 4-20. How has the student artist applied color in this reduction print? How does the use of color, repeated shapes, and undulating space affect the visual movement the viewer experiences?
Student work, Daniel Zagaya, *City Sensibilities.*

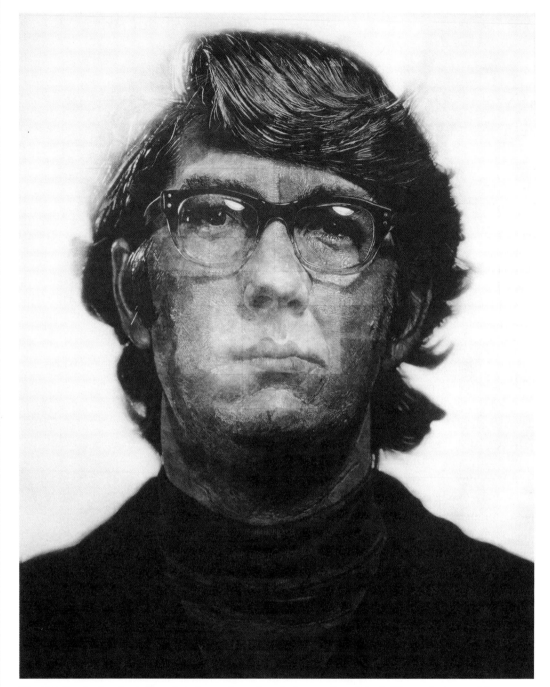

Fig. 5-1. Look closely at the print shown here. In what ways does it look like a photograph? How can you tell it isn't one?
Chuck Close, *Keith*, 1972. Mezzotint and roulette, printed in black.

5 Intaglio

Developed from goldsmithing in the Renaissance—and its precursor, metal engraving—intaglio (*in TAH lee oh*) is one of the oldest printmaking methods. Intaglio was developed as an alternative to wood engraving. Artists found they could cut lines into the metal plate to create works that looked more like a drawing or painting.

Metal engraving and the other intaglio methods offered the printmaker increased opportunity of expression with line and value. This was important to printmakers responsible for reproducing painting designs as engravings, and to all artists of the Renaissance and beyond as they sought to convey faithful representations of the world, its places, and its people.

The intaglio method of printmaking is still widely used today, especially by artists seeking to create designs or representations requiring fluid line and the realistic light and dark values that we have come to expect from photography.

In this chapter, you will learn:

- the basic process of intaglio design and printing
- how to create tonal effects using intaglio methods

drypoint

hatching

mezzotint

Intaglio Basics

Intaglio refers to the process of cutting lines into a specially coated metal plate such as zinc or copper and dipping the plate in an acid bath to "etch" out the design created. During the inking process, ink is squeezed into the etched design. When paper is run through an etching press, it is forced into the design and the ink is transferred to the paper.

Intaglio is fundamentally different from the relief process. Although both relief and intaglio involve creating a design by carving, engraving, or etching into a wood or metal plate, they are distinct opposites. In relief, ink prints from a *raised* surface—the design, or remaining part of the plate that has not been carved or graved away. In intaglio, ink is printed not from a raised surface but from the ink squeezed into the design *below* the surface of the plate.

Fig. 5-2. A carved and etched intaglio plate.
Student work, Andrea Haury, etching example.

Fig. 5-3. Dutch artist Lucas van Leyden created some of the most important prints of the Renaissance. How has the artist used deliberate graven line in creating linear perspective?
Lucas van Leyden, *Christ Presented to the People,* 1510. Copperplate engraving.

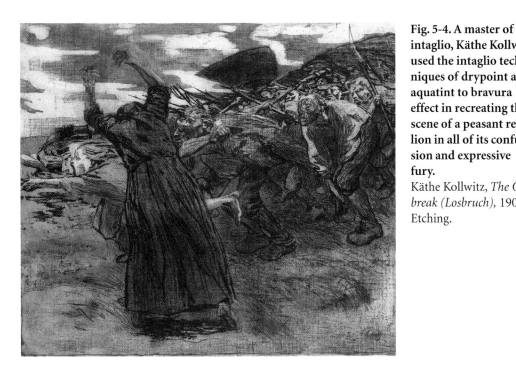

Fig. 5-4. A master of intaglio, Käthe Kollwitz used the intaglio techniques of drypoint and aquatint to bravura effect in recreating the scene of a peasant rebellion in all of its confusion and expressive fury.
Käthe Kollwitz, *The Outbreak (Losbruch)*, 1903. Etching.

Note It Today, alternative materials such as Plexiglas, plastic, and recycled CDs can be successfully used for intaglio plates.

Fig. 5-5. The German artist Albrecht Dürer was accomplished not only at woodcut but also at the intaglio method shown here. Why might intaglio be a better method than woodcut for this subject?
Albrecht Dürer, *Women's caps.* Engraving.

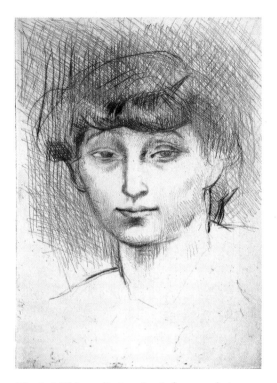

Intaglio Techniques

The techniques of intaglio are:
- engraving
- drypoint
- aquatint
- mezzotint

All of these techniques are capable of producing intaglio prints. They can also be used in combination. All have been around for hundreds of years and all are still used by contemporary artists today.

Fig. 5-6. This realistic print is from early in Picasso's career. Why might the artist have chosen the intaglio method for this design? Pablo Picasso, *Portrait of Fernande Olivier.* Drypoint.

Fig. 5-7. The use of perspective in this etched print gives the illusion of the building reaching into space. Can you think of ways to create the same effect in your work? Student work, Lauren Grezlak, *Building of Shades.*

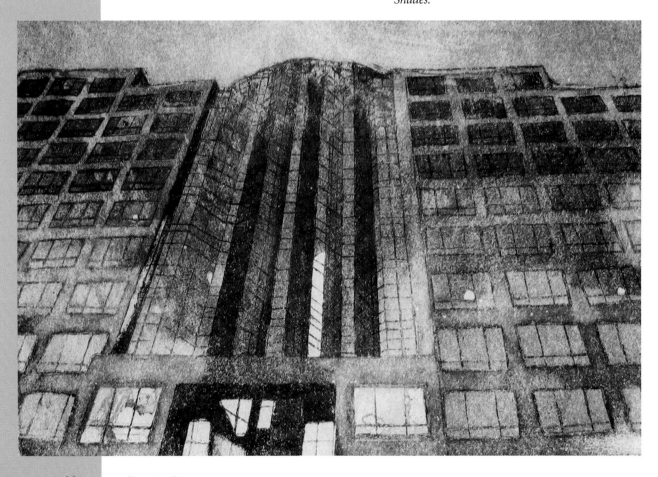

Engraving and Drypoint

As noted in Chapter 3, Basic Relief, Renaissance relief printmakers invented the engraving burin as a means of translating designs to wood. In the **engraving** technique, a burin is especially useful for creating a steady, unchanging line. Later, engravers like Israhel van Meckenem in Germany began to work copper plates, creating the first intaglio prints. However, these prints were still created by an engraving process. Contemporary printmakers such as Louise Bourgeois continue to experiment with the engraving burin.

Like its precursor the engraving, which uses a burin, the **drypoint** design is created with a sharp tool called an *etching needle*. It handles more like a pencil, which makes it easier to draw on the plate. The etching needle is made of steel, often with a diamond point. The needle creates a burr when drawn across the metal. This burr, in turn, produces a soft line when printed.

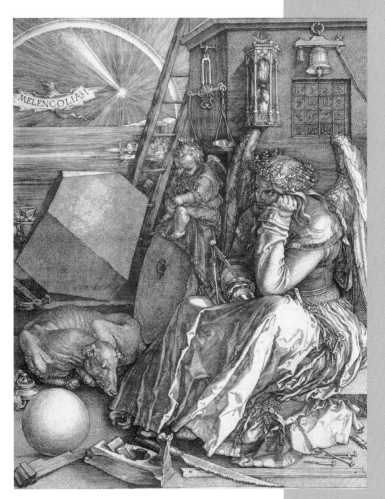

Fig. 5-9. Italian Renaissance prints, such as this composition, gave classical visual expression to the traditional stories. How does this print combine the regularized, deeper, and darker marks of the engraver's burin with the lighter, more drawing-like effects of the etching needle?
Albrecht Dürer, *Melancholia,* 1514. Engraving.

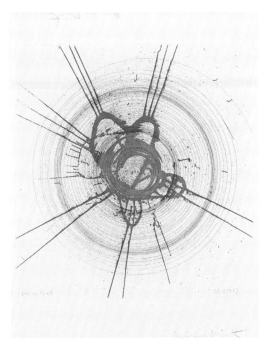

Fig. 5-8. The English artist Damien Hirst created some radial intaglio prints by using a turntable and some unusual tools such as a screwdriver to create grooves in the plate.
Damien Hirst, *Global a-go-go for Joe,* from "In a Spin, the Action of the World on Things," Volume 1, 2002. One from a portfolio of twenty-three etchings, aquatints, and drypoints.

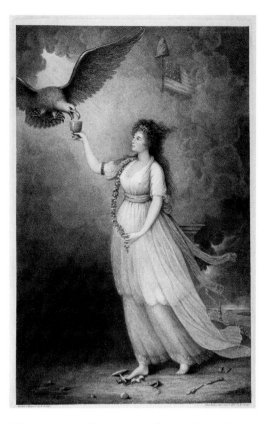

Note It The line created by the drypoint technique is more pencil-like and irregular than that created by the engraving burin.

Try It Try using both the engraving burin and the etching needle. What do you notice about the difference between the two tools?

Safety Tip Special care should be taken when using the etching needle, as both ends are extremely sharp.

Fig. 5-10. American prints of the eighteenth century such as this one were a sign of the era's dominant symbols and democratic ideals. Edward Savage, *Liberty, in the Form of the Goddess of Youth: Giving Support to the Bald Eagle.* Stipple engraving on cream laid paper.

Fig. 5-11. Notice the regularity of the engraving marks in this print. Louise Bourgeois, *Spiraling Arrows*, 2004. Engraving on paper.

Fig. 5-12. Why might the engraver, rather than the etching needle used in drypoint, be useful for creating lines and shapes shown in this print? Louise Bourgeois, *M is for Mother*, 2003. Drypoint on paper.

Create an Intaglio Print

1 When your plate is ready to print, it is important for it to be clean and dry. Begin by using a card or scrap of mat board to force the ink into the etched areas. This is called "carding the plate."

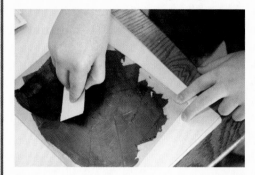

2 Wipe the plate down using crumpled newsprint. (Pages from an old phone book make a great source for wiping the plate.) Use circular motions to avoid wiping the ink out of the incised lines.

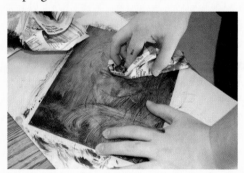

3 Clean the edges of the plate so that there won't be a visible line on the plate mark.

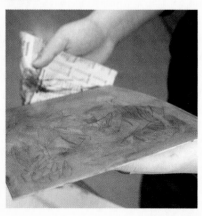

4 Use printing paper that has been soaked to remove the sizing. Paper should be blotted and thoroughly dampened. Place dampened paper on top of the inked plate and run through an etching press.

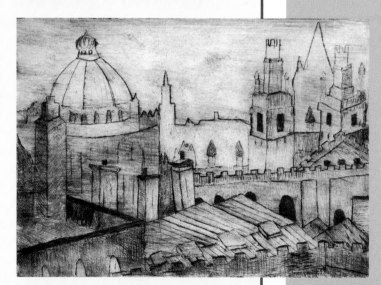

Fig. 5-13. The intaglio process is well suited to depicting urban landscapes. How are lights and darks used in this print suggest the forms of a medieval town?
Student work, Heather Golding, *Oxford.*

Drypoint Effects

The potential of drypoint for use in representing human figures and natural forms was realized by a succession of major printmakers across Europe including Guido Reni, Anthony van Dyck, and Jacob Ruisdael in Holland. In fact, the first artists to use etching often *combined* it with the engraver's burin, as in Fig. 5-9. In these works, viewers can see the separate effects created by the two tools.

Creating Value in Drypoint

The drypoint technique of the intaglio printmaking process uses hatching and cross-hatching to produce the image. **Hatching** is a way to create shaded areas with line. The lines are parallel to each other and closer together in the areas which need to be darker. The hatching method was used by early commercial printers to produce shaded drawings in books and newspapers. By using hatching instead of solid areas, less ink is used and cleaner copies are produced.

To create even darker areas, **cross-hatching** is used. Cross-hatching is just as it sounds—hatching lines are crossed.

hatching **cross-hatching**

Note It In the 1600s, artists increasingly switched to the use of copper rather than iron plates.

Try It Use sketch paper to practice different styles of hatching and cross-hatching. First try hatching loosely. Don't worry if all lines aren't parallel. Then try hatching in a more rigid pattern. Try each style, varying the pressure on the pencil and the width between your lines. How might you apply these line styles to a design in drypoint using an etching needle?

Safety Tip The purpose of drypoint is to create a burr when drawing the lines in your image. The burr gives softness to the line when it is printed. Be careful that you don't brush your hand across the plate to clear away the scrapings. This action will cut the side of your hand.

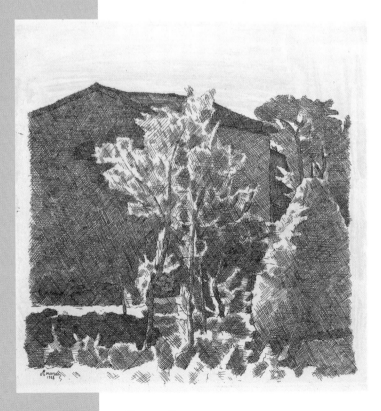

Fig. 5-14. Hatching and cross-hatching are age-old techniques. How are they used here for a "modern," geometric effect?
Giorgio Morandi, *Il Poggio al mattino (Hillside in the Morning),* 1928, probably printed in the early 1940s. Etching.

Value

Value is defined as the darkness or lightness of a color. In printmaking, it refers to tonal changes in a picture. Intaglio techniques provide the means to create a picture with a wide range of tonal values. Rembrandt was a genius at combining the mastery of the etching and drypoint in addition to the artistry of the print. His prints show a wide range of tones, from the blackest black to a subtle hint of gray. In Fig. 5-15, he used etching and drypoint techniques to create tone. He later utilized the newly invented aquatint technique to create subtle differences in darker and lighter areas. Aquatints can be etched 20 to 30 times to create many values in a picture.

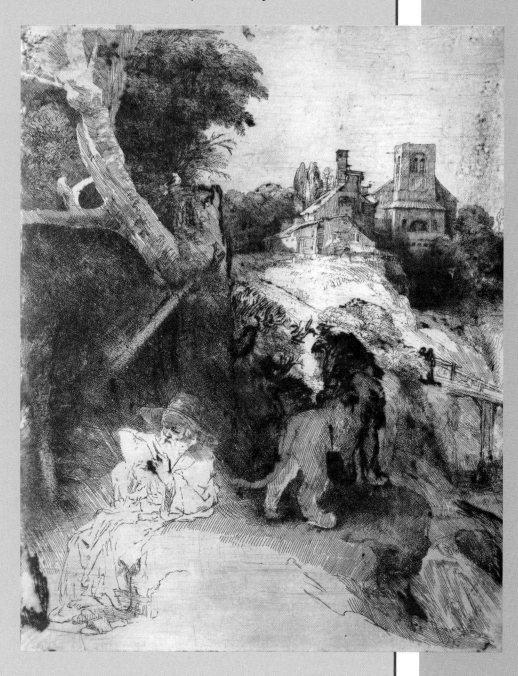

Fig. 5-15. Where do you see areas of deep shadow? Where do you see areas of sunlight? Rembrandt Harmensz van Rijn, *St. Jerome in a Hilly Landscape,* c. 1653. Etching and drypoint.

Multiple Etchings

It has been said that an artist thinks differently when working on a print than on a painting. Why? The answer lies in the possibilities of successive states that is possible only with prints. The painter works to complete a canvas and then moves on. He or she may make new paintings of the same motif, or subject, but each is a work on its own. The printmaker, however, works through successive states, each new and different. The printmaker makes a journey of change, documented in each print or state of the print, that can be ongoing as the print takes different states.

Printing from multiple etching versions allows the printmaker to explore and document an image as it takes its final print form. By etching the plate several times, different values can be obtained in the printed images. This allows the printmaker to experiment with value ranges.

Try It Explore your own self-portrait in a pencil value drawing. How might you develop your drawing as an intaglio print?

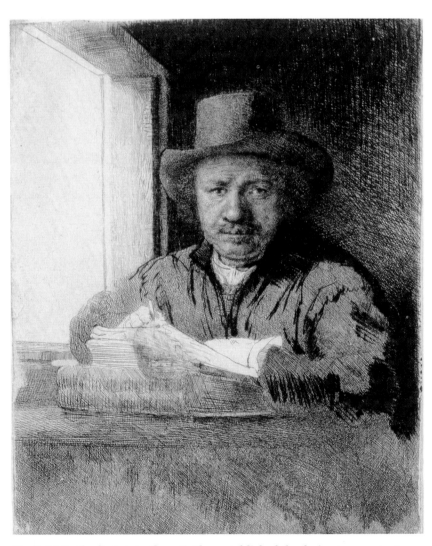

Fig. 5-16. In the first state, the artist has established the design to an extent before stopping.
Rembrandt Harmensz van Rijn, *Self-Portrait at a Window*, c. 1648. 1st state. Etching, retouched with drypoint.

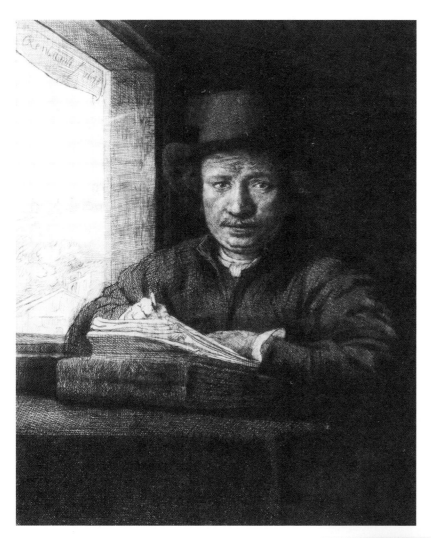

Fig. 5-17. Compare this second state of a self-portrait to the first state in Fig. 5-16. Where do you see additional lines and areas of light and dark?
Rembrandt Harmensz van Rijn, *Self-Portrait at a Window.* Etching and drypoint.

Fig. 5-18. How does the artist's delicate use of hatching to create contours and values help give expressiveness to this sensitive portrait?
Dox Thrash, *Abraham*, c. 1937. Etching and drypoint.

Aquatint

A second intaglio technique is **aquatint**, in which an acid-resistant resin is used to achieve tonal effects. When the plate is dipped into an acid bath, the resin on the plate repels the acid, creating areas of light and dark.

Fig. 5-19. Aquatint uses acid-resistant resin to achieve tonal effects.
Francisco de Goya y Lucientes, *El sueño de la razon produce monstruos (The Sleep of Reason Produces Monsters),* first published in 1799. Plate 43 from the series *Los Caprichos.* Etching.

Fig. 5-20. Notice the light source on the face of the subject. How effective is the use of cross-hatching to produce striking results? Student work, Emma Cooper, *Contemplation—Self-Portrait.*

Fig. 5-21. How has the print-maker used lines to create the image? How would you describe the direction and use of the lines to form the solid areas of the stripes? Jim Dodson, *Faded Glory*, 1984. Etching.

Mezzotint

Another method of creating an intaglio print is the **mezzotint**. The word mezzotint comes from the Italian *mezzo-tinto*, which means "halftone or half-painted." Producing a mezzotint is a way of creating different tones or values in the print without using hatching, stipple dots, or other drawing techniques. A tool called a rocker is used to create a texture on the plate that can be printed. The more textured an area, the darker it prints.

Fig. 5-22. This intaglio print uses a mezzotint technique. What do you notice about the way the printmaker has organized space and light and dark?
Susan Rothenberg, *Boneman*, 1986. Mezzotint printed on paper.

Fig. 5-23. This print is considered one of the last great French colored prints of the eighteenth century. Notice the delicacy of colors. The print closely resembles a watercolor.
Philibert-Louis Debucourt, *La Promenade Publique*, 1792. Mezzotint, aquatint, etching, and engraving with roulette.

There are two approaches in creating a mezzotint. "Dark to light" requires that the entire plate be covered by the rocker texture. The artist then burnishes (smoothes or scrapes) away areas that should print lighter. The "light to dark" method allows the artist to add the texture of the rocker in areas to print darker.

Fig. 5-24. Do you think this print was created by a "dark to light" or "light to dark" mezzotint approach?
Carol Wax, *The Oliver,* 2004. Color mezzotint engraving.

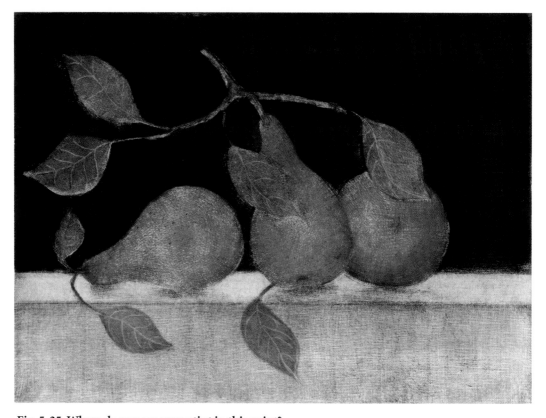

Fig. 5-25. Where do you see mezzotint in this print?
David Crown, *Trio of Pears,* 2002. Four-plate color mezzotint.

Mary Cassatt and the Impressionists

Fig. 5-26. Can you see the differences in the two Mary Cassatt works? One is a painting and one is a print. Is it apparent that different techniques are used? Can you identify the methods?
Mary Cassatt, *Portrait of the Artist,* 1878. Gouache on wove paper laid down to buff-colored wood-pulp paper.

Impressionism in painting was a style intended to capture fleeting effects of light and color. To the Impressionists, subject matter was secondary to process. Thus, intimate views of landscapes and everyday life were of primary importance over historical, religious, allegorical, or literary subjects. For the Impressionists, printmaking was an affordable way to make their work available to a wider public, while the many printmaking processes were explored to mimic painting effects.

Mary Cassatt was influenced by Impressionism in many ways. Visible in her prints are the soft contours of Renoir, the broad areas of flat color from Manet's work, and the overall light Impressionist palette. She learned printmaking from her mentor Edgar Degas (1834–1918) in 1879. In the 1880s she switched from soft-ground etching in favor of drypoint, where a design is scratched into a copper plate with a sharp needle. Such a technique creates lines with rough, burred edges. The ink caught in the burrs produces soft-edged, fuzzy lines.

Fig. 5-27. Impressionist printmaker Mary Cassatt developed this print as part of a series of scenes of everyday life. What "echoes" of the Japanese woodcut style can you identify in this print?
Mary Cassatt, *The Letter.* Color drypoint and aquatint on cream laid paper.

The Letter (Fig. 5-27) comes from a series that Cassatt titled merely *The Ten*, scenes of everyday life. The creative inspiration for this print was the massive 1890 show of Japanese woodcut prints in Paris. The curving lines, combination of patterns, and scenes of ordinary life with decreased depth and shadow influenced her. It is also reminiscent of scenes by Renoir and Pissarro of young women engaged in intimate household activities.

Studio Experience
Radial Design in Drypoint

An excellent way to experience the drypoint method of intaglio is to use a CD as a plate. In this Studio Experience, you'll design your own intaglio print by using drypoint to develop a composition with radial balance. Using colored watercolor pencils and damp paper results in a multicolored print when rolled through the press.

Before You Begin

You will need:
- recycled CDs
- etching needles
- sketch paper
- pencils
- watercolor pencils
- printer's ink
- etching press

1. Review the definition of radial balance in Chapter 2. Think about the way you can use pattern to create your design, and then produce several different ideas from which to choose. Develop several sketches of your design. What changes will you make in your final design?

Create It

2. Use an etching needle to create your design on the CD. Carefully trace the design with the etching needle. For areas that need to be darker, consider using hatching or cross-hatching.

3. Add color with watercolor pencils.

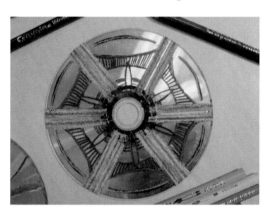

4. Roll ink onto the plate. The plate is now ready for printing.

5. The final print is lifted from the plate.

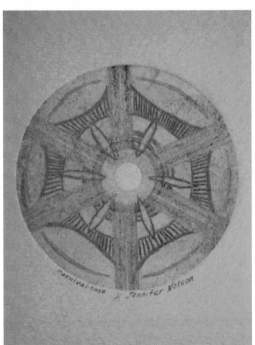

Fig. 5-28. The result of your work is a beautiful print. It contains a radial balance design, color, and a printed background. All of this is from a discarded CD.
Student work, Jennifer Nelson, *Carnival*.

Check It

Is your design balanced from the center out to the edges? Did you create a variety of lines and solid areas? Was your printing consistent? Did you sign and number your edition?

Safety Tip When using the etching press, be sure to stand at the side of the press while turning the handles so that you won't get hit if the press slips.

Rubric: Studio Assessment

4	3	2	1
Composition • Use of Elements and Principles			
No significant omissions; effective use of radial balance to produce a cohesive end product.	Composition clearly shows intention to create radial balance.	Composition is awkward but shows some purpose.	Weak composition which lacks evidence of intent does not demonstrate radial balance.
Use of Media and Techniques • Line Quality • Hatching • Cross-Hatching			
Has knowledge of a variety of techniques and is able to execute and integrate with visual representation with great facility.	Has sound knowledge of a variety of techniques and is able to execute and integrate with visual representation.	Has knowledge of some techniques but is not able to execute and integrate with visual representation.	Fails to retain knowledge of techniques and its execution and integration with visual representation.
Craftsmanship • Printing • Edition Quality			
Excellent, neat execution. Good printing technique with no smudges. Includes edition numbers and signature.	Above average printing with slight deficiencies evident in final project. Complete edition.	Shows some area of skill in a limited area. Irregular printing technique with smudges and poor ink coverage.	Unfinished edition. Lack of printing technique. No edition numbers or signatures.

Career Profile
Trenton Doyle Hancock

Trenton Doyle Hancock (b. 1974) lives in Houston but is originally from Oklahoma City. He attended Texas A&M University and received his master's degree from Tyler School of Art, Temple University, in Philadelphia. During his career he has created a whole universe that is unique to his paintings and prints. He has created a number of characters and used them to portray a story in his artwork—a story that he has continued to develop for the last ten years. His figures include priest Sesom, who is a major character, Paul, Bow-Headed Lou, Baby Curt, Shy Jerry, Anthony, TB, F-Shine, and Betto Watchow. Other groups include the Mounds, the Darkness Babies, and the Goddess Painter.

"The first character that I came up with was Torpedoboy, and that was around the fourth grade. I was looking at a lot of comic books—*Spider-Man, Superman*. That stuff was really important to me, as it is to most little boys at that age. For me, it was a way to escape, not being very sports-oriented."

"The idea of building characters that I could call my own, masses of them that related to each other, started in high school, because at that point, I started to think about my future, and what am I gonna do when school is over? And I thought I'd draw comic books. I didn't think anything about painting the mythology, but then someone said, 'Why don't you try it?'"

Hancock has used his characters in many different media. He has done paintings, drawings, sculptures, and prints. Most recently his characters of good and evil are becoming the subject of a ballet called *Cult of Color: Call to Color* by Ballet Austin. The original idea for the ballet using Hancock's characters was set in motion by Ballet Austin's artistic director, Stephen Mills. The story is about the Vegans who live in a world of black and white. The priest Sesom introduces color to them. Hancock has had the opportunity to work with many artists to develop the multiple facets of this production. From storyline to costumes and backdrops, he has seen his world come to life.

Fig. 5-29. In this print, the artist uses imaginary characters and settings to create a fantastical world. What imaginary worlds can you create in your own prints? Trenton Doyle Hancock, *Harmony from the Ossified Theosophied*, 2005. One from a portfolio of eight etchings and aquatints.

Chapter Review

Recall What are hatching and cross-hatching?

Understand How does the intaglio plate differ from the relief plate? How is the printing process different?

Apply Create a portfolio of two or more intaglio techniques. Include a range of subjects or a series on a single subject.

Analyze How has Mary Cassatt organized the composition in her intaglio print *The Letter* (Fig. 5-27)? How are the print's composition and use of color and repeated pattern reflective of Japanese woodcuts?

Synthesize Write an imaginary journal entry in which you are Rembrandt and you explain your thought process as a printmaker in developing the two states of the self-portrait shown in Figures 5-16 and 5-17. Explain why you made the changes you did between the two states.

Evaluate Look back at the self-portrait by Dox Thrash in Fig. 5-18. How successful is this print?

Writing About Art

In Fig. 5-19, Goya's *The Sleep of Reason Produces Monsters,* look at the image closely. What do you see? Write an essay about the things you see in the print and what you think they might mean. Describe each subject and how they add symbolism and meaning to the overall work.

For Your Portfolio

It is necessary to reassess your work periodically. Know that you will not keep all of the work you do in your portfolio. Ask your teacher or someone recommended by your teacher to go through your portfolio with you and discuss the merits of each piece. This will give you some direction in what needs to be done next.

Fig. 5-30. This drypoint was made with a rigid plastic plate. The strong source of light on the subject's head creates a dramatic contrast between the areas of light and shadow. Student work, Daniel Melcher, *Lightheaded.*

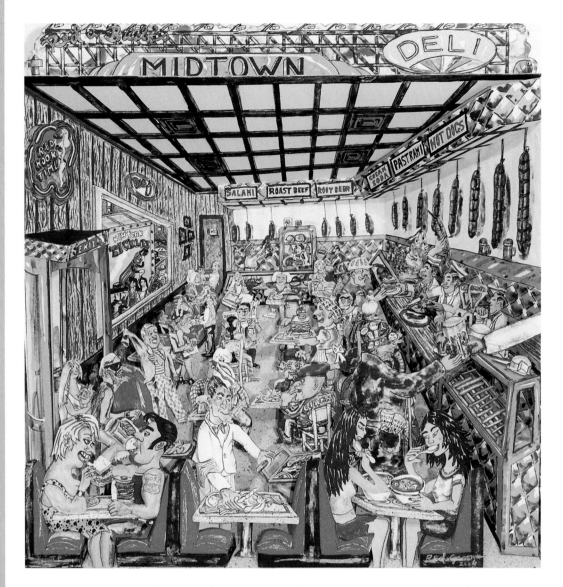

Fig. 6-1. In his often playful views of contemporary life, artist Red Grooms explores the pulse of Manhattan and other metropolitan settings. In what ways does this lithograph show variety? What unifies the lithograph?
Red Grooms, *Deli*, 2004. Color 3-D lithograph.

6 Lithography

Lithography is the third of the four major methods of printmaking. You may recall from Chapter 1 that lithography is a *planographic* process. That means the image is created directly on the flat surface, or plane, to be printed from. That makes planography totally different from the relief and intaglio methods. In planography, the design is not carved or raised and etched. Instead, it is drawn as an artist might draw or paint onto canvas, paper, or any other flat surface.

In this chapter, you will learn how lithographs are made. You'll learn about *monotype*, the second planographic method, in Chapter 7. But first, in this chapter, you will:

- learn about the development of lithography
- learn some of the techniques of lithography
- create your own lithograph from a collaged design

planography

litho collage

paper-based lithography

Lithography Basics

To make a lithograph, the artist uses a greasy crayon or other chemically reactive drawing tool on a stone, metal, or paper surface. Professional artists and commercial printers usually work on stone or metal surfaces. Stones are not common in the high school classroom, but excellent results can also be obtained working on specially coated paper surfaces.

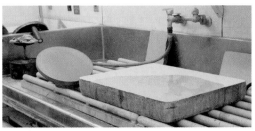

Fig. 6-2. Lithographic stones require special handling. Before an image can be placed on the stone, the stone must be ground down so that it is completely free of any previous image.

After the artist has drawn a design on the stone or other surface, the surface is treated with a chemical that causes ink to be attracted to the greasy areas only. The unmarked parts of the surface are receptive to water but repel the grease. After the surface is dampened, the ink is applied with a roller and sticks to the design but not to the areas to be left unprinted.

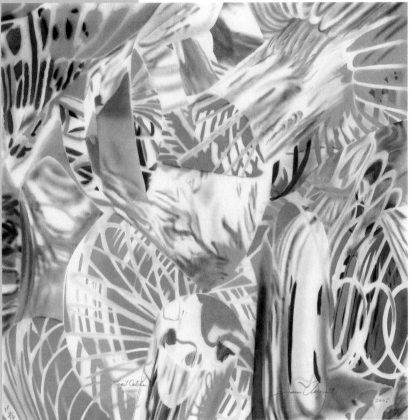

Fig. 6-3. This artist has fun with his lithograph images. By creating original prints, artists can make their work available to more collectors. James Rosenquist, *Light-catcher*, 2005. Lithograph in 10 colors.

Fig. 6-4. In lithography, the design is printed from the inked stone on damp paper with the use of a lithography press.

A Collaborative Process

Artists who work with stone lithography usually work with a professional printer. These professionals team with the artist to ink and pull the edition of prints. The printer may help the artist with planning the layers of color to be inked and other technical factors that affect the finished print.

Note It Think of oil and water and how they don't mix. Because lithography is based on the chemical interaction that occurs on the surface of the plate, it is often called "chemical printing."

Try It Markmaking and drawing skills are very important in the lithographic process. In lithography, a simple line drawing you make with nothing but a permanent marker can be used to create a successful edition of prints.

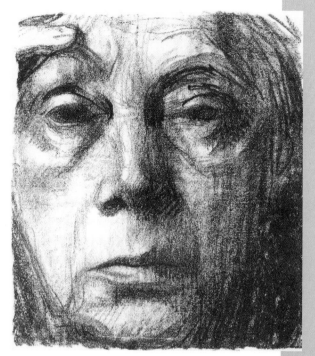

Fig. 6-6. With lithography, the printmaker is free to make multiple copies of a drawing. Even though each copy is only a print, it may well have the look and feel of an original drawing. How does this self-portrait lithograph have the look and feel of a drawing done in graphite or chalk?
Käthe Kollwitz, *Self-Portrait*, 1898. Print.

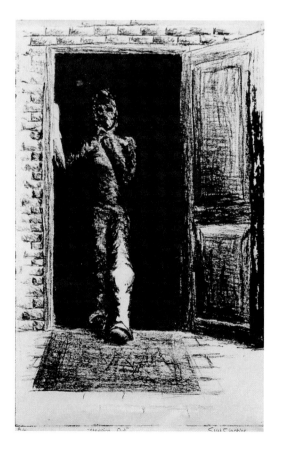

Safety Tip Lithography chemicals can be toxic. Never use any lithography materials except under proper supervision and with adequate training, protective gear, and supervision.

Fig. 6-5. The black and white of lithograph can be a very dynamic image without the addition of color. In this image, the dark doorway pulls viewers into the picture by making us wonder what is happening on the other side.
Student work, Sarah Simpkins, *Stepping Out*.

A New Technology

Lithography, in contrast to relief and intaglio printing, is a relatively new print-making method that developed in the late 1700s. Lithography's inventor, Alois Senefelder of Munich, was a playwright who sought an inexpensive way to print his own plays. Artists used a highly polished Bavarian limestone. Even today, the same Bavarian limestone that was first used for lithographic stones is used throughout the world and is considered to be the ideal surface for the technique. After its invention, experimentation with lithography spread quickly from Munich throughout Germany and eventually to France and to Italy. The first Munich publisher and printer set up shop in Milan in 1807. As a new technology for producing multiple originals, it took off in popularity in the 1800s when artists and printmakers who had previously worked in intaglio and relief discovered this method. Unlike etching and engraving, lithography required only that an artist could draw. A skilled printer could do the rest.

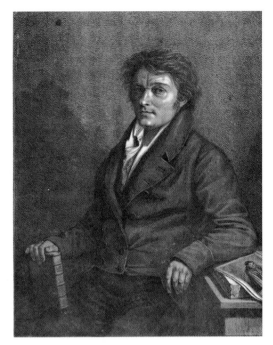

Fig. 6-7. Alois Senefelder called this method *lithography*, after the Greek word *lithos* meaning "stone" and *graph* meaning " to write." Lorenz Quaglio, *Portrait of Senefelder*, 1818. Lithograph on paper.

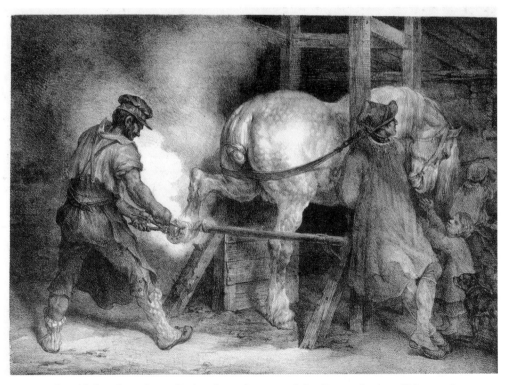

Fig. 6-8. It's said that the painter Gericault made some of the first truly great lithographs. Working on smooth stone, he was able to achieve wonderful effects, as in the steam seen here. Théodore Géricault, *The Flemish Farrier*, 1821. Lithograph on paper.

Lithography and Printing

Lithography was also found to have strong commercial applications. The first printers to work with lithographic stones found them to be more reliable than copper plates. Because the stone can be quite durable, lithography gained popularity among artists and publishers wishing to produce artists' work in multiples.

The new process allowed printmakers to draw their designs more quickly, directly onto stones, rather than etching or carving in reverse as with the other existing print-making methods. This, and the ease of working in pen or crayon on fine limestone, made it easier to achieve the design effects, accuracy of details, range of moods, and gestural expressiveness.

Fig. 6-10. In this early Italian lithograph, the artist pictures the terror and agitation of a forest conflagration sparked by a nearby active volcano.
Cesare della Chiesa di Benevello, *Spontaneous Combustion of a Forest near Colterra in 1829*. Lithograph: crayon and brush with spatter and scraping.

Fig. 6-9. Any spot where the crayon touches the peaks on the surface of the stone, however lightly, will print with ink.
Cesare della Chiesa di Benevello, *Spontaneous Combustion of a Forest near Colterra in 1829* (detail of Fig. 6-10). Lithograph: crayon and brush with spatter and scraping.

Note It When using a lithograph crayon, as in drawing with charcoal on toothed paper, variation in tone is achieved through the size and density of ink marks.

Lithography, Commerce, and Culture

The invention of lithography provided a strong stimulus to artistic and printing activity in a pre-photography era when images of people, places, and things were in greater demand than ever before. For the excitement it generated and the change in the way multiples could be created, the impact of lithography has been likened to today's computer and communications technology revolution.

Fig. 6-11. The English Romantic poet William Blake also designed, illustrated, and printed his own editions of his literary works.
William Blake, "Little Lamb who made thee . . ." from *Songs of Innocence*. Lithograph.

Fig. 6-12. Faust and Mephistopheles are characters from the German writer Goethe's novel *Faust*. Why might lithography be an excellent medium for rendering the design shown in this print?
Eugène Delacroix, *Faust and Mephistopheles Galloping on the Night of the Witches' Sabbath*, 1826–27. Crayon lithograph with scraping.

Fig. 6-13. How are the figures and landscape shown in this French print of the Neoclassical style drawn to suggest the idealized forms of ancient classicism?
Joshua Cristall, *Apollo and the Muses*, 1816. Pen lithograph.

Lithography provided a fruitful outlet for the prevailing artistic styles of the 1800s, in particular Romanticism and Neoclassicism. In order to sell multiples, dealers and publishers encouraged painters and printmakers to try the new method, and painters to translate their designs to lithography. Lithography took off as a commercial illustrative method.

Fig. 6-14. This lithograph incorporates the use of actual postage stamps affixed to the print. It is reminiscent of the Grafton Tyler Brown images (Figs. 6-25 and 6-26) done more than 100 years earlier which use a map in the composition. How do you think the images relate?
David Gamble, *Ysolina,* 1996. Lithograph.

Stone Lithography

The process of stone lithography has changed little since it was first developed in the late 1700s.

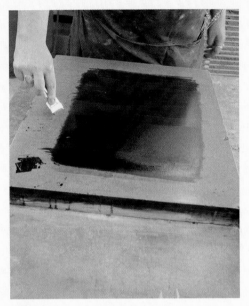

1 The artist scrapes and spreads the ink to prepare it for the roller.

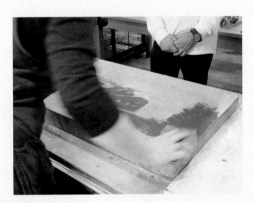

3 The plate is coated with ink. The printing ink sticks to the remaining "ghost image" of the drawing.

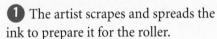

2 The printmaker draws the image directly on the surface of the stone. The drawing is then covered with a chemical such as lithotine, which dissolves the drawing.

4 Pulling the print.

Paper-Based Lithography

Nearly since lithography's inception, print-makers have been using coated paper as a lithographic surface. Alois Senefelder himself developed a specially coated "paper stone." The print in Fig. 6-15 was created from such a stone.

Fig. 6-15. Early litho styles drew on drawing techniques used in existing methods of printmaking. What line techniques do you recognize in this lithograph?
Jean Louis André Théodore Géricault, *The Sleeping Fish Merchant,* 1820. Pen lithograph.

"Drawing" with Lithography

From precise lines for making organic or geometric shapes, to careful figurative sketching, to flat areas of color, the numerous effects that printmakers working in lithography can achieve is one reason for the medium's enduring popularity.

Fig. 6-16. With lithography, the printmaker could work sparingly as in pencil drawing or roughly in the manner of a charcoal sketch. How would you describe the style of this print?
Jean Baptiste Chometon, *The Artist's Mother and Sister,* 1819. Crayon lithograph.

Fig. 6-17. How would you describe the drawing style of this German Expressionist print?
Erich Heckel, *Dancers,* 1911. Lithograph..

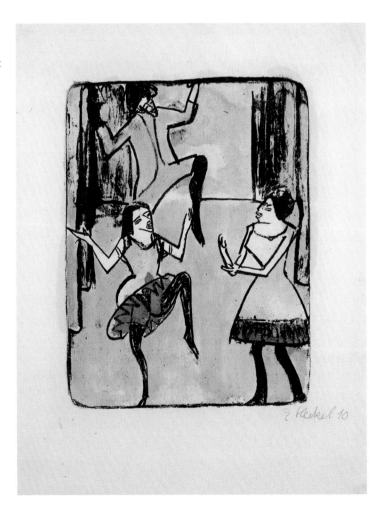

Fig. 6-18. You can make your own lithographic print using a specially coated paper that acts in the same manner as a lithographic stone. Your drawing, on the paper covered in gum Arabic and then inked in the same manner as a lithographic stone, can be printed on a press with excellent results.

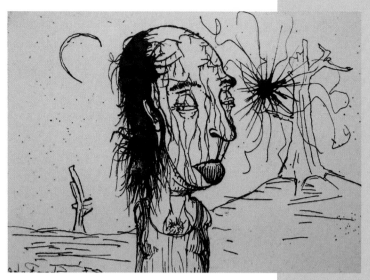

Fig. 6-19. This student used a permanent marker for his line drawing of a surreal landscape on a paper printing plate. Notice that he was able to use his normal drawing style without any special techniques. What advantages can you see for this method and materials? Student work, Shaun Ridge, *Surreal Scene*.

Fig. 6-20. What special techniques do you notice in this image? Student work, Nick Canterbury, *Love Vertigo*.

Mezzotint Style

Drawing techniques in lithography include the linear forms of pen and ink, the looser forms of crayon drawing, and the value contrasts of the mezzotint drawing style.

The practice of scratching away inked areas to create areas of highlight is a basic subtractive drawing technique. Lithographs can be created using pen and ink to create sharp lines, or with crayons, which can be used to draw loose forms and shapes.

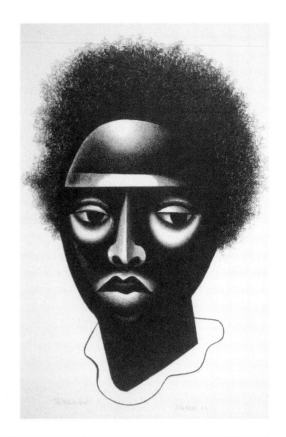

Fig. 6-21. Is the figure in this portrait fully realistic? In what ways does the figure resemble a sculpture?
Elizabeth Catlett, *Black Girl.* 2004. Lithograph.

Fig. 6-22. For his series, *Spanish Entertainment*, Goya tried the new medium for the first time. Would you say he used an additive or subtractive drawing process to develop the design shown here?
Francisco de Goya, *Dibersion de Espana (Spanish Entertainment),* from "Bulls of Bordeaux," 1825. Lithograph on wove paper.

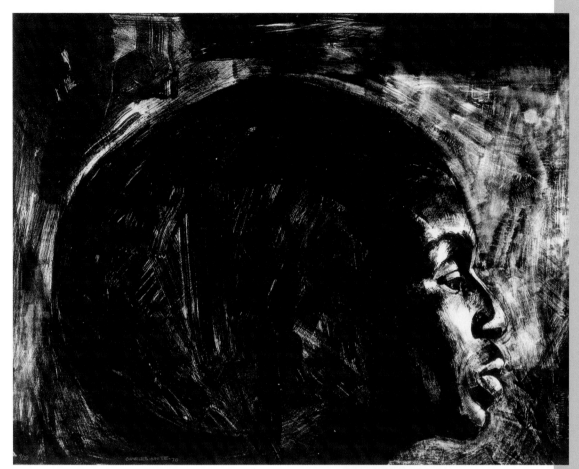

Fig. 6-23. As in drawing and painting, with lithography you can manipulate positive and negative to show space and forms.
Charles White, *Hasty B,* 1970. Lithograph.

Drawing in the mezzotint style will produce value contrasts. You learned about mezzotint in Chapter 5. The mezzotint created using the intaglio method requires a rocker. In lithography, a mezzotint is created by scratching away inked areas to form highlights. This practice is a basic subtractive drawing technique.

Try It Create a print in which you work the design negatively, or subtractively, before inking and printing. How will you handle space and form?

Fig. 6-24. This student artist uses a crayon-drawing lithographic style. What is the mood of this print?
Student work, Kelsey Ryon, *Bitter.*

Color Lithography

Well into the 1900s, lithography was used to create both advertising posters and for inexpensive reproductions of original paintings for use in home décor, including calendars and pictures for domestic decoration. Lithography had commercial applications as well. It was useful for mass producing illustrations on maps, cards, and tins.

Most early color lithographs, like the prints of Currier and Ives, were hand colored. It was only later that artists and commercial enterprises explored the superimposition of stones to build up color as in painting. The technique of using multiple stones with the same design to print different colors developed later, in the 1800s. The first true color lithography was developed in the mid-1800s, at which time lithography achieved more realistic effect than was possible in relief printing or hand-colored mezzotint because of the fluidity of line which could be produced.

Chromolithography

In the era before color photography, chromolithography was used to reproduce paintings at low cost and high volume for the consumer market. Chromolithography differs from color lithography in that it is a commercial reproductive process involving the copying of an original by a careful building up of layers of color in heavy, oil-based inks. With chromolithography the artist can layer inks to recreate the color effects found in paintings—or even to recreate the paintings themselves. Today's equivalent of the chromolithography is the *giclee* reproduction—a process used to print digital color copies of paintings onto paper or canvas.

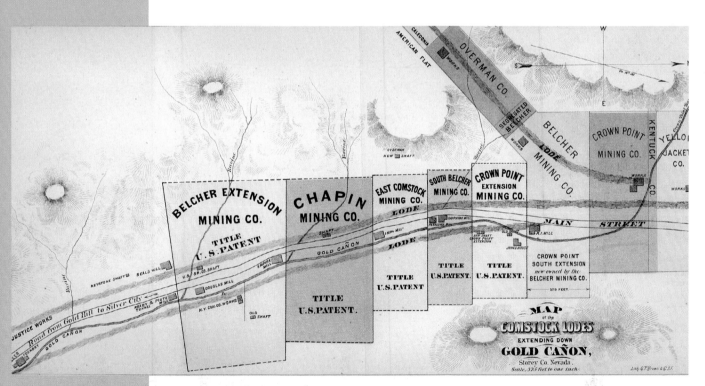

Fig. 6-25. How has the printmaker used color tints in the map shown here? What information is communicated?
Grafton Tyler Brown, *Map of Comstock Lodes Extending Down Gold Cañon, Storey Co. Nevada*, 1868. Paper, lithography ink.

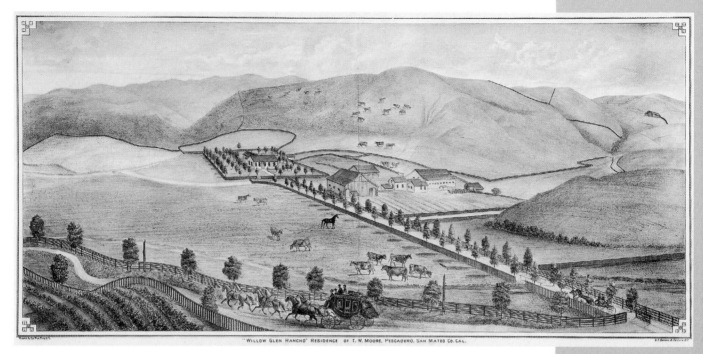

Fig. 6-26. Documenting the expanding frontier and newly settled lands of the American West were mapmakers, journalists, and others, such as Grafton Tyler Brown, an African-American cartographer, painter, and lithographer. How is color used in this lithograph?
Grafton Tyler Brown, "Willow Glen Ranchero," *Residence of T.W. Moore, Pescadero, San Mateo County, California,* c. 1800s. Lithograph with hand-coloring.

Note It Chromolithographs are not original prints but reproductions and they usually carry the term "after" in the credit information to acknowledge the original creator of the design. *After* in this sense means "in imitation or in the manner of someone else." Follow the practice in your own prints. Any time you copy another artist's original design, you need to use the term "after" and the original artist's name in the title you create for your copy.

Fig. 6-27. How has the student artist used color in this color lithograph?
Student work, Danielle Watson, *Cades Cove in Color.*

Lithography and New Media

The introduction of steam in the 1800s led to faster printing processes, including offset lithography. Offset printing uses a grease-resist process that requires ink and water. Unlike lithography, it does not require a reversal. In offset printing, the design is offset onto the paper with a rubber blanket. For commercial purposes, lithography became less important in illustration and advertising. Yet, as a major printmaking method allowing for a range of expressive possibilities, it is still widely practiced by artists and used in handcrafted special edition books, artists' books, and other fine art applications.

In the 1900s, photography—a film-based process that depends on the halftone image—more or less replaced lithography as the most efficient way to illustrate books. However, lithography was still used as the main medium for posters up until the 1960s, when silkscreening came into popularity. As a fine art form, color lithography blossomed, starting at the same time. Though no longer used in commercial processes, it continues to flourish today as an art form.

Fig. 6-28. Compare the image shown here to the treatment of the image by Delacroix in Fig. 6-12. How do the artists' styles differ?
Luis Jimenez, *Howl*, 1977. Color lithograph on paper.

Fig. 6-29. Color application in abstract prints is key to the effects achieved. How has color been applied in this abstract lithograph?
Emmi Whitehorse, *Jackstraw*, 1999.
Lithograph on white Thai mulberry paper.

Fig. 6-30. This artist used watercolor to add color to the print. Do you think this enhanced the image? What other ways could the color be added?
Student work, Amanda Gertsen, *Envy*.

Recording Daily Life

Important printmakers of the twentieth century include George Bellows, a member of the Ash Can School of painters. The group centered its efforts on subjects of everyday life in New York City. The artist's lithograph *Dempsey and Firpo* (Fig. 6-32) was developed from illustrations Bellows created while covering the historic prize-fight for the *Saturday Evening Post*.

During World War II, women and African Americans were recruited to work in factories. The experience of blacks and whites riding public transportation together—as shown by John Woodrow Wilson of Boston in his *Elevated Streetcar Scene* (Fig. 6-31)—would have been unusual at the time.

Fig. 6-31. This print tells the story of an African American on his way to work in the Boston Navy Yard during World War II.
John Woodrow Wilson, *Elevated Streetcar Scene*, 1945. Lithograph.

Fig. 6-32. How has the printmaker used value in showing the instant Jack Dempsey knocks his opponent out of the ring?
George Bellows. *Dempsey and Firpo*, 1924. Lithograph.

Romare Bearden

Romare Bearden grew up in New York during the Harlem Renaissance. He began studying art in high school. His father was active in the New York arts scene and often invited jazz musicians to the family home. Music played a major part in Bearden's life and his art.

Bearden's early style was social realist. He learned about European modernism while studying in Paris. After working in the studio of American cubist Stuart Davis, he learned how to incorporate ideas about jazz into his work. Increasingly during his career, Bearden's art reflected the black experience, particularly that of life in the rural South and in the city.

Bearden viewed jazz as a symbol of the energy of humanity. He began producing color lithographs in the 1970s because he wanted to produce multiples of his images so they would be available to a wide cross section of the African-American community. He had previously experimented with the photostatic process or early photocopier, to produce multiples of his collages, for which he is best known.

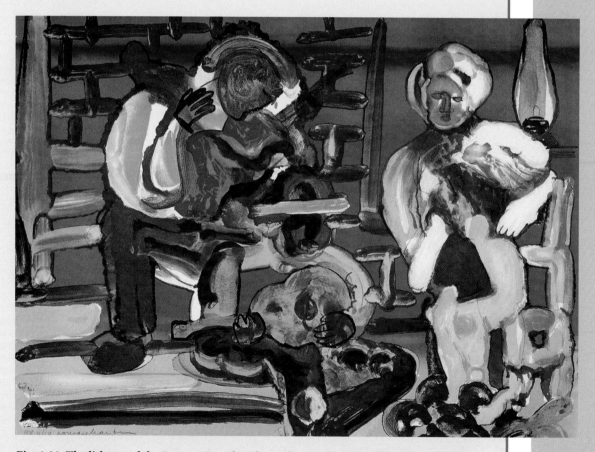

Fig. 6-33. The lithograph by Romare Bearden shown here is from his *Jazz* series. Like his scenes of life in the rural South, the series emphasized the vital contributions of African Americans to U.S. culture. What style did the artist use? How did he use color to balance the composition?
Romare Bearden, *Louisiana Serenade* from the "Jazz Series," 1979. Color lithograph on cream wove paper.

Lithography and Collage

Transfer Lithography

In transfer lithography, the printmaker draws the design on transfer paper. After the design is created on transfer paper, it is transferred to the printing surface. The transferred image can then be drawn into with a litho crayon, permanent marker, or **tushe**, which is a liquefied waxy, greasy substance.

Fig. 6-34. This lithograph was printed in five colors, plus black, from coated paper plates. The multiple-image design was transferred to the litho plate from a photocopy. David Gamble, *Terra de Mer*, 1995. Hand-colored lithograph in five colors.

Fig. 6-35. Lithographs and other prints of the 1960s made increasing use of Pop culture imagery. The artist incorporated movie film stills of stars of the times for the figures in this print.
Robert Rauschenberg, *Breakthrough II*, 1965. Lithograph.

Try It To transfer a copier image, place the copy face-down and positioned on the plate. Brush the back of the image with acetone. Burnish the image with the end of a paintbrush or run it through an etching press.

Fig. 6-36. Beginning with a collage, this image was transferred to a paper printing plate to create the edition. Do you think the image would be as unified without the added color?
Student work, Rebecca Williamson, *Summer Days*.

Rhythm and Movement

Artworks achieve rhythm and movement through the use of repetition and variation of lines, shapes, and colors. In the lithograph version of his painting *The Scream*, Edvard Munch's design is reduced to its essence, without the use of color available in oil painting. Munch's iconic lithograph achieves its effects of rhythm and movement through the use of the long gouge-like marks that resemble woodcut carving or long brushstrokes. In fact, Munch combined lithography and woodcut in some works.

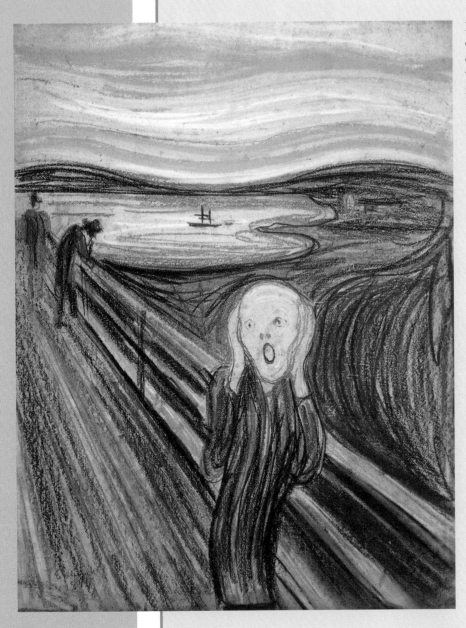

Fig. 6-37. In the lithograph version of his painting *The Scream*, Munch's design is reduced to its essence, without the use of color available in oil painting. Where do you see rhythm and movement? Edvard Munch, *Geschrei (The Scream)*, 1895. Lithograph.

Transfer Collage to Litho Paper

Run through press to offset collage image onto lithosketch paper.

1 Lay the paper litho plate on the bed of the printing press. Place your copier image face-down and centered on the plate.

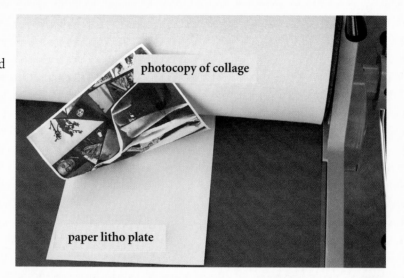

photocopy of collage

paper litho plate

2 Place one sheet of news-print on top. Brush acetone on the news-print covering the area of the copier image, and place two sheets of news-print on top.

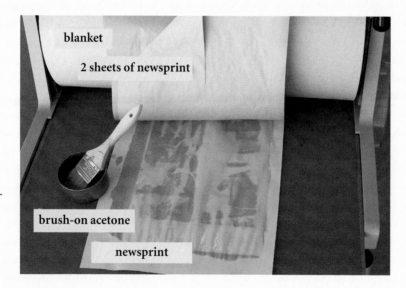

blanket

2 sheets of newsprint

brush-on acetone

newsprint

3 Lower the blanket and run through the press once. Immediately remove the layers of paper from the plate.

4 The plate is now ready to be drawn into the image before printing.

Studio Experience
Litho Collage

In this Studio Experience, you'll create a lithograph by transferring a collaged design to a paper litho plate, and then modify the design before printing.

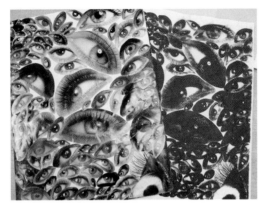

Collage and litho paper transfer.

Before You Begin

Decide on a theme you would like to use for your print. Choose a subject and then look for magazine pictures of the same item in different sizes.

You will need:
- assorted magazines
- glue sticks
- litho pencils or litho crayons
- permanent markers
- acetone
- newsprint
- litho paper
- plate solution
- lithosketch ink
- printing paper

Create It

1. With subject matter in mind, search through magazines and find items of different sizes to use in your collage. Cut each image out carefully without including too much of the surrounding areas. As you create the image, think about overlapping shapes, different sizes, and arrangement of parts. Have your teacher check your composition before you glue it to the white paper.

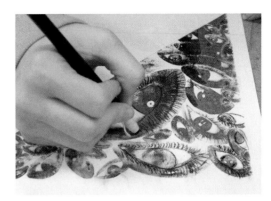

Adding details to the litho transfer design.

2. After the collage is complete, make a photocopy of the image. (The transfer method is explained in the How To on page 29.) After the collage image is transferred to the litho paper, you can draw directly on the litho plate with litho pencils or litho crayons. A permanent marker can be used for solid lines.

3. Printing is accomplished by following the directions of the manufacturer. First, you apply a wetting solution or plate solution to the completed plate. Then you roll ink onto the surface. Ink will attach itself to the image areas and be repelled in the white areas.

Adding solution to the plate.

4. After inking, the plate should be put through a press with the desired paper. Sign and number your print when complete.

Inking the print.

Pulling the print.

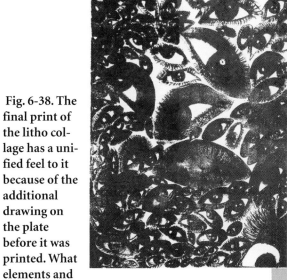

Fig. 6-38. The final print of the litho collage has a unified feel to it because of the additional drawing on the plate before it was printed. What elements and principles can you find in the print? Student work, Craven Trainor, *The Eyes Have It.*

Journal Connection

After completing the collage for your lithograph, write a short paragraph explaining how you determined what to include. What factors limited the images used or caused you to increase the number of parts? Thinking through the process will help you to refine and develop your personal artist's statement.

Rubric: Studio Assessment

4	3	2	1
Idea Communication • Theme expressed through image choice			
A strong composition that uses collaged elements to create a complex image.	Composition clearly shows overlapping, placement, and intention to follow theme.	Composition is awkward, no overlapping of shapes, but shows some purpose.	Weak composition that lacks evidence of intention or consideration/haphazard.
Elements and Principles • Repetition • Unity • Value • Contrast			
No significant omissions; effective use of elements and principles throughout the design process to produce a cohesive end product.	Project considered in very wide context; reasonable use of elements and principles throughout the design process to produce a thoughtful end product.	Few additional factors other than immediate focus; limited use of the elements and principles throughout the design process to produce a product.	Very limited view/focus; unable to use the elements and principles throughout the design process to produce a product.
Media Use • Litho crayons used emphasize elements of design			
Neat execution. Takes type of media into account to create variety of line in drawing with shading.	Above-average rendering with slight deficiencies evident in final project.	Shows some evidence of skill in limited area.	Unable to recognize own ability; hindered by limitations.
Work Process • Printing processes			
Neat, crisp. Great attention to detail. Good ink coverage, no smudges.	Could use some touch-up work but overall very good; some unlinked areas, small imperfections.	Needs a lot of touch-up work. Artist should pay more attention to detail.	Work has many problems and looks sloppy because it has been put together too fast or with little or no attention to detail.

Career Profile
Beauvais Lyons

Printmaker and teacher Beauvais Lyons lives in an artistic world centered in imagination and possibility. He believes that artists are ultimately storytellers and sometimes artists' works can be regarded as props to tell their stories.

Lyons is the self-appointed director of the Hokes Archives, a museum dedicated to the "fabrication and documentation of rare and unusual cultural artifacts." In fact, the Hokes Archives consists of Lyons's own artworks. Lyons invented the idea of the museum and even the idea of the museum's founder, the ""proto-post-Victorian" nineteenth-century artist/publisher/collector Everritt Ormsby Hokes (as in "hoax").

Since the 1980s, Lyons has created works that challenge our ideas of what constitutes the truth in reality—what he calls "academic parody"—in a variety of mediums. For much of this time, he fabricated artworks and artifacts of documented imaginary cultures, such as the Aazudians and the Apasht. More recently he has been interested in biography, folk art, medicine, and zoology.

Says Lyons, "My lithographs are influenced by plates from old encyclopedias, the novellas of Jorge Luis Borges, eighteenth-century science, nineteenth-century printing, natural history museums, the travel writings of Christopher Underdown, mirrors and lenses, anthrospheres, wunderkammers, and various forms of neglected scholarship. I prize the vernacular history of art. I prefer the facsimile to the original, and the imaginary to the real. I believe history is a work of fiction."

Lyons is professor of art at the University of Tennessee, Knoxville (UTK), School of Art and head of the UTK Print Workshop, which is one of the top university printmaking departments in the nation.

Web Link

For more information about the Hokes Archives, visit web.utk.edu/~blyons/

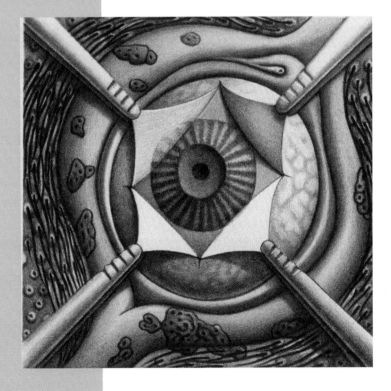

Fig. 6-39. This print is one of twenty-five lithographs by the artist in a traveling exhibition titled "Hokes Medical Arts." What story might this print be telling? Beauvais Lyons, *Planche X*. Lithograph.

Chapter Review

Recall What kind of printmaking process is lithography?

Understand How is the planographic process of lithography different from the relief and intaglio methods described in earlier chapters?

Analyze Compare Fig. 6-21 and Fig. 6-23. How are the styles and compositions of the prints alike and different?

Apply Draw a landscape or cityscape design to be reproduced as a paper-based lithograph. How will you use space in your design? What stylistic attributes will your print show?

Synthesize Read a story or poem and illustrate with a drawing to be created as a lithograph. Refer to Fig. 6-11, William Blake.

Evaluate Look at the Italian print in Fig. 6-9 and Fig. 6-10. How does this lithograph succeed in documenting the results of the volcano and in placing the scene in space?

Writing About Art

Compare and contrast the portraits by Käthe Kollwitz (Fig. 6-6) and Elizabeth Catlett (Fig. 6-21). How do these artists' styles differ in the two portraits? What do they have in common?

For Your Portfolio

Another way of maintaining a portfolio is with digital images. Although many colleges would like to see the actual pieces, a CD portfolio is a good way to send your work to many places. Use a digital camera and be sure the image is in focus, well lighted and centered so that nothing is showing around the edges.

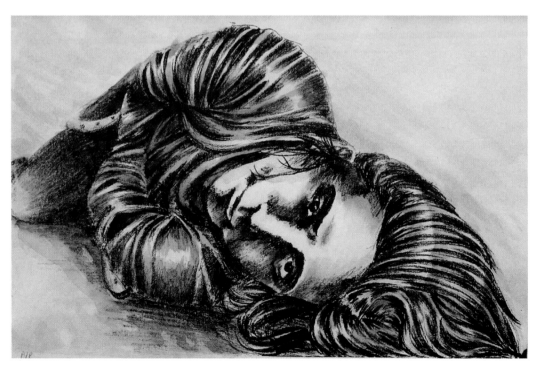

Fig. 6-40. Notice the fluid use of line to create this image. Do you think the same effects could have been created with another method?
Student work, Kelsey Ryon, *Sour.*

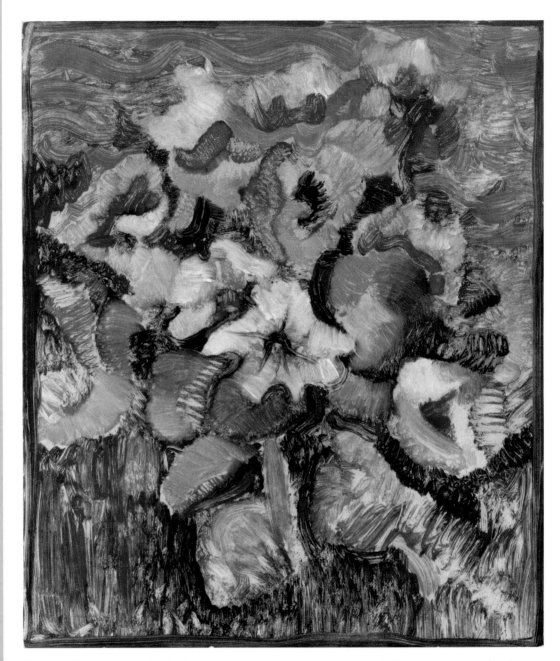

Fig. 7-1. Monotypes can be designed spontaneously and produced quickly—two reasons for the printmaking medium's huge popularity.
Blanche Lazzell, *Petunias II*, 1922. Color monotype.

7 Monotype

Imagine the possibilities of a printmaking method that can be done in a short time, on any smooth surface, and allows for pulling single, unique graphics with or without a press. As many artists have discovered, monotype is one of the simplest yet most exciting and versatile of printmaking media. That's why it is widely practiced today among painters and printmakers alike.

In this chapter, you will:

- learn about the techniques and history of monotype
- explore ways of creating monotypes
- create your own monotype

painterly

reductive

reverse transfer

"Painting" with Monotype

At its most basic, a **monotype** print is a reverse transfer of a painting, which can be one or more colors. It is most often done by drawing or painting directly on a flat surface such as metal, glass, or plastic. The design is then printed with an etching press or by hand transfer. As with lithography, monotype is a planographic process; the design is not carved or etched but created on the flat surface plane to be printed. However, unlike lithographs, monotypes are by definition not multiples but single-edition original prints. *Mono-* means "one." Because the surface of the plate is feature-less—no etching or incision marks are made into it—only one print is created. The plate can be printed a second time, but only a ghost image will be present.

Monotype is different from monoprint. A **monoprint** is a single print, too, but it is made from a plate that has been carved or etched. The process of making a print is the same for both monotypes and monoprints, but a monotype is made from a clean surface.

Fig. 7-3. Monotype is one of today's most popular printmaking methods. This artist works in an abstract style.
Jules Olitski, *After the Fire*, 2004. Monotype on rag paper.

Fig. 7-2. African-American artist Romare Bearden's monotype captures the freshness and intensity of a live jazz ensemble.
Romare Bearden, *Zach Whyte's Beau Brummell Band*, 1980. Oil monotype with paint on paper.

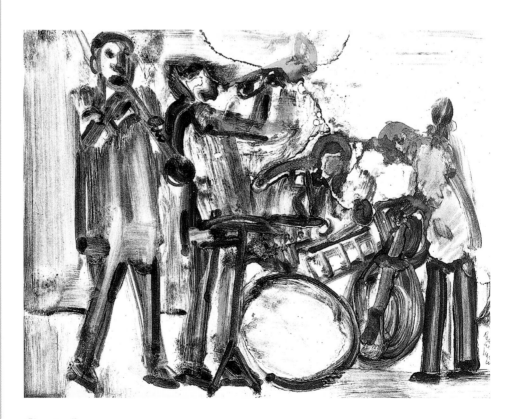

Try It Choose a sketch from your sketchbook to develop as a monotype. Render the drawing in graphite at the same size you plan to make your print. Place a clear surface, such as a very thin, flexible plastic sheet suitable for printing, over the drawing and, using the underdrawing as a guide, redraw in printer's ink on the clear surface. Print the monotype with an etching press or by hand.

Fig. 7-5. This monotype was created on a frosted, thin, flexible plastic sheet suitable for printing and then printed with damp printing paper. Ink is applied in a painterly manner and usually only produces one monotype.
Student work, Kate Turnbull, *Liger.*

Additions to Monotype

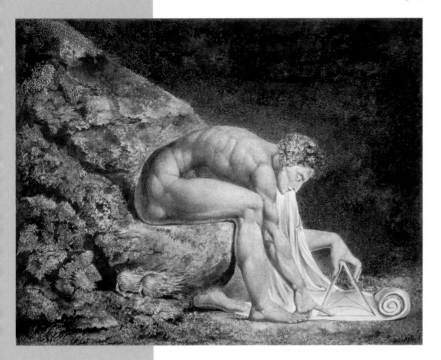

While they are one of a kind, monotypes need not be made from a single impression. The printmaker may wipe and re-ink the plate to add additional colors or features to the monotype. Alternatively, he or she may add details by hand using pastel, watercolor, or other means.

Fig. 7-6. English Romantic poet and artist William Blake illustrated his own books. The rare monotype shown here was printed from oil and tempera mixed with chalk. Blake then added finishing details in ink and watercolor. William Blake, *Newton,* 1795/ca. 1805. Color print finished in ink and watercolor on paper.

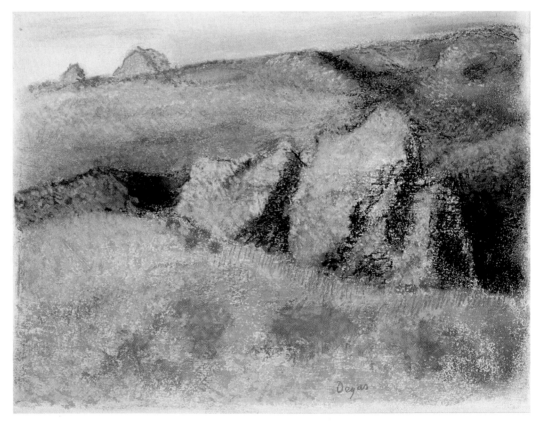

Fig. 7-7. In the above example, Degas drew in pastel over a monotype base. Landscape examples such as this pointed the way toward modernism and abstraction. Edgar Degas, *Landscape with Rocks,* 1892. Pastel over monotype in oil colors.

Repetition and Variety

When shapes, forms, colors, or other art elements are used in artworks, they create visual repetition. Repetition can be pleasing—to a degree, that is. Eventually, your eye seeks a break from a pattern that has become predictable. That's where variety comes in. There's a reason it's often called "the spice of life."

In his monotype *Orange Market*, thought to be based on a scene from Venice, Italy, the American artist Maurice Prendergast creates a rich color field of yellow in the lower half of the print in his abstract rendering of pile of oranges jumbled on market tables. In the upper half of the scene, a series of market umbrellas—the first much darker in color than the rest—are pitched at slightly different angles. The repeated forms of the umbrellas, which are varied in color and placement, are overlapped as they recede to the back of the market. The repeated and varied colors and shapes of the print contribute to other design effects, including visual rhythm and movement.

Fig. 7-8. Where do you see repetition and variety in the print?
Maurice Prendergast, *Orange Market*, 1900. Monotype, printed in color.

Fig. 7-9. This monotype was printed in layers. The artist also wrote some thoughts across the image. Do you think this process would help you develop an idea?
Student work, Taylor Timmons, *Structure*.

Color Monotype

To make a monotype, you need only ink, a printing surface, paper, and baren or press. The most common approach to monotype is to draw in ink directly on the plate, pulling the print with an etching press.

1 Laying out colors to begin the monotype.

2 Colors applied to rigid plastic sheet to be printed. Notice the dashed line, indicating the size of the paper to be used for the print.

3 Printing the monotype on an etching press.

4 The finished print. Note the printed design is a reversal, or mirror image, of the initial inked design. Student work, Samantha Jacobs.

Reductive Technique

Another method for producing a monotype is to use a subtractive process. You learned that in lithography the artist can scratch or otherwise work the stone to remove drawn areas. Monotype provides a similar opportunity in that the artist always has the option of wiping or scraping ink away from the design in a reductive process that results in a "dark-field" monotype. Scraping tools can include cardboard.

Try It Create a monotype using the reductive technique.

Wiping away ink to create reductive print.

Getting ready to lay damp or dry paper onto inked surface.

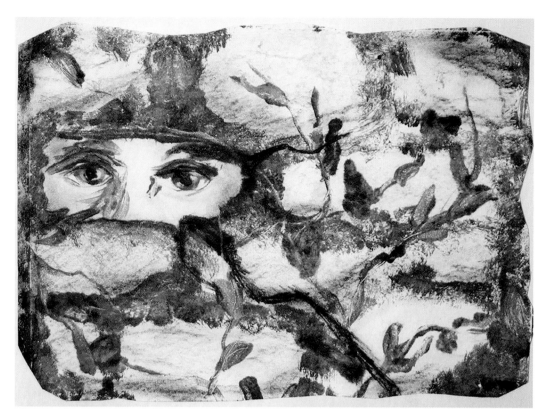

Fig. 7-10. For this monotype created with the reductive technique, the printmaker added water-color in the face, cheeks, and eyes. How might you add just a touch of embellishment to your reductive monotype?
Student work, Soozie Lowry, *The Grass is Greener.*

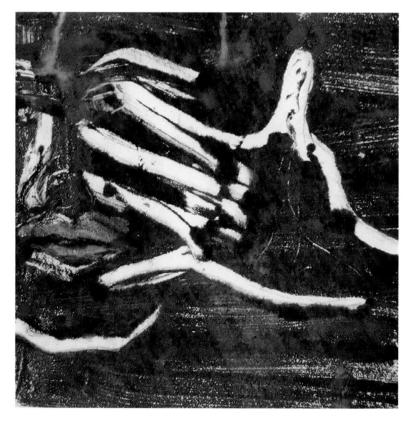

Fig. 7-11. How has the student artist used positive and negative space to develop this monotype?
Student work, Soozie Lowry, *Self-Conscious.*

Degas and Monotype

You learned in Chapter 6 that lithography was invented in 1798. Monotype was invented more than a century earlier, as art historians credit the seventeenth-century artist Benedetto Castiglione (1616–1670) with the discovery of monotype. Working from a heavily inked etching plate, Castiglione removed the ink from areas not intended to print.

A century later, the English Romantic poet William Blake and the French Impressionist painter Edgar Degas were two of the first established artists to experiment with the method. In fact, Degas and other French Impressionist printmakers made hundreds of monotypes in various styles, exploring the technical possibilities of the medium and inspiring others to go beyond the earliest stylistic and technical explorations. Said to dislike the term *monotype*, Degas called these works "drawings done in greasy ink and printed."

Fig. 7-13. Created on site by the artist or later, from memory, this monotype landscape used a reductive method of inking the plate and wiping away the areas not to be printed. Some critics suggest Degas's personal experiments with photography may have led him to pursue the monotype method, which could be used to achieve a quick, valued rendering not so different from a photograph.
Edgar Degas, *The Path Up The Hill*, 1877–79. Monotype.

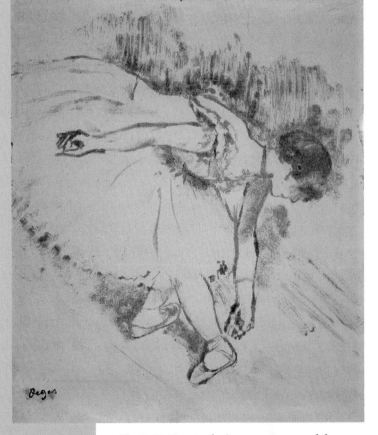

Fig. 7-12. Due to the impermanence of the surface design on the plate, monotype has been called an "intimate" medium—both demanding and directly reflective of the artist's technical expertise and ideas.
Edgar Degas, *Dancer*, 1878–80. Monotype.

Try It Design a landscape or still life in an abstract style Degas used in the monotype in Fig. 7-14. What colors will you use? How will you suggest forms without making them fully defined?

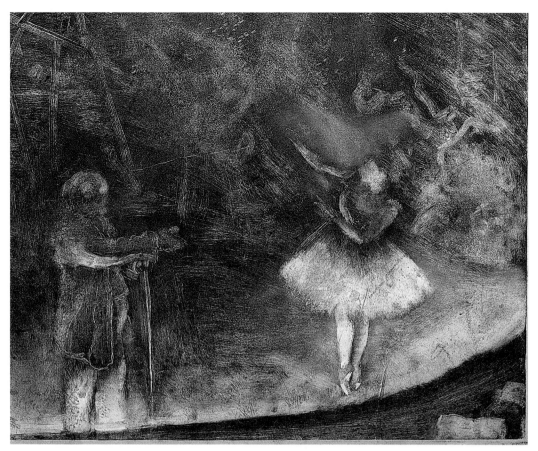

Fig. 7-14. Edgar Degas was well established as a painter in Paris when he attempted his first monotype. Done in collaboration with fellow artist Vicomte Ludovic Napoléon Lepic, the print exemplifies the reductive method. The white line areas on the monotype were heightened with chalk or a watercolor wash.

Edgar Degas, executed in collaboration with Ludovic Napoléon Lepic, *The Ballet Master (Le maïtre de ballet)*, c. 1874. Monotype heightened and corrected with white chalk or wash.

Fig. 7-15. Notice the painterly quality used in this image. Monotype gives the artist an opportunity to use painting techniques to create a print.

Student work, Heidi Jarin, *Colorful Flowers.*

Transfer Techniques

By working on a clear surface laid over your drawing, you can render an existing design as a monotype by transferring the design to the printing surface.

Trace transfer is another technique. As the French artist Paul Gauguin discovered, working in Tahiti with few tools and supplies, monotypes can also be created by laying printing paper over the inked plate and drawing on the paper in pen or pencil; the pressure will transfer ink to the reverse of the paper.

Try It Transfer an existing design via the trace-transfer technique. Simply lay an existing drawing over dry printing paper on top of any smooth surface with a thin layer of ink, then trace over the drawing lines with pen or pencil. The pressure will transfer ink to the reverse of the printing paper.

Fig. 7-16. In his letters, Gauguin described rolling out printer's ink on a sheet of paper, then laying a second sheet on top of it and drawing "whatever pleases you . . . The harder and thinner your pencil (as well as your paper), the finer will be the resulting line."
Paul Gauguin, *Two Marquesans,* ca. 1902. Monotype.

Fig. 7-17. While working in Tahiti with limited art supplies, the French Post-Impressionist Paul Gauguin found monotype an efficient medium. The monotype shown here carries hand-painted additions.
Paul Gauguin, *Ia Orana Maria (Ave Maria)*, 1894.

Fig. 7-18. Although only one monotype can be printed successfully, the plate can be repainted or recolored to make additional prints that will also each be one of a kind. The monotypes will be similar, but not enough to form an edition of prints.
Student work, Elizabeth Royce, *Abyss*.

Monotype Today

Monotype today is put to no end of artistic uses. Many printmakers continue to experiment with basic monotype processes, while others explore the use of multiple transfers.

Fig. 7-19. This monotype was actually created in three impressions. The black color was achieved by overprinting the three primaries.
Gail Ayres, *Mason Jar.* Monotype.

Fig. 7-20. This monotype incorporates calligraphic symbols. What message or feeling does this monotype create?
Anne Moore, *In Memoriam.* Monotype.

Michael Mazur

Born in 1935, Michael Mazur is an artist who exhibits internationally and is renowned for his large-scale monotypes. Prints such as *Wakeby Day II* are the result of multiple impressions on a single receiving surface, whether paper or canvas. The plate is wiped off after one image is transferred and another design is created and printed over the initial one, creating a sophisticated depth to the work. Mazur sometimes makes additions to the monotype in pastel or other media.

Wakeby Day II is part of a series inspired by the artist's memories of Wakeby Lake, on Cape Cod. Basing his compositions on memory gives the sub-jects a lyrical quality. The darker small section inset on the work's two right panels represents a nighttime view of the same scene. Here, the printmaker explores the passage of time, the rhythms of nature, and the multiple layers of memory and experience.

In his graphics, Mazur brings to the printed image the spontaneity and immediacy of painting. Inspired by the monotypes of Edgar Degas, Mazur has used the phenomenon of "ghosts," the pale residual images that monotype can produce, to explore serial, or narrative, ideas in which the image evolves from sheet to sheet.

Fig. 7-21. The darker small section inset on the work's two right panels represents a nighttime view of the same scene. How does this device help the artist to explore the motif of the lake?
Michael Mazur, *Wakeby Day II,* 1982. Monotype triptych.

Studio Experience
Watercolor Monotype

Before You Begin

There are many themes which allow you to come up with your own personal imagery. Consider the ideas used in Islamic art. You can go online or to the library to research examples of *arabesque*, *geometric*, and *calligraphic* designs. Select two of these designs to incorporate into a drawing or painting you have previously completed in your sketchbook.

You will need:
- frosted, thin, flexible and/or rigid plastic sheet suitable for printing
- watercolor crayons
- printing paper
- large tray in which to soak your paper
- newsprint or blotter paper—paper must be blotted or colors will run.
- access to a printing press

Fig. 7-22.
Student work, Jenny Franklin,
Hanging by a Syllable.

Create It

1. Take a drawing that you have completed in your sketchbook and incorporate two of the following: arabesque, geometric, or calligraphic designs (from your Islamic research) into your composition.

2. After finalizing your design, tape a piece of frosted, thin flexible plastic sheet suitable for printing into place over your drawing, with the frosted side up. Begin to draw your design on the see-through plastic. You should lay down enough watercolor crayon so that when you hold the piece of plastic up to the light, not much light comes through.

Check It

When the plate is ready, print the plate on a printing press using printing paper that has been thoroughly soaked and rinsed. (The soaking removes the sizing from the paper so that it won't stick to the printing plate.) You will be able to pull two prints from the plate. The first print will be very dark and the second will be much lighter.

Journal Connection

If you write in your journal regularly, be sure to keep track of ideas that you might use later. These ideas might be a starting point for a new artwork. Sometimes, all it takes is a spark to get you started again. Don't ever waste an idea—write it down so you'll have a record of it for later.

Fig. 7-23. In addition to the calligraphy and geometric shapes, this artist has incorporated a border into the image. What does it do to the composition? Student work, Elizabeth Royce, *Aidan*.

Rubric: Studio Assessment

4	3	2	1
Research and Composition			
Excellent research producing strong composition that addresses complex visual and/or conceptual idea.	Good research, composition clearly shows intention to convey idea.	Poor research, composition is awkward but shows some purpose.	Weak composition that lacks evidence of intent or consideration/haphazard.
Procedures • Transferring Image • Printing			
Excellent procedural processes. Exhibits technical excellence closely followed demonstrated procedures.	Reasonable use of materials and processes. Followed demonstrated procedures with few omissions.	Normal use of processes and some mistakes in procedure.	Poor or wasteful use of media/equipment. Procedures not followed.
Craftsmanship • Printing			
Excellent, good execution. Solid coverage of color.	Above average printing with slight deficiencies.	Shows some area of skill in a limited area.	Unfinished. Poor application of color.

Career Profile
Samella Lewis

Printmaker Samella Lewis has had a long and accomplished career in many areas. In addition to being an artist, she is an art educator, writer, and filmmaker.

Lewis began drawing and painting at the age of four. Her childhood was spent in Louisiana. Her artistic work, deeply personal, reflects her own experience in what she saw as the injustices routinely suffered by African Americans. It also reflects the struggle for humanity and freedom among people of color. Lewis feels that art should express the experiences of individuals and communities. She has called the artist "a community resource, valued and supported because he or she . . . gets to the heart of community life."

Lewis is a champion of the African-American woman in today's world. "Black women are nurturers," she told *Essence* magazine. "We nurture our families by seriously listening to and seriously considering what they tell us. We also have an obligation to see that valuing and collecting our art is a significant aspect of nurturing. We must familiarize ourselves with our historical and contemporary art in order to understand and know ourselves."

Lewis studied under the tutelage of artist Elizabeth Catlett and art educator Victor Lowenfeld. She holds degrees from Hampton Institute and Ohio State University, and her many distinctions include a Fulbright Fellowship, a Ford Foundation Fellowship, and a Humanities Distinguished Scholar Award. As founder of the Museum of African American Art in Los Angeles, she has provided a venue for African Americans to show their work and have it recognized for its connections to their culture.

Web Link
See more work by Samella Lewis at:
www.hearne
fineart.com

Fig. 7-24. Many of Samella Lewis's prints have African Americans as their subjects. What style has the printmaker used in this monotype? How does this monotype succeed or fail in expressing the humanity of the subject? Samella Lewis, *Mother and Child,* 2005. Monoprint.

Chapter Review

Recall What printmaking method is monotype?

Understand Why is a monotype always created in an edition of one?

Apply Demonstrate how the trace transfer monotype method differs from traditional monotype.

Analyze Select a full-figure portrait from this chapter that effectively uses a variety of lines. Describe the different types of lines in the monotype. How did the artist indicate the figure—with lines, shading, or a combination?

Synthesize Create a timeline by locating the dates of artworks in the chapter (excluding student art). What do you notice about the choice of subject matter and the artistic styles used in monotype over time?

Evaluate Compare and contrast the landscapes by Edgar Degas in Figs. 7-7 and 7-13. How do the two monotypes differ? How do they both succeed in suggesting landscape?

Writing About Art

Write a review of Fig. 7-14, *The Ballet Master,* by Edgar Degas. Write as if you were an art critic who hates Degas' work. Look at the picture and cite reasons for your statements. Share your work with the class.

For Your Portfolio

When preparing your portfolio, be sure that everything is of professional or show quality. Everything doesn't have to be matted, but it does need to be clean and free of smudges. Be sure all your work is signed. Before showing your portfolio, make sure that all your work is turned the same way. If you take the time to show some care in your preparation, you will see positive results.

Fig. 7-25. The heavy application of watercolor crayon for this monotype provided a dense rich color to the print. Experiment with different techniques such as watercolor and watercolor pencils to find the different looks of each.
Student work, Kelly Burke, *Tree of Life.*

Key Terms

serigraphy
Pop Art
photo silkscreen
photo emulsion
stencil

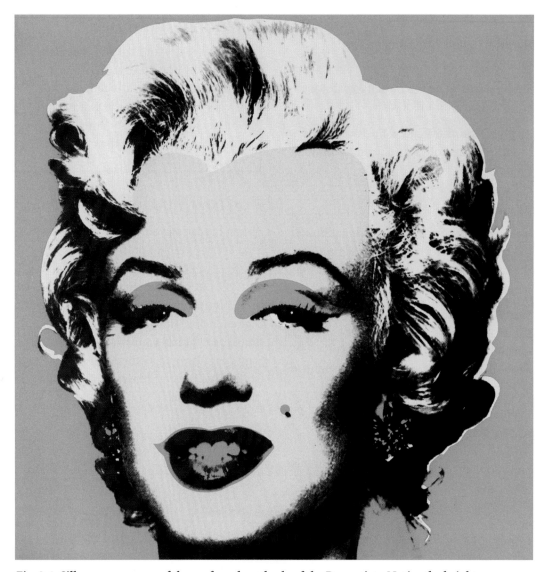

Fig. 8-1. Silkscreen was one of the preferred methods of the Pop artists. Notice the bright colors, incorporation of photographic imagery, and layered shapes in the print shown here. Andy Warhol, *Untitled* from *Marilyn Monroe (Marilyn)*, 1967. One from a portfolio of ten screenprints.

8 Silkscreen

ilkscreen is unique among printmaking methods because it is a stencil process. In silkscreen—also called screen printing—ink is pushed through a fabric screen. The ink leaves an even impression on the printing surface beneath the screen. Although the screened image is a flat, solid color, variety in silkscreen can be achieved through the design, through the use of multiple impressions, or by using mixed methods such as painting over the screen print. While manufacturing processes use carousel presses to create T-shirts and other commercial products in large volumes, you can apply the same basic process in the art room to create a print using nothing more than a screened frame, ink, and a squeegee.

In this chapter, you will:

- learn about the history of silkscreen
- learn methods of silkscreening
- create your own silkscreen

process

messages

materials

Silkscreen Basics

Screen printing, or silkscreen, is the fourth of the major methods of printmaking. Silkscreen prints are quickly produced and can be used for posters, T-shirts, and fine art prints. Silkscreens can be made by using stencils, one for each color.

Though the process as used today was first developed by Japanese artists of the 1800s, the art of stenciling is believed to have been used by the ancient Egyptians and Greeks as early as 2500 BCE.

In both commercial and fine art applications, artists create a silkscreen by pushing ink through a screen onto paper, creating an image. **Stencils** block out or determine where the ink will go. The shape of the stencil allows the ink to pass through the screen and reproduce the shape on the receiving surface below.

Note It In the early 1900s, the Englishman Samuel Simon patented the use of a silk fabric as a ground to hold a stencil in place while printing. The multicolor process of silk screening, called screen printing, was developed shortly afterward in the United States, by John Pilsworth of San Francisco.

Pulling a squeegee across a screen.

Silkscreen paints. Many different colors are available for your designs.

Silk screens.

Pulling a screen print.

Commercial Applications

Silkscreen was adopted early on for graphic design and sign making, and remains in wide use today. In the 1960s, Pop artists fully discovered the expressive potential of the method. Pop Art received its label because the art used common, popular images like soup cans and comic strip characters. **Pop Art** was flat, with almost no brushstrokes. Silkscreen became a favorite medium for Pop artists. These artists, in turn, have influenced new generations of advertising designers. In today's prints, designers make innovative use of drawing and photography. The photo silkscreen process will be explained later in this chapter.

Fig. 8-2. In this graphic design, you can see many different items from everyday life. How has the artist used color and space? What visual effects are created?
El Hortelano, *Citizens*, 1983. Serigraph.

A carousel printer for silkscreening T-shirts in large volumes.

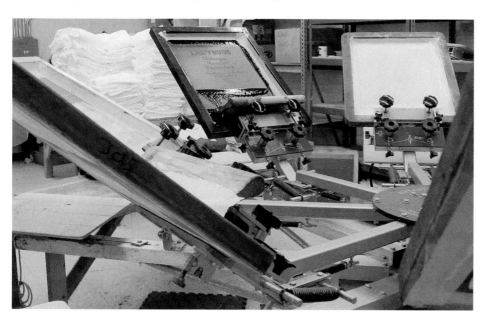

Serigraphy

When produced as a fine art print, the silkscreen process is called **serigraphy**, and the print is called a *serigraph*. This terminology was first used in the 1930s by Carl Zigrosser, who was the curator of prints at the Philadelphia Museum of Art. Zigrosser and other museum print curators wanted to distinguish art prints made by the silkscreen process from the commercial silkscreens used in advertising.

Note It The term *serigraphy* comes from the Latin word *seri*, meaning "silk," and the Greek word *graphein*, which means "to write or draw."

Pochoir

Serigraphy also includes the pochoir (*PO SHWAH*) print, which is made *without* a screen. *Pochoir* is the French word for stenciling. It was used as a method of coloring pictures thousands of years ago in China. Pochoir was introduced in the 1800s to the French publishing industry. What makes pochoir different from stenciling for everyday commercial illustration is the artist's eye and hand. In fact, pochoir is often called hand coloring, or hand illustration. Beautiful pochoir books were produced during the 1920s. (See the Handbook Timeline for another example.)

Fig. 8-3. In color pochoir, the artist hand stencils the print without use of a screen. Matisse made extensive use of the technique, both independently and in collaboration with publishers creating illustrated books.
Henri Matisse, *Icarus: Plate 8* from *Jazz*, 1944-47. Paper cutouts.

Fig. 8-4. Henri Matisse created his own pochoir designs but also oversaw limited edition pochoir prints made after his own paintings by publishers. The example shown here includes hand coloring and was created as a book illustration.
Henri Matisse, *Le Buffet*, 1929. Color pochoir (hand-colored stencil print) after a painting.

Qualities of Silkscreen

Because the silkscreen process produces solid areas of color or flat shapes, the elements of color and shape are essential to consider when producing a silkscreen.

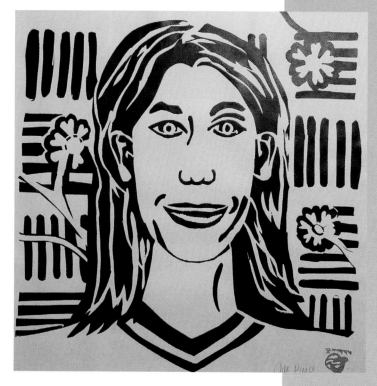

Fig. 8-5. A paper stencil was used to produce this student self-portrait. Notice the use of positive and negative space to show details.
Student work, Jill Pierce, *Self-portrait of Jill*.

Color in Silkscreen

The colors in a screen print can be bold and bright or mixed into subtle shades. The serigraph can have as many colors as the printmaker desires.

When printing with transparent inks, a color may be gained by printing one color over another. For example, if a yellow area prints over a red area, the color orange is gained. If yellow prints over blue, green might be the result. If the ink is opaque, however, it will be necessary to begin printing with the lightest colors first. With this sequence, colors that print on top of each other will cover completely the color underneath. They will also remain bright and not fade into each other. Colors can overlap so that white spaces won't show between shapes.

Try It A simple way to experience the process is to cut a stencil of your name. Draw the letters of your name in block style or balloon letters on newsprint. Cut around the outside of the letters with a utility knife. Keep the background to be used as your stencil. If you have letters that have a center, like O or A, cut out the center and set them aside. When you have finished, place the stencil on another piece of paper, put the centers of the letters in place. Brush paint from the outside in, for each letter. When you remove the stencil, you'll have a print of your name.

Fig. 8-6. Subtle changes in color can add dimension to the silkscreen print. Do you think that changing the colors used would change the effect of this print?
Shahzia Sikander, *Afloat,* 2001. Screenprint.

Fig. 8-7. Silkscreen allows the artist to play with positive and negative space in the images. Do you see how the artist uses color to create the focal points of his composition?
Kenzo Okada, *Morning Glories,* 1975. Screenprint.

Fig. 8-8. Contemporary African-American artist Sam Gilliam laid down abstract patterns of color to create this energetic design.
Sam Gilliam, *T Shirt*, from the portfolio "Equal Employment Opportunity is the Law," 1973. Serigraph on paper.

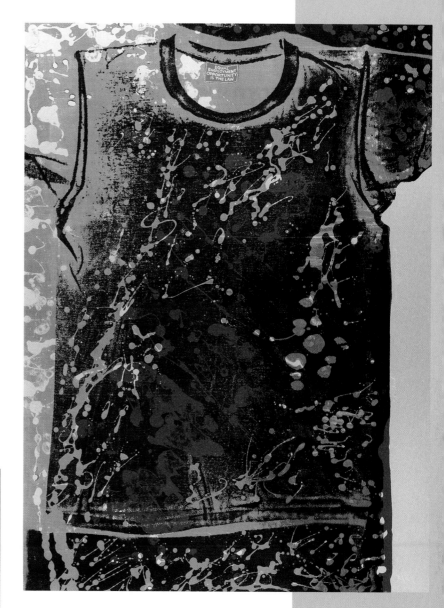

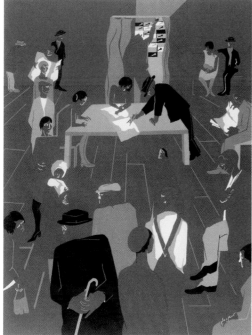

Fig. 8-9. Jacob Lawrence's paintings and prints alike are composed with careful design of interlocking shapes. How are shape and color used in this silkscreen?
Jacob Lawrence, *The 1920's . . . The Migrants Cast Their Ballots*, 1974. Silkscreen print.

The Stencil Method

Paper stencils are the easiest way to produce a silkscreen print. After the design is completed, the artist separates the colors by tracing around each color on a separate piece of paper. Each stencil is then cut using a utility knife.

These paper stencils can be used to make as many as one hundred prints. After the edition is made, the paper stencils should be thrown away.

Glue and Tusche Method

In this method, the design is painted or drawn on the screen with liquid tusche or tusche crayon. After it is dry, glue is squeegeed across the screen. The glue is allowed to dry and then the tusche is removed with paint thinner or turpentine. The result is a screen ready for printing.

Fig. 8-10. This artist used the glue and tusche method to create the rough edges and drips in his image. Do you think the title gives some insight to the design?
Larry Stewart, *Tribute to Annie Oakley*. Silkscreen.

Photo Silkscreen Method

The **photo silkscreen** method allows artists to use photographic images in their work. To create a photo screen, it is necessary to coat the screen with **photo emulsion** and dry it in a dark space. The screen will then be light sensitive. A darkroom is the ideal setting for the light exposure of the screen, but sunlight can also be used to make the exposure.

The positive image needs to be in close contact with the screen. If you are using a light table, a piece of foam can be placed inside the screen with a piece of glass on top of the artwork to ensure complete contact. If using sunlight, attach the positive image to the screen with rubber cement. If using rubber cement, be sure to glue only in areas of the screen that won't wash out because rubber cement will clog up the screen.

Exposure times vary but are usually explained in the directions included with the emulsion. After the screen is exposed, the positive areas should be washed out with warm water. When the screen is completely dry, it is ready to print.

Try It An easy way to do a silkscreen is by using leaves. Lay the paper out first. Place leaves in an arrangement on the paper. Place the silkscreen on top and pull a color across. The background will be the ink color and the leaves will be the color of the paper. The ink will hold the leaves on the screen so that you can replace the paper and make several more prints.

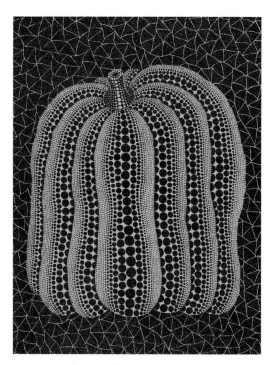

Fig. 8-11. The use of geometric shapes has created a different look for this design. Do you think the print would be better or worse if the design was more realistically rendered? Yayoi Kusama, *A Pumpkin (BT)*, 2004. Silkscreen.

Fig. 8-12. Roger Jackson uses the photographic silkscreen method to print the detail color of his image. The image began as a pen and ink drawing that was made into a transparency. The transparency was used to expose the photo emulsion coated screen. He then used paper stencils to block out areas and create new color shapes for his image. How many colors can you count in this picture? (There were 32 colors used.) Roger Jackson, *North Gay St. Viaduct*. Silkscreen.

Andy Warhol
(United States, 1928–1987)

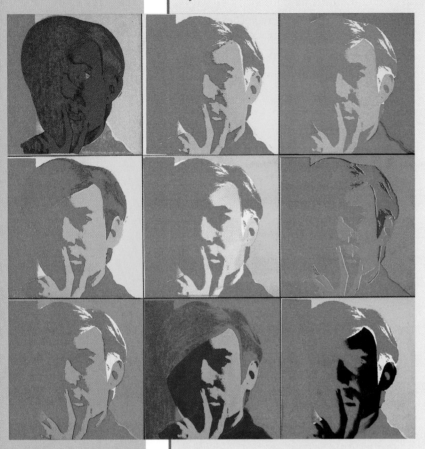

Fig. 8-13. Andy Warhol's studio was called The Factory. What connotation does the name The Factory have? How do the processes of printmaking, and especially the silkscreen images like those created by Warhol, relate to the idea of mass production in a factory?
Andy Warhol, *Self-Portrait*, 1966. Silkscreen ink of synthetic polymer paint on nine canvases.

Andy Warhol, more than any other artist, is the name most people associate with Pop Art. He entered the art world by creating window displays and commercial designs. Such work reached a mass market. When he turned to fine art as a career, he hoped to reach the same mass market, using many of the techniques he had used in advertising, especially the silkscreen process.

Silkscreen, which became popular in package design, T-shirt decoration, and posters during the 1960s, was one of Warhol's favorite mediums. The silkscreen process leaves a smooth, brushstroke-free surface that heightens the impact of the image as a mass-produced object. Warhol used the silkscreen printmaking method to produce multiple, identical images. Although his works were meant to be comments on his times, Warhol distanced himself from any personal content or narrative.

Aside from images of Campbell's soup cans and Marilyn Monroe, Warhol is also well known for his numerous self-portraits. Like many of his other subjects, the multiple photographed image was a frequent device used by Warhol. Despite the fact that it is a likeness of himself, he reduces the personal impact by multiplying the images, much like a row of cans with the same label in a grocery store. This particular work combines the silkscreen with hand-applied color. The garish synthetic colors further reduce the personal aspect of the "multiple" self-portrait.

Stretch a Frame

To make your own silkscreen, or replace a screen that has damaged fabric or blocked areas, all you need to know is how to stretch silk onto a wooden frame, much like stretching a canvas as preparation for a painting.

1 Assemble your materials. These include:
- a wooden frame
- a fabric screen
- a staple gun and staples
- a stencil knife

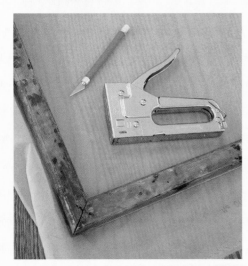

2 Lay a piece of fabric that is larger than the screen across the frame. Make sure that the threads run parallel with the edge of the frame. If the fabric is not straight, it can cause problems in printing.

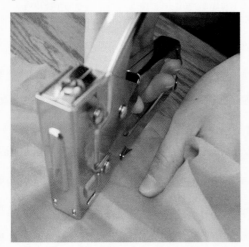

3 Start stapling the fabric at the center of each side and work your way out. As you staple, pull the fabric out and down. Staple two or three staples and then staple directly across in the same manner. Be sure to keep the threads of the fabric parallel with the sides of the frame.

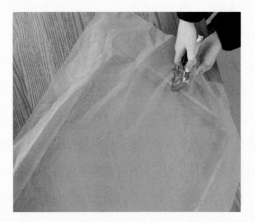

4 After the fabric is attached on all sides, trim away the excess so that it is even with the frame. Then wash the screen with soap and water to remove all the sizing from the fabric. Allow the screen to dry completely. At this time, the screen can be taped to create the printing area.

Unity and Variety

The use of stenciling to make silkscreen prints allows for full exploration of flat areas of color. Positive and negative shapes can convey power, boldness, liveliness, action, or calm. Shape and color can be used to create varied design effects. Silkscreen allows the artist to work in layers of color and see the results immediately. Similarities in color and the method itself permit a range of shadows and subtleties that are not possible in other processes. A final pull of the squeegee can unify a whole print by connecting all the parts of the image.

Fig. 8-14. Op artist Victor Vasarely often worked in grid format. How do larger blocks of light and dark in the print shown here relate to the tiny alternating pattern of the screen grid itself?
Victor Vasarely, *SIKRA-MC*, 1968. Screenprint.

Everyday Life

The Pop Artists used the material realities of everyday life as the subject matter for their art. They felt that ordinary people found most of their entertainment in television, magazines, or comics. The everyday objects and mass-produced objects were given the same significance as the unique. Silkscreen gave these artists the opportunity to create the same images quickly and make these prints available to the public. Consumerism and the materialistic practices of the day gave the artist an opportunity to create works that were accepted readily by the public. It changed the way people thought about art and helped to dissolve the gap between "high art" and "low art."

These artists also emphasized the new social values of the time. The new society was superficial, flashy, transitory and lived in the recently developed suburbs, the very opposite of the values esteemed for so long by artists of the past. Everyday trips to the supermarket and the constant advertisements seen in magazines and on television gave artists ideas to use in their work.

Fig. 8-15. The artist uses Ben-day dots in many of his images. They were invented by Benjamin Day to give shadow or tone to printing. They are similar to photographic halftones except they remain the same size and are just closer or farther apart. Ben-day dots are used most often in comic books.
Roy Lichtenstein, *Wallpaper with Blue Floor Interior*, 1992. Five panel, nine color screenprint.

Messages

As an artist creates an artwork, there is an opportunity to express personal beliefs and share those beliefs with the public. Many artists use their work to call attention to the themes of their time such as endangered species, the threat of nuclear holocaust, and human suffering. See page 192 in Chapter 9 to learn more about the artist Sue Coe.

Fig. 8-16. The stenciled type in this silkscreen suggests the carved type of letterpress printing. Ben Shahn, *H Bomb Poster*, 1960. Color serigraph.

Fig. 8-17. This print was created as part of a series on endangered species. Why might printmaking be an effective medium for a series of prints? How has the printmaker used the silkscreen method in this design? Andy Warhol, *Bighorn Ram*, Endangered Species Series, 1983. One from portfolio of ten screenprints and colophon.

Fig. 8-18. This print was produced with handcut masking film. The film was attached to the screen with acetone. This film is different from photographic film in that it peels away from a plastic backing. The positive areas are cut away with a utility knife to create the image. Donna Anderson, *Expectation*. Silkscreen.

Silkscreen Today

Silkscreen printing is still used extensively in both the commercial and fine art areas. As mentioned earlier, T-shirts are one of the most common uses of screen printing. You might be surprised to learn that signs on trucks, called fleet marking, are made by this process. Fleet marking identifies trucks that travel the highways carrying anything from furniture to cement. Look at the name or picture on the side of a truck. Most likely the image was printed by the silkscreen method onto a special material that could be applied to the side of the truck. It is much easier and faster to print the material and then apply it to the vehicle.

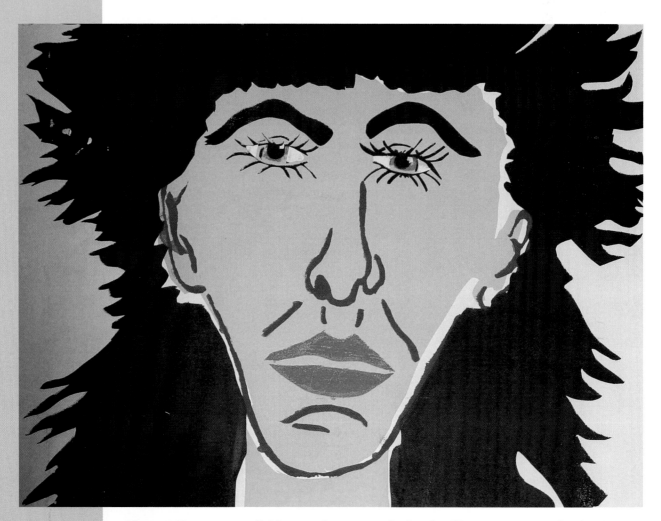

Fig. 8-19. How can you tell this artwork was created using the silkscreen process? What is unique about the shapes this artist used to create the image?
Student work, Tony Ewing, *Steely Greene.*

Fig. 8-20. Compare this silkscreen by contemporary artist Keith Haring to the relief shown in Fig. 1-14 on page 12 by Eldzier Cortor. Aside from the subject matter, how are the prints similar and different? Which differences do you notice that relate to the different media used?
Keith Haring, *Untitled*, 1985. Silkscreen.

Fig. 8-21. This artist makes prints using a variety of print-making methods. Why might he have chosen silkscreen for this design?
Michael Mazur, *Serpentine Orchids*, 2005. Four-color screen print on Rives BFK.

Color Separation for a Screen Print

To create a multiple-color silkscreen design on a T-shirt, you need to know how to separate colors for a screen print. The process illustrated here was developed by commercial screenprinter John Douglas. This design uses a seven-step process—six color separations, plus black. The six color separations are: light blue, dark blue, red, light yellow, dark yellow, and gray or silver. The screen printer that can produce a design like this will handle each shirt seven times before the shirt is finished. And you thought it was "just a T-shirt."

Fig. 8-22. The truck and paint gun shown in this 7-color silkscreen were drawn by hand before being scanned into Photoshop and arranged for the final design.
John Douglas, *Top Gun,* T-shirt design.

T-shirt with original drawings for the design.

gray/silver

lemon yellow/light yellow

bright red

dark blue

dark yellow/light orange

light royal blue

black detail

Studio Experience
Silkscreen

This studio features a combination of two different techniques—paper stencils and drawing fluid with screen filler.

Before You Begin

Think about all the things you like. Do you have hobbies, play sports, or enjoy listening to music? Do you have a special pair of shoes? Make a list of the things you like best. Draw pictures of these favorites arranging them on the page with overlapping areas.

You will need:
- newsprint
- paint and brush
- pencil
- tracing paper
- permanent marker
- utility knife
- silkscreen
- squeegee
- silkscreen inks
- drawing fluid
- screen and screen filler

Create It

1. Complete your drawing and paint your picture with solid colors. Don't paint in a painterly manner, but only to show the color of each object in the picture.

2. Begin to make stencils for each color. Separate the colors by tracing all the shapes of the same color onto the same sheet of newsprint. Use a separate sheet of newsprint for each color. If you have six colors in your picture, then you will have six separate sheets of newsprint.

3. To complete each stencil, use a utility knife to cut a hole in the newsprint outlining the shape of each object. The newsprint will block out the screen except where the ink will go.

4. Lay the stencil for the first color on the paper to be printed. Place the screen on top of the stencil. Pour ink onto the silkscreen and push the ink through the stencil with a squeegee. Continue printing each color, carefully aligning with the original drawing to set up. If colors are to overlap, print lighter colors first.

Original drawings and detail, or final stage of design traced and redrawn with permanent marker on tracing paper.

5. To add a detail screen, which is the outline of the image, first prepare it with drawing fluid and allow it to dry overnight. Then add screen filler. The directions are included when the supplies are purchased.

6. Use the detail screen to print the details after the stenciled areas are complete.

Checking detail screen for any needed corrections before final printing.

Fig. 8-23. The finished print.
Student work, Bria Woodfin, *Things I like.*

Pulling the squeegee to print a detail color.

Rubric: Studio Assessment

	4	3	2	1
Composition				
	A strong composition which addresses complex visual and/or conceptual ideas.	Composition clearly shows overlapping, placement, and intention to balance shapes.	Composition is awkward, no overlapping of shapes, but shows some purpose.	Weak composition which lacks evidence of intention or consideration/haphazard.
Planning and Organization				
	Effective use of class time; demonstrates clear focus and intent throughout the design process.	Reasonable use of class time; illustrates intelligent use of modifications to original design ideas.	Limited use of class time; recognizes need for planning in and throughout the design process.	Off-task for majority of class time; failure to produce original plan or adequately modify or redesign.
Craftsmanship				
	Neat execution. Exhibits intent while recognizing own limitations.	Above average rendering with slight deficiencies evident in final project.	Shows some evidence of skill in limited area.	Unable to recognize own ability; hindered by limitations.

John Douglas

John Douglas is presently the owner of Animal-at-Work, a freelance design company in Knoxville, Tennessee. He arrived in this position through a lot of hard work and developed talent. With a bachelor of fine arts degree (B.F.A.) in Illustration, he has owned a company and developed a line of goods. Most recently, he has been writing and illustrating a children's book. John's artwork has been selected for art competitions since elementary school. He won first place when he was in the seventh grade for a pencil portrait of himself at the age of five. He continued to do artwork and in high school won both gold and silver medals in the Scholastic Art Competition. In addition, his work was on display statewide in numerous exhibits and contests. Although John uses computer programs extensively in his design work, he also draws extremely well. Drawing facilitates his ability to create unique designs. It is also an advantage because customers can tell him what they want and he can produce it.

Says John, "Having worked professionally since my graduation in 1991, I have discovered that the term commercial artist is more or less a misnomer. When one is bound by the parameters set forth by a paying client, the best you can hope for is to satisfy that client. It's a little like playing Name That Tune. Someone brings me a print of a van Gogh and asks me to recreate it in three colors. Although I have many regular clients who sing my praises, I have rarely been satisfied as an artist by the artwork I have produced for them."

"Some people assume that I am an artist *because* I have a degree. To the contrary, I have a degree because I'm an artist. True art comes from the soul. I believe that kind of talent is something you're born with. That ability to feel and see a thing differently is innate. Theories and skills can be learned, and they must be in order for someone to excel with their talent. It's no different than the path of a professional athlete. Natural ability will only get you so far. It must be supplemented with knowledge and skill."

Fig. 8-24. How many colors do you think were used in this silkscreen? If you look closely, you can see that shadows and variations of color are gained by overlapping some of the colors.
John Douglas, *An Orange Sunday*, 1989. Serigraphy, paper stencil, and tusche.

Chapter Review

Recall What is Pop Art?

Understand How does photo silkscreen work? What advantages does it give to the artist?

Apply Consider one of the ideas in your sketchbook and do a preliminary painting/sketch of how it would work as a silkscreen print. Show the painting/sketch to your teacher and discuss its merits.

Analyze Look at the picture *Wallpaper with Blue Floor Interior* by Roy Lichtenstein. Which elements of art can you identify in the picture? Would this picture have been as successful if the artist had used another method besides silkscreen?

Synthesize Create a poster showing the steps involved in creating a silkscreen print.

Evaluate Compare the process of creating a silkscreen print with the process of creating a reduction print. Which method would you choose as your favorite? Give the pros and cons of each method as you see them as an artist.

Writing About Art

Likes and dislikes play a large part in our lives in everything from our clothing to the food we eat. Choose a print from this book that you like and one that you don't like. Look closely at each and make a list of the good and bad points of each. Write a short paragraph explaining your decision. What makes you like or dislike the print? Is it the colors, the subject matter, the process?

For Your Portfolio

Your portfolio reveals a lot about you when it is seen by decision makers for scholarship opportunities. Keep a variety of artwork in your portfolio to show where you started and how you have grown. Think about each piece and how far you have evolved as an artist during its completion. Make it a habit to write a statement about this journey and keep it with the artwork. This will help you to focus on what you have to say in your work and what your work says about you.

Fig. 8-25. This artist created a unique background for his print by blending colors before he printed on top of the creation. Can you see how many colors were used for the background?
Student work, Shaun Ridge, *Shaun's Green.*

Fig. 9-1. In this mixed method print, contemporary artist Miriam Schapiro pays homage to the Mexican artist Frida Kahlo. What multiple techniques were used to create this print?
Miriam Schapiro, *Frida and Me,* 1990. Color lithograph, fabric, and color Xerox.

9 Mixed Methods and New Directions

While each printmaking method offers exciting possibilities, artists have often achieved the most successful results by combining printmaking methods or by incorporating hand additions. Digital technologies continue to provide printmakers with new tools to create designs. The range of technical approaches that printmakers can continue to pursue in the future knows no limits.

In this closing chapter you will learn about approaches to combining printmaking methods. Lithography can be combined with silkscreening, relief, or intaglio and digital images can be manipulated to serve as the basis for any type of print. These approaches offer many variations on the basic printmaking methods. You'll also learn how to add hand alterations to your prints and how to make embossed prints, which use no ink.

embellishment

collagraph

digital design

Combining Methods

Combining different printmaking methods gives artists opportunities to experiment with different images. An artist can use a specific design and make changes to it by adding another color or printing another plate. If a print or design doesn't come out as planned, the artist can use any of the many printmaking techniques to rework it until it is complete. In the examples shown in this chapter, there are combinations of many different techniques. As you look at the images, think about how they would look if the artists had not combined different methods. Would an image have been as successful?

Fig. 9-2. What two methods do you see combined in this playful work?
Robert Rauschenberg, *Cardbird Door,* 1971. Cardboard, paper, tape, wood, metal, offset lithography, and screenprint.

Fig. 9-3. The use of intaglio techniques in mixed method printmaking can lead to exciting discoveries. This artist makes sculptures that explore this same figure/shape motif.
Manolo Valdés, *Perfil I,* 2006. Etching with color collage.

Fig. 9-4. Munch was a major experimenter in his art and especially his prints. This print overlays two major methods, lithography and relief.
Edvard Munch, *Vampire II,* 1895–1902. Lithograph.

Fig. 9-5. Contemporary artist Kara Walker likes to challenge audiences with her powerful graphics such as this lithograph-silkscreen combination. How would you interpret the images in this print?
Kara Walker, *Confederate Prisoners Being Conducted from Jonesborough to Atlanta from Harper's Pictorial History of the Civil War (Annotated)*, 2005. One from a portfolio of fifteen lithograph and screenprints.

Try It Use the computer to create a design that you will produce as a silkscreen. Using a drawing or painting program, draw shapes and fill them with the colors you plan to use. After you've created the design and your teacher has approved it, print out the image and use it to trace your paper stencils for the silkscreen. You'll be able to see the colors in place before you produce the print.

Fig. 9-6. The artist developed this design by photographing postcards, then combining them using digital design to create the photo-reproduction used in the final serigraph.
Dieter Roth, from *6 Piccadillies* [title not known], 1970. Screenprint and offset lithograph on paper, print.

Fig. 9-7. Terry Winters incorporates both old and new methods. The artist scanned drawings into digital images and manipulated them on the computer. The images were then laser cut into wood blocks and printed in white ink on paper rinsed in black.
Terry Winters, *Graphic Primitives*, 1998. Portfolio of 9 woodcuts printed on Japanese Kochi paper.

Fig. 9-8. Contemporary artist Sarah Sze's installation sculptures surprise and entertain audiences. Sze based this print on one of her own sculptural designs.
Sarah Sze, *Day*, 2005. Offset lithography, silkscreen..

Hand Additions

Many times, an image that doesn't print well can be turned into a successful work by embellishment. Outlining the shapes of the printed areas or drawing a repeated pattern can make a print more exciting. Embellishing your prints by handcoloring them with colored pencil, pen, or watercolor is another way to add color and to experiment with color combinations. For example, Mary Azarian, who trained as a painter, handcolors many of her woodcuts. (See Fig. 3-26, on page 66.) Andy Warhol is another artist who painted on the canvas before silkscreening designs over the paint. Some artists use the print as a starting point and then draw, paint, collage, or stencil on top so that they have an image that is represented in many ways.

Fig. 9-9. Oil paints were applied to the silk-screened images to complete this work. Notice how the colors lead the eye through the many parts of the picture. Is the artist telling a story with the images he chose? Do you like the results?
Robert Rauschenberg, *Estate,* 1963. Oil and silk-screened inks on canvas.

Fig. 9-10. Notice that the image is facing in the opposite direction than the print. The image was reversed or a mirror image when printed.
Student work, Shaun Ridge, *It's Me!*

Fig. 9-11. This student used different papers with both colored pencil and oil pastels to experiment with his self-portrait embellished prints.
Student work, Shaun Ridge, *Self-portraits in Blue and Orange.*

Printing on Different Papers

There are papers made specifically for printmaking just as there are watercolor papers and construction papers. The printmaking papers can usually withstand being put through a press and printed without tearing or falling apart. Although printmaking papers give the best results, other papers can also be used. Good results for relief prints can be obtained with regular copy paper. Printing on different papers can produce unusual outcomes. Refer to the handbook for a list of papers and which work best for each method.

Experimentation is one of the most exciting aspects in printmaking. The artist created this print by using recycled linoleum plates. Old carved linoleum was cut into pieces and then printed on different materials. Wallpaper, newspaper, acetate, and regular paper were used for the images. The pieces were then arranged and glued to a large surface area. Duct tape and brass brads were used to attach and accent the parts.

Fig. 9-12. This image is a mixed media work using printing methods. Why do you think it is still considered a print?
Student work, Riley Goddard, *Thoobah.*

Fig. 9-13. This linocut was printed on two different papers—drawing paper and brown card stock—and embellished with colored pencil. Notice how the student makes each image a one-of-a-kind artwork by using different patterns and colors of embellishment.
Student work, Rachel Scalf, *Chester*.

Fig. 9-14. The artist states that this is his "visual interpretation of a black hole." He has used silkscreen, relief, and embossing to create the image. Do you think the same effect could be produced with only one of these methods?
R. Lee Hebert, *Love Letter to Christophe Galfard*, 2008. Serigraph, destroyed block SINTRA relief print with embossing.

Variations on the Major Methods

Chine Collé

Chine collé is a process used predominantly in intaglio printing. A piece of very thin paper, such as rice paper, is placed on the inked plate and then coated with rice flour glue. A piece of damp printing paper is placed on top of the glued side of the rice paper. When both papers go through the press, the image is printed on the thin paper and glued to the backing at the same time. This method allows more detail to be printed on the thin paper. Without gluing the paper and printing at the same time, the thin paper would tear as it went through the press. Colored rice paper is also used to add areas of color to the print.

Fig. 9-16. Chine collé is an excellent way to add pops of color to an intaglio print. Do you think this print would be as successful without the added color?
Student work, Tammany Ogden, *Red*. Soft ground intaglio print with red chine collé application.

Fig. 9-15. Known for her monumental outdoor sculptures, Nevelson has also created many prints. This example is unusual because it is cast paper. Ask your teacher how you can use your linoleum plate to create a work like this.
Louise Nevelson, *Dawnscape*, 1978. Cast paper pulp.

Embossing

If you have ever seen a notarized document, which contains a raised official seal, then you have seen an example of **embossing**. Embossing is a way of printing an image without using ink. It can be created with layers of cardboard or from any relief plate. The plate is put through the press on high pressure to force the paper into the recessed areas of the plate. It is important to use paper that is dampened so that it will not crack or tear. You will create an embossing in the studio experience later in this chapter.

Collagraphs

A **collagraph** is another form of a relief print. It comes from the word *collage*. The plate can be made from a sturdy base such as mat board or cardboard. Then different materials such as paper, sand, glue, or found objects are glued to the plate to build layers that will create a relief area that will print. After the items are added to the base, a coat of sealer is applied to make sure everything is stuck to the plate. The plate is then inked and printed like a regular relief print.

The plate is very versatile because it can also be inked as an intaglio. In an intaglio, the ink is forced into the depressions in the plate. A wide variety of well-placed objects can produce a very interesting image. The image can become even more exciting with some experimentation; fascinating effects can result by rolling ink onto the wiped plate. Printing on different types of paper can also change the look.

Try It A good place to start to develop a collagraph is with your sketchbook. On a table, lay materials you might use to make a collagraph—things like paper clips, tissue paper, or crushed aluminum foil. Begin to arrange them in different patterns. Quickly sketch their positions on your paper. As you make several different arrangements in a short period of time, see if a design begins to show itself. As you continue to work, an idea will develop.

Fig. 9-18. This collagraph was produced by attaching objects to the printing surface, applying a coat of sealant, and then printing in the intaglio method. Color was added separately.
Bill Shinn, *Lost in Leisure*. Collagraph.

Fig. 9-17. This is the completed printing plate for Fig. 9-18, *Lost in Leisure.* This plate can be printed with a relief method, an intaglio method, or both.
Bill Shinn, plate for *Lost in Leisure.*

Make a Collagraph

The process of making a collagraph begins with choosing objects that you can use on your collagraphic plate. Be sure that they can be flattened enough to stay on the plate and go through the press easily. As when planning any project, consider the elements and principles of design. Do the objects suggest a theme? Are your shapes related? Experiment with the placement of your materials. Do you have balance in your positive and negative space? Have you considered the colors you would like to use?

1 Place the objects and materials on the plate. When you are satisfied with your arrangement, glue the materials onto the plate.

2 Draw figures on foil-faced posterboard with a ballpoint pen. Then cut out each figure and glue it on the plate. The figures will stand out in relief; a slight shadow around them on the pulled print will give the figures some depth.

3 Seal the plate and let it dry overnight.

4 Ink the plate and use a press to pull a print. You can add touches of color by hand to bring out certain objects in your collagraph.

Fig. 9-19. This collagraph uses many textures to create interest. What articles do you think the artist used to create the design on the fan?
Student work, Suzanne Reneken, *Geisha*.

Fig. 9-20. The collagraph plate was created by attaching different materials to a piece of illustration board. At the top, a plastic comb was pressed into damp watercolor paper, dried, and covered in polymer. Next, a piece of twine is glued down. Then slivers of chip board were mixed with glue and dried. Other objects used in the plate include sandpaper, embossed paper, glitter, and foil-faced posterboard. The foil has been drawn into with a ballpoint pen.

Fig. 9-21. The collagraph print is pulled on damp watercolor paper using a press after rubbing down the plate with black ink and then wiping it clean.

Unity and Variety

In creating a print with unity and variety, the printmaker may consider how the repetition of detail will be affected and also how similarities of color and tone will aid cohesiveness. The subject of Anselm Kiefer's print *Grane* relates to German composer Richard Wagner's opera *The Ring* (1853). In the opera, the character Brunhilde, grieving the death of the opera's hero, builds a funeral pyre. Kiefer's print shows Brunhilde's horse, Grane, whom Brunhilde has ridden into the flames in a gesture of self-sacrifice. Kiefer used mixed methods to create the sense of epic drama in this scene. The upward movement of the flames beneath Grane's skeletal frame into the smoldering beam-like panel atop the print contributes to this powerful effect.

Fig. 9-22. This print uses woodcut with paint and stain additions, produced on thirteen sheets of paper. What gives the image variety? How does the use of color help unify the print? Anselm Kiefer, *Grane*, 1980-93. Woodcut, printed in black with paint additions.

Use a Digital Design for an Original Print

You can apply a digital process to develop a design that you will print using traditional printmaking methods. The first step is to digitize or scan your drawing, design or a texture. Then you can manipulate your design until you arrive at a composition that you would like to incorporate into the print you are making. You can print a background using scanned objects as shown below.

This workflow allows for variation and experimentation in design development.

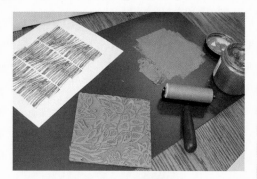

1 Scan the item you plan to incorporate into your print, using whatever program is available.

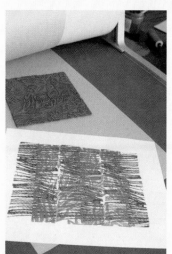

4 This artist has used burlap to create a textured background for a relief print.

2 Proceed to crop, cut and paste until you have achieved the desired results. Save your final design.

3 Print out as many pages as needed for your edition. Print your edition using the digital component prepared on the computer.

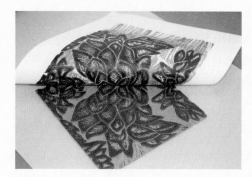

5 The print uses two colors which are slightly offset.

Kiki Smith

Kiki Smith is identified with feminist art because, since the 1980s, most of her work has concerned the human, primarily the female, body. In her work it is used as a vehicle for knowledge, belief, and storytelling. Smith was the daughter of minimalist sculptor Tony Smith and grew up in New Jersey.

As a young girl, she helped her father make cardboard models of his primary sculptures. This formalist training served her well in her own work. While studying art she also studied emergency medicine. This inquiry had a profound impact on her artworks.

In her recent prints, Smith has turned often to fairy tales to search for dramatic female personae and alter egos. This image is based on Lewis Carroll's book *Alice's Adventures Under Ground* (1886).

The aquatint process allowed Smith to simulate the textures of the various birds, achieving fine detail with the drypoint and etching techniques. In order to depict the animals as close to their actual size as possible, Smith had to use a copperplate that is monumental compared to most etched or engraved works.

Fig. 9-23. Notice how the artist's use of sanding enhanced the simulated textures of the aquatint. What feeling or experience does this print seem to explore?
Kiki Smith, *Pool of Tears II (after Lewis Carroll)*, 2000. Etching, aquatint, drypoint, and sanding with watercolor additions.

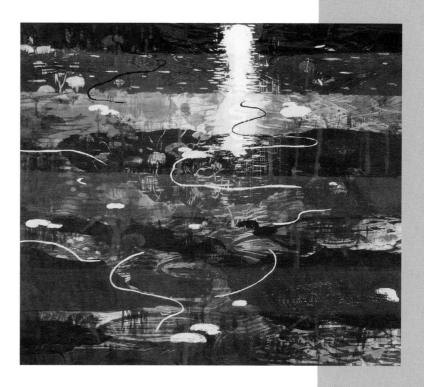

Fig. 9-24. The lake shown in this mixed media print is a common motif for contemporary printmaker Michael Mazur.
Michael Mazur, *Pond Edge V (Reflections)*, 2007. Aquatint, woodcut, and silkscreen.

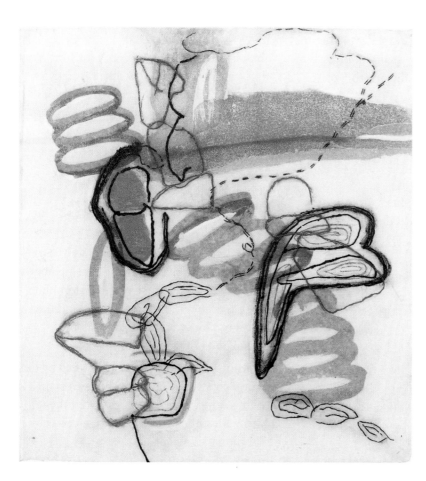

Fig. 9-25. This lake motif was created on rigid plastic sheet. How is this print both similar to and different from the print above?
Michael Mazur, *Lake I,* 2004. Etching, aquatint, wood relief, and engraved Plexiglas.

Studio Experience
Embossing

In this studio experience, you will create a print without using any ink, using a process called embossing. An embossed design has both raised and lowered areas. Think about your image in terms of layers, which will create the high and low areas.

Before You Begin

Think about an image that might be interesting for this type of print. Look at the examples of a hamburger and a jellyfish on page 191. The subject matter needs to be a strong image that will not require color or lines to communicate the theme. Shapes are important. Tiny details might be difficult to execute in this particular method. Keep in mind that in addition to the print being a mirror image, the areas that are highest in your plate will be the most depressed areas of your final print. For example, the sesame seeds that are raised on the hamburger bun are the lowest areas on the printing plate.

You will need:
- illustration board, mat board, or chip board
- utility knife
- scissors
- glue stick (a glue stick works better than glue because it doesn't warp the board, so that the board stays flat)
- masking tape
- carbon paper
- pencil
- good printing paper; student watercolor paper also works well

Create It

1. Trace your drawing, using carbon paper, onto the board, which will be your plate. Use this as your base.

2. Trace individual parts of your drawing onto additional pieces of board, which will be glued in layers on your plate. Remember, raised areas on your plate will be depressed in your print.

3. Using the utility knife, cut into your base to create the areas that will be the highest parts of your print. Since no drawing or color is being used, the high and low areas of your print are the only things which will convey the design.

4. Use the ruler to cut the plate evenly around the edges to create the plate mark.

5. Spray the plate with a thin coat of clear acrylic and allow to dry overnight.

6. Soak the printing paper for about 15 minutes to remove the sizing. (Sizing may cause the paper to stick to the plate.) Blot the paper to remove excess water and then let sit for about ten minutes so that it is damp and not wet.

7. Print by running the plate covered by the damp paper through an etching press on a tight setting. It's a good idea to test the setting with some printing paper scraps before running the final print.

8. Create your edition, allowing prints to dry completely on a flat surface. Then sign and number your edition.

Fig. 9-26. Layers of cardboard are used to create the plate for this embossing. Do you think the artist created the feeling of floating with the arrangement of parts?
Student work, Sarah Saverzapf, *Deep Sea*.

Check It

Did your embossing come out as you expected? Did the design you chose work well in this process? Did you have enough different layers to create interest? Was your subject identifiable without using lines and color? Can you think of ways you could have changed your design to improve the outcome? Are the edges of your embossing crisp and sharp?

Safety Tip When using a utility knife to cut your designs, stick the blade in a scrap piece of foam between cuts. It keeps the knife from rolling off the table and protects your fingers from accidents.

Fig. 9-27. Notice the sesame seeds on the bun of the hamburger. Do you think the plate was higher or lower in that area?
Student work, Suzanne Reneken, *Hamburger*.

Rubric: Studio Assessment

4	3	2	1
Composition • Arrangement			
Strong composition which addresses complex visual and/or conceptual idea.	Good composition clearly shows intention to convey idea.	Composition is awkward but shows some purpose.	Weak composition which lacks evidence of intent or consideration; haphazard.
Procedures • Building Image			
Exhibits technical excellence; closely followed demonstrated procedures.	Followed demonstrated procedures with few omissions.	Normal use of processes; some mistakes in procedure.	Poor outcome; procedures not followed.
Craftsmanship • Printing			
Excellent, good execution. Crisp edges of images.	Above average printing with slight deficiencies.	Shows some area of skill in a limited area.	Unfinished; poor printing of image.

Career Profile
Sue Coe

English-born Sue Coe studied art at the Chelsea School of Art and the Royal College of Art, in London. She moved to New York after graduation and taught at the School of the Visual Arts. She considers herself a journalist who uses images instead of words. She investigates political events and social injustices and the results of those investigations are printed in newspapers or magazines. They also hang in numerous museums. She is an artist who uses her talent creating images protesting against wars, prejudice, and inequality.

She states: "I got involved with making prints, because it was a way to disseminate my work in an affordable way. At first I found a very elderly gentleman who could do photo etching—he did the plates for supermarket boxes—and he thought it would not make any difference if it was 'art.' Then we got a small table top press for making original etchings, and my friend, who was an all-night cab driver in New York City, read a book about how to make prints, and since then we have made thousands of prints. Now, because I live in the woods, and most of the workers around here are lumberjacks, who give me wood slices, I carve wood blocks and spoon them. I love prints because of the elegance of black and white, and maybe one color, and all you need is wood, ink, and a spoon. Many of my prints are used as fund raisers for different causes, mostly animal rights. The content drives the form in my work, and I am most concerned with propagating ideas and being a visual journalist. Also, I can respond immediately to the daily news, unlike my other works of paintings and drawings that are very labor intensive."

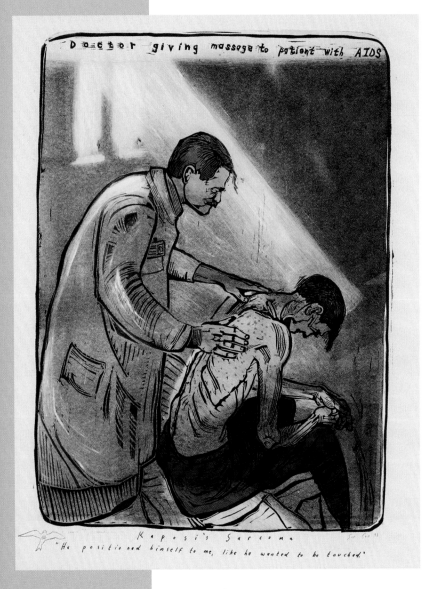

Fig. 9-28. Sue Coe says that printmaking allows her to respond immediately to the daily news. In what ways might the printmaking medium aid an artist's ability to express herself or himself quickly and effectively?
Sue Coe, *Doctor Giving Massage to Patient with AIDS,* from the New Provincetown Print Project, 1993. Linoleum cut and monotype with ink additions from a portfolio of four prints.

Chapter Review

Recall What is embellishment?

Understand Why do artists use more than one type of printmaking in a work of art?

Apply Take one of your prints and embellish it, using colored pencils or markers. Develop the design and make the print into a unique work of art.

Analyze Analyze *Vampire* (Fig. 9-4) by Edvard Munch. What methods were used? How does each method contribute to the feeling expressed in the image? In what ways did the artist use the elements and principles of art to enhance the design?

Synthesize Compare the drawing in Fig. 9-10 with the embellished print in Fig. 9-11. Look at the details in the inked drawing. How do these details show up in the linoleum print?

Evaluate Look at the print by Jim Dine in Fig. 4-3 on p. 71. Look at other prints by this artist. What are some of the subjects used? Why do you think he uses these particular images? Does his use of the same images diminish his work in your eyes?

Fig. 9-4

Writing About Art

Sue Coe describes herself as a "visual journalist." Look at her print on the previous page and write a newspaper article to accompany the image. What ideas do you think Ms. Coe wanted to convey?

For Your Portfolio

When preparing your portfolio, make sure that you have a variety of subject matter in your work—portraits, landscapes, deep space, still life, abstract, etc. It is important to show how versatile you are.

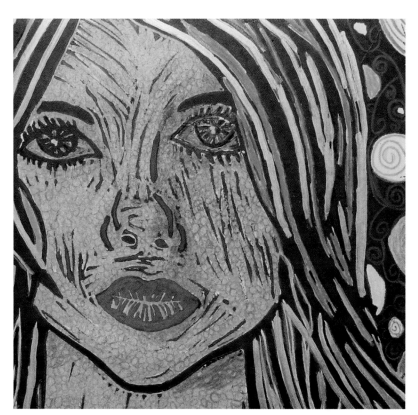

Fig. 9-29. The embellishment on this image was carefully planned. The artist used small circles to create the texture on the face. What other element is repeated in this image? Student work, Julia Zagaya, *Orange Lady*.

Studio Handbook

Safety in the Printmaking Studio

Printmaking requires care and attention to keep you and everyone around you safe. The tools that are used and the chemicals that are needed can sometimes cause problems. General precautions include lung and skin protection. Make sure the art studio is properly ventilated with window fans or several open windows to allow adequate airflow. Use exhaust fans with hoods when working with chemicals. Protect your skin by using disposable gloves when working with inks, solvents, glues, and other media that can irritate your skin.

The following tips are separated by technique.

Relief Printing

Tools Exercise the most caution when using sharp cutting tools. Keep your hands behind the cutting implements. Also, use a bench hook to stabilize the linoleum or wood as it is being cut.

Inks Speedball inks have been used in the classroom for many years and have a great staying power. They are also nontoxic. Water-based inks can be used with great success.

Intaglio Printing

Tools Be careful when you use tools needed for this process. Etching needles are double-ended and very sharp. The edges of metal plates may be sharp and can cause severe damage. Do not brush your hand across the plate when you are creating a drypoint. The burr that is formed on the plate will cut the side of your hand.

Inks Most intaglio inks require solvents to clean the plate after printing. A relatively new intaglio ink which has been used successfully is made by Akua Inks. This ink can be cleaned up by using dish detergent. It is nontoxic and easy to use in the art classroom.

Chemicals If using acid to etch the plate, it is necessary to take precautions. Face masks, goggles, and gloves should be worn to protect the skin and eyes from the chemical. The most common acid used on steel and zinc plates is nitric acid. An acid bath is created with the acid and water. Use caution when sliding the plate into the solution.

Planography

Inks Monotype inks that are nontoxic are available. Lithograph inks usually need solvents for cleanup.

Chemicals Caution should be used when handling the chemicals in lithography. Lithotine is used to wash out the design on the stone. It can also be used for cleanup. Lithotine is a substitute for turpentine.

Silkscreen

Inks Silkscreen inks come in a variety of mixtures. Water-based inks work well on papers, but printing on T-shirts requires something more permanent. Some of these inks contain ammonia, which bonds to the fabric when heat is applied. In the classroom, it is much safer to use water-based products. Speedball has a line of inks that are safe, nontoxic, and highly recommended.

Safe Materials

Select art materials tested and certified by the Art and Creative Materials Institute, Inc. (ACMI). The Institute's AP seal appears on products that "contain no materials in sufficient quantities to be toxic or injurious to humans or to cause acute or chronic health problems." The CL seal is on art materials for adults that are "certified to be properly labeled for any known health risks and are accompanied by information on the safe and proper use of such materials." Keep up with the latest safety advisories through OSHA, the U.S. Department of Labor Occupational Safety and Health Administration, www.osha.gov.

Papers

There are a number of different papers that can be used in printmaking. They range anywhere from the very expensive to copy paper and colored tissue. The method is generally the guide when choosing papers. It would be difficult to print an intaglio, which needs a damp paper, with a paper that falls apart when it is wet. The surface is a factor in the decision. Budget is also a consideration when choosing papers. Some of the less expensive papers work just as well in the classroom. Prints have been done on brown paper towels and still won awards. It's not necessarily *what* it is as *how* it is used.

Here are some papers and the printmaking method they can be used for. Paper prices change and there are often sales where good papers can be obtained for a price that fits in your budget.

- Arches 88—intaglio, lithography, and silkscreen
- Fabriano Rosapina Heavyweight—intaglio, embossing, and silkscreen
- Kozo Lightweight—block printing and chin collé
- Mulberry—block printing, chin collé, lithography, and silkscreen
- Rives BFK Heavyweight—etching, embossing, lithography, and silkscreen
- Somerset Paper (satin, textured, and velvet)—etching, embossing, lithography, and silkscreen
- Molly Hawkins Super Drawing paper—excellent for relief printing and silkscreen
- Molly Hawkins 150lb Tagboard White—silkscreen
- regular copy paper—linoleum prints (This weight works great when making books.)
- colored tissue paper—relief prints (Don't burnish when using this; just lay the tissue on top of the inked plate and then lay newspaper on top before rubbing across the back with your hand. Lift tissue carefully and lay flat to dry.)

As in everything, neatness counts! Whatever paper you choose, be careful to keep it clean while you are printing.

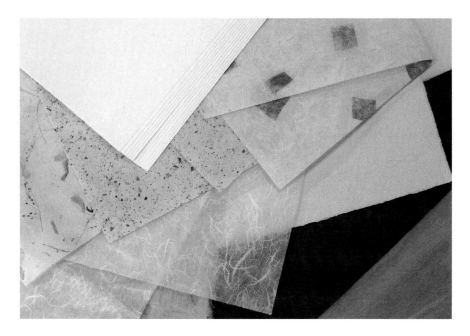

Assorted printing papers. The assortment of printing papers include handmade Japanese papers for relief printing, as well as watermarked Rives for intaglio and embossing and white tagboard for silkscreen.

Printing

The printing process is one of the favorite things for most students. Printing can be accomplished with a press or done by hand. Depending on the technique used, different presses work for different methods. An etching press is the most versatile, because it can be used for relief, intaglio and monotype.

Using an Etching Press

Not everyone has a large etching press, but the smaller presses work just as well. The most important thing to remember on either size press is to have both sides even for even pressure. When moving the blanket between runs, the calibration handles can sometimes shift. Just check and make sure both sides have the same reading so that your print will have even pressure.

Using a Lithography Press

A lithography press is only needed if you are using lithography stones. It has a board that lays on top of the stone and paper. There is a layer of grease on another board and the pressure is applied as the stone/paper/board slide under the pressure point.

This allows the large stone to be printed. Most of the time, you will use paper or plastic lithograph plates and can do your printing with an etching press.

Hand Printing

A press is not always needed to make a print. As you learned in the Stamping Studio and the Pattern Studio, successful prints can be made by inking the plate and pressing it onto the paper. This works better if you are pressing a plate that is smaller than a large linoleum plate, but a large linoleum plate can also be printed by hand. Burnishing is a way of printing by hand. When burnishing a print, you ink the plate as usual and lay the paper on top. Then use a wooden spoon or even a plastic furniture mover to carefully press the paper against the inked plate. It works better if you place another piece of scrap paper between the burnisher and the printing paper so the printing paper won't tear. As you work, carefully lift the edge of the paper to check and see if you are getting a good impression. Is it printing solid? If not, replace the corner of the paper and continue to burnish. Continue with this method until you have covered the entire surface of the plate. When you remove the paper you will have an excellent print, without having used a press.

Different types of Barens. Shown in the picture above are different barens that are available for hand printing. Clockwise, they are a red plastic baren with wooden handle, a wooden spoon, Japanese barens with banana leaves, and a simple furniture mover from a Home Depot or Loews.

Enlarging a Design

To change the scale of an artwork, you make it larger but keep it in the same proportions as the original art.

1. Draw a grid of lines over your art with a ruler. Or, draw a grid on a sheet of acetate and lay that over your artwork.

2. Draw a second pencil grid on a larger sheet of paper. Make squares on this grid proportionally larger than the first grid. For example, to double the size of a drawing, space lines one inch apart in the first grid, but two inches apart in the larger grid.

3. Carefully copy the contents of each square on the small grid into each corresponding square on the larger grid.

Signing a Print Edition

As you've learned, a print is a multiple. As a multiple, each one should look exactly alike. The artist keeps track of the images he or she has made by signing and numbering the prints. The group of prints is called an edition. The edition number looks like a fraction. The number on the bottom is the total number of prints produced. The number at the top is the order in which the prints were made. Hence, 4/20 would be the fourth print out of a total of twenty prints.

At times, you might see other numbers or letters at the bottom of the print. T/P, A/P, or State I are examples of other edition numbers. T/P stands for trial proof. A trial proof is usually done when the artist is experimenting with color or different papers. A/P stands for Artist Proof. An artist proof is done when everything is exactly as the artist intends. The Artist Proof is the final copy for the artist and he may print several before the final run of the edition. State I or II or III occurs when the artist decides to return to the plate and work on it again.

On pages 94 and 95 in the intaglio chapter, you can see examples of two states of a print by Rembrandt. Looking at the second state, you can see where he spent more time working on the surface of the plate. There are more lines and the areas of light and dark have changed somewhat.

After the final edition is complete, it is time to sign the prints. Prints should be signed in pencil. Signing in pencil doesn't take away from the print image and it also doesn't bleed or run. At the bottom of the print, on the left, put the title of your print. In the center, put the edition number. On the bottom right, sign your name. You may also add the year if you like. Be sure to sign close to the bottom edge of the print so that your name will still show when the print is matted.

Storing Your Prints

Keeping your prints in pristine condition is of utmost importance. The way the prints are stored will determine if they stay in good shape. Here are three different ways to protect your prints.

Making a Print Portfolio

When storing your prints, the primary concern is to keep them flat and dry. To do this, it's a good idea to prepare a place where they can be stored. Decide first how large your prints will be. If you usually work with a standard size paper which is not larger than 18" x 24", then you need to add only a few inches to each side of your portfolio to make sure edges of your prints are not damaged. Use either a corrugated cardboard or a heavyweight mat board for your covers. A size of 24" x 30" would give you three inches all around.

tape on both sides

Leave a space of three inches between the long edges of the two boards to make a hinge. Cover the boards with paper. Brown or white bulletin board paper works well; colored papers sometimes bleed. After gluing the boards in place on the paper, wrap the edges of the paper around the boards, as though you were wrapping a present. Another sheet of bulletin board paper can be glued on the inside of the boards. Stack books on top of the boards so they will dry flat. Then you will have a portfolio for storing your prints. Keep in mind this is only for storage. When carrying your prints, it is better to use a purchased portfolio to protect them.

corner detail

Making a Box for Your Artwork

Draw this box pattern on 24" x 36" cardboard. Cut on the solid lines and score the dotted lines. Fold the box together and glue the side flaps.

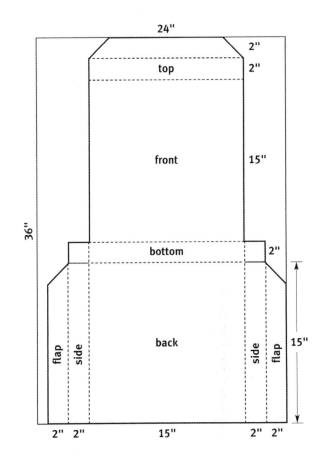

Matting a Print

After your print is complete, its preservation is an important consideration. A mat is the usual choice. The use of a mat serves two purposes: (1) to protect and keep it flat and (2) to create a pleasing presentation of your work. A mat is a frame cut from a thick cardboard called mat board. It is placed around the outside edge of the print image with a hinged backing piece from which the print hangs freely. The print is attached to the backing piece only at the top edge. It is important for the print to hang freely so that it

Backing Sheet

Presentation Mat

A general rule for matting prints is to have the bottom edge of the frame ½" larger than the top and sides. Having the extra room at the bottom is more visually pleasing.

Mat and backing should be the same size and stack together.

Mat and backing sheets hinged together at the top.

remains intact without dents or wrinkles. Paper is very susceptible to variations in humidity, which means the paper can stretch or shrink according to the amount of moisture in the air. If the paper is attached all the way around, it can become damaged when the moisture content changes. Shrinking can cause the print to split or tear, and stretching can cause the print to wrinkle.

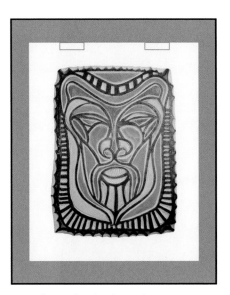

Print hinged to backing sheet

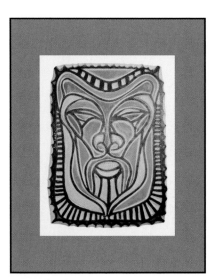

Matted Print

mmusuyidee: good luck

sesa woruban: transformation

Obi Nka Bi: warning against backstabbing

gye nyame: peace

bese saka: sack of cola nuts

Adinkra Symbols

Adinkra (sometimes, andinkra) symbols are small, symbolic pictures used to decorate colorful patterned cloth made by fabric designers in Ghana. Designs are made by cutting patterns into pieces of calabash gourd, then stamping them on fabric with black ink made from iron oxide. The fabric is created in varied colors and patterns, and used in funerals, weddings, and other special occasions. Adinkra cloth is not used for everyday purposes because it cannot be washed.

The name Adinkra comes from the name of a legendary king who was conquered by the Ashante people. According to legend, this king wore luxurious patterned fabrics. Adinkra means "goodbye," and the special cloth was reserved for funeral garments.

Adinkra fabric is now used for a variety of special occasions, and there are dozens of adinkra symbols used to impart a variety of meanings to the finished cloth. Many symbolize virtues, folk tales and proverbs, animals, and even historical events, and most are very old, having been passed down through generations.

Here is an example of the cloth:

Asante People, Adinkra cloth. Stamped cotton.

Printmaking Chop Worksheet

Name_____ Date_____

Chop Design Worksheet

Think about several ways to express an image or symbol that represents you. Consider your interests, your cultural background, or your talents. Do some sketches to decide how you will convey this idea on paper. After you do a number of sketches, choose one or two to develop completely.

Printmaking Chop Record

1	2	3	4
5	6	7	8
9	10	11	12
13	14	15	16
17	18	19	20
21	22	23	24

Names

1.

2.

3.

4.

5.

6.

7.

8.

9.

10.

11.

12.

13.

14.

15.

16.

17.

18.

19.

20.

21.

22.

23.

24.

I Am Poem

1st Stanza

I am *(two special qualities about yourself)*

I wonder *(something you are actually curious about)*

I hear *(sounds you enjoy)*

I see *(your favorite sights)*

I want *(an actual desire)*

I am *(repeat the first line)*

2nd Stanza

I imagine *(a place or situation other than here)*

I feel *(feelings you experience in your daily living)*

I touch *(or influence someone or something)*

I worry *(something that makes you sad)*

I cry *(something that makes you sad)*

I am *(repeat the first line of the poem)*

3rd Stanza

I understand *(something you know is true)*

I say *(something you believe in)*

I dream *(something you hope for)*

I try *(something you really make an effort to do)*

I hope *(something you actually hope for)*

I am *(repeat the first line of the poem)*

adapted from Suzi Mee
Teachers and Writers Collaborative

I AM

by_____

1st Stanza

I am _____

I wonder _____

I hear _____

I see _____

I want _____

I am _____

2nd Stanza

I imagine _____

I feel _____

I touch _____

I worry _____

I cry _____

I am _____

3rd Stanza

I understand _____

I say _____

I dream _____

I try _____

I hope _____

I am _____

Constructing a Process Book

1. Cut one piece of paper 63 inches long and 9 inches high, or tape seven pieces of 9" x 9" paper hinged together. Pages for the book are either folded from one long sheet (butcher paper can be used) or made from individual pages hinged together.

2. Covers should be ½" larger on each side so that ¼" overhangs the page size. Covers are 9½" x 9½". They can be made from chipboard, mat board, or cardboard. Marbleized paper or handmade papers are used to wrap the cover boards.

3. Accordion-fold the papers. Attach a cover board at each end.

4. Attach prints, in order, to the center of each page.

5. Print bookplate and attach on the inside front cover:

When complete, your process book will show everyone how you created your beautiful reduction print.

This is a "process" book.
It demonstrates the steps involved
in creating a multicolored linoleum print.
The print is usually
called a "reduction print" because
the area printed is reduced
each time a new color is added.

Created by:

Title:

Date:

Printmaking Societies and Organizations

There are many printmaking societies and organizations that have web sites that show members' images. To see a diverse group of printmaking images, visit some of the sites listed below. This list is compiled and maintained by McClain's Printmaking Supplies at www.imcclains.com. They also list workshop and artist information.

The American Color Print Society is a non-profit national organization founded in Philadelphia, Pennsylvania, in 1939 for the purposes of exhibiting both color and black and white prints. It is an invitational members organization. Exhibitions in even years are open to nonmembers whose work is juried for admission as well as for prizes. To contact them, go to www.americancolorprint society.org.

The American Print Alliance publishes the magazine *Contemporary Impressions* and a guide to print workshops in the United States and Canada. It is also the umbrella organization for many printmaking groups around the country. You can contact them through their web site http://www.printalliance.org/alliance/al_subscribe.html.

Association of Estonian Printmakers promotes printmaking in that country. As their web site says, "The main meeting place for printmakers is still the printmaking studio opened in 1947. A technician is always there, ready and willing to help, and all kinds of information is traditionally posted on the door. Everything is as it has been—the century old printing press and the scent of printing in the air. Anyone can come and print at any time." So if you would like to visit fellow printmakers in that part of the world, here is the web site with their address: www.estograph.ee/aep.shtml.

Art on Paper publishes a Guide to Print Workshops in its November and March issues that lists print workshops and their services in the United States and abroad. To subscribe to the magazine or order back copies, go to www.art onpaper.com.

Artists in Canada maintains a site with links to Canadian printmakers, suppliers, articles, and other interesting information at www.artistsin canada.com.

Atlanta Printmakers Studio is a new group in Atlanta, Georgia, founded to promote the art of printmaking by offering access to a well-equipped studio and diverse educational programs. To contact them, go to their web site at www.atlantaprintmakers studio.org.

Australian Print Workshop has an annual program of exhibitions and projects, and offers a selection of high quality original limited edition Australian prints for sale online. www.australianprintworkshop.com

Baren Forum is an online, ongoing convention for woodblock printmakers, with an emphasis on moku hanga. Lots of information, regular print exchanges among members, plus a chat room. Check it out at www.barenforum.org/.

Book Arts Classified is the "town square" of the book arts community. In it you will find listings of handcrafted books and equipment for sale, conferences, shows, exhibits, workshops, and much more. On their web site is a directory of people and organizations involved in book arts, including printmakers. Go to www.bookarts.com.

Build Your Own Press is an interesting web site offering plans for building your own etching press. Click on www.dougforsythegallery.com to see the site.

The California Society of Printmakers is the second oldest printmaking society in the United States and the largest. The Society sponsors exhibitions on a local and national level; carries out educational activities; and publishes a journal, *The California Printmaker*. Their web site is www.caprintmakers.org.

The Carving Consortium is the site for a group of people focused on the art of soft block carving and printing with attention to the creative process. You can find them at www.negia.net.

Chicago Printmakers Collaborative was "founded in 1989 to provide Chicago area printmakers with a facility and community to pursue their work." Workshops and private instruction, studio access, lectures, and exhibitions are all offered by the group. For more, go to www.chicagoprint makers.com or call 773-293-2070.

Conrad Machine Company manufactures table top and floor presses and occasionally offers used presses for sale. They also make a monotype press for light pressure applications, such as printing woodcuts and linocuts as well as monotypes. Contact them at 231-893-7455 or through www.con-radmachine.com.

Cork Printmakers in Ireland offers "a professional, open access, fine art print workshop so as to facilitate printmakers and visual artists working through the medium of print. A range of presses, tools, equipment and materials, required to produce a body of work, are available to members." Classes are offered. Contact them through their web site www.corkprint makers.ie/.

CWAJ, or the College Women's Association of Japan, holds a print show and sale every year in Tokyo, Japan. While the prints themselves are sold only at the show, each year a full-color catalog is produced. It is an inspiring reference book of printmaking. CWAJ catalogs can be ordered from Joan Hess, jhess@hei.net.

The Drawing Studio in Portland, Oregon, offers drawing and monotype classes. We understand you can rent the use of their press on an hourly basis. For information and details, contact them through their web site, www.pdxdrawingstudio.com.

Edinburgh Printmakers (Scotland) mission statement says the "Edinburgh Printmakers aims to promote the understanding of printmaking and pursue excellence in its practice by providing, maintaining and staffing an inexpensive open-access studio and free admission gallery." Access to studio space and sign up for workshops can be arranged by going to www.edinburgh-printmakers.co.

Florida Printmakers is a non-profit organization first incorporated by David Hunter in Orlando in 1986; his purpose was to better educate the public on handmade prints. The goal of the Florida Printmakers is to promote the art of printmaking in the state of Florida through exhibitions of the membership, and to attract members from around the world. Interested? Go to www.members.aol.com/flprintmakers.

Greenwich Printmakers in London, England, is a co-op that offers members a permanent display of their work in their own gallery. Guest artists are also shown. For information about current exhibits go to www.greenwich-printmakers.org.

Jobs in the Arts run by NYFA (New York Foundation for the Arts) lists job opportunities available around the country on their web site at www.nyfa.org. They also offer a national directory of awards, funding, services, and other resources for artists in all disciplines.

Journal of the Print World, Inc. is a quarterly newspaper for printmakers and print collectors that lists exhibits and fairs, auctions and sales, antique shops selling prints, and museum and library shows. Reviews of new books and articles on printers and printmaking make this a very useful publication. Contact them by writing to PO Box 978, Meredith, NH 03253-0978.

KIWA (Kyoto International Woodprint Association) holds an international woodblock competition, sponsors exhibits and classes, and has the ultimate purpose of opening a museum for woodblock prints gathered from around the world. For more information, or to join KIWA, go to www.kiwa.net.

Los Angeles Printmaking Society is dedicated to the encouragement of printmaking, devoted to the interest of printmakers, public collection and private collectors of fine prints, and sponsors juried exhibitions. There's a great print at the top of their home page at www.laprintmakers.com.

Maryland Printmakers, Inc. is a member of the American Print Alliance. The organization promotes printmaking to the general public and artists working in the media through sponsorship of juried exhibits, a slide registry, newsletter, lectures, demonstrations and programs. Membership is open to any individual committed to the promotion of printmaking. To find out more please go to www.maryland printmakers.org.

MAPC (Mid America Print Council) membership includes printmakers, papermakers, book artists, students, curators, and collectors from across North America. The organization publishes a journal, sponsors portfolio exchanges, holds exhibits, and runs a biennial conference that is the second largest in the United States. Their web site is homepages.ius.edu/special/mapc/MAPC.html.

Middle Tennessee State University has a great listing of workshops both internationally and here in the United States at www.mtsu.edu/~art/printmaking/workshops.html and a listing of Printmaking Organizations world-wide at www.mtsu.edu/~art/printmaking/organizations.html.

The New Mexico Printmakers sponsors a quarterly field trip or studio tour and one or two annual juried group shows open to submissions from Society members. In addition they run a gallery, Works on Paper, located next door to the Georgia O'Keeffe Museum in Santa Fe. In addition to original hand-pulled prints, the gallery features watercolors, pastels, drawings, mixed media, and other works on paper. Their web site is www.newmexicoprintmakers.com/society.html.

Non-Toxic Print Society promotes the new human health-friendly approach to printmaking. Their goal is to provide exhibition opportunities to those who embrace the new non-toxic methods. For information contact Professor Gloria Maya, Expressive Art Department, Western New Mexico University at mayag@silver.wnmu.edu.

The Northwest Artist Registry accepts submissions periodically for its regional online registry. This curated registry will feature work from artists living in Washington, Oregon, or Idaho. For information, go to www.nwartistregistry.org.

Northwest Print Arts See PAN (Print Arts Northwest)

1000 Woodcuts is woodblock artist Maria Arango's site. You could spend days traveling through the numerous links to other woodblock printmakers, galleries, how-to sites, and much, much more. Go to www.1000woodcuts.com.

Open Bite is an open access print workshop run within the Printmaking Studio at The School of Communication and Contemporary Arts, Edith Cowan University in Australia. The studio is supported by a regular Artist in Residence/Guest Lecture program. The studio also operates a professional print publishing program for artists. www.soca.ecu.edu.au/school/print/openbite/index.html

PAN (Print Arts Northwest) is the gallery for the Northwest Print Council. Their site has information about the organization, a calendar of events, and work by member artists, as well as information about printmaking processes. Every third Thursday of the month, PAN holds a Brown Bag Lunch Art Talk with local printmakers doing demonstrations and talking about their art. For information about PAN, go to their web site, www.printartsnw.org.

Peregrine Press in Portland, Maine, is a co-operative printmaking studio with about 28 members working in a wide variety of printmaking methods, including relief. They also offer workshops. If you are interested in joining or taking a class, you can contact them through www.peregrine-press.com.

Pittsburgh Print Group's purpose is to "support artists who are printmakers through exhibitions, educational projects, and other promotional activities, as well as a commitment to the advancement and promotion of the printmaking art." They are part of the Pittsburgh Center for the Arts, which offers classes in printmaking. More information can be found at www.pittsburghprintgroup.com or www.pittsburgharts.org.

Pressworks is a printmaking co-op in South Seattle that has existed for over twenty years. If you are interested in membership or have any questions, you can contact Laurie at gallo-brown@qwest.net.

Print Australia provides a venue for the promotion of Australian printmaking and assists artists world-wide in exhibiting their work. Check it out at www.acay.com.au/~severn/.

The Print Club of Rochester in New York has been in existence since 1934, and has an unbroken string of commissioned prints and successful shows. They also have educational demonstrations and lectures given by visiting artists. Go to their web site, www.roc-printclub.com.

The Print Council of America is a "professional organization of print specialists with a current membership of over 200 individuals most of whom represent collections of works of art on paper throughout the United States and Canada. While the organization is comprised primarily of museum curators, it also includes university professors, conservators of works on paper, and independent scholars with a strong commitment to the study of prints." Their web site is www.printcouncil.org/index.html.

The Print Council of Australia Inc. is a non-profit visual arts organization that promotes all forms of contemporary prints, artists' books, and paper art through IMPRINT magazine, a print subscription program, collection of Australian prints as well as networking services. www.printcouncil.org

Print Zero Studios, Seattle, Washington, sponsors print exchanges and non-juried exhibitions with work from artists world-wide. www.printzerostudios.com

Printmakers Council, UK "promotes the art of printmaking and the work of contemporary printmakers . . . by organizing a program of exhibitions in London, throughout the Great Britain, and worldwide. These exhibitions show both traditional skills and innovatory printmaking techniques." Exhibits and workshops arranged through the group are listed at www.printmaker.co.uk/pmc/.

Printmakers.Info is a collective linking place for all printmakers of the world to link up and share their common interests and ideas. And it is free! To sign up, go to www.printmakers.info.

The Printmaking Council of New Jersey specializes in promoting the fine art of printmaking. Exhibits, classes and workshops, Scout programs, and birthday parties are among the events they sponsor. Papermaking and darkroom equipment are available as well as a full printmaking studio. Their web site is www.printnj.org.

Printmaking Today is a journal for printmaking practitioners published in England. It offers articles and information on all kinds of printing including a substantial number on relief printmaking. For subscription information and to request a sample copy, go to www.cellopress.co.

Printworks Magazine, an online resource, offers information on national and international workshops, competitions, exhibits, suppliers and much more. www.artmondo.net

Resingrave Get the answers to all your questions about this carving medium used by engravers and intaglio printmakers. Along with a comparison of Resingrave to end-grain wood or metal plates, and a discussion of its engraving characteristics, this site includes a gallery of prints pulled from Resingrave. Go to hometown.aol.com/resinrn/index.htm.

Rostow & Jung, creators of Akua Kolor inks, maintain a list of instructors and workshops around the country that focus on using non-toxic materials for monotype, intaglio, and relief printmaking at www.water basedinks.com/workshops.html.

Seattle Print Arts holds classes; sends out email announcements about exhibits, shows, competitions, supplies for sale, and more; and publishes a newsletter. Lots of great information here! www.seattleprintarts. org

SAGA (Society of American Graphic Artists) in New York City has a membership which practices a full range of printmaking processes. SAGA sponsors national and international exhibitions, demonstrations and symposiums, and issues a newsletter. For more, go to www.clt.astate.edu/Elind/sagamain.htm.

The site for **Solarplates** contains good information about using this plate-making material, troubleshooting tips, plus a schedule of Dan Weldon's classes and workshops. www.solarplate.com

Southern Oregon Printmaking Association is located in Ashland, Oregon. SOPA is a non-toxic printmaking studio which offers facilities, classes, and gallery space in a supportive, working artists' community. Call (541) 488-9466 or email sopa@ashlandhome.net.

The **Southern Graphics Council** advances the professional standing of artists who make original prints, drawings, books, and hand-made paper. Their annual conference is the largest printmaking conference in the United States and draws participants from around the world. Awards, publications, and exhibitions sponsored by the Council promote greater understanding, scholarship, and enjoyment of these art forms. Their web site is www.southerngraphics.org.

If you are looking for a top-of-the-line table top or floor press check out **Takach Press Corporation** in Albuquerque, New Mexico. You can contact them at 800-248-3460 or go to www.takachpress.com.

Want to add words to your art? **The Turtle Press** offers their original, hand-made alphabet stamp sets at reasonable prices. Go to www.turtlearts.com/ alphabets.

The **Washington Print Club** is open to all who are interested in fine art prints and the graphic arts: collectors, connoisseurs, artists, and just plain folks who enjoy prints as an art form. Club programs include tours of exhibitions, private collections and artists' studios in the Washington, D.C. area, a biennial show, panel discussions, and lectures. More information can be found at home.comcast.net/~washington-printclub/wpcsite.html.

To contact **Whelan Press** of Santa Fe, New Mexico, directly, go to www.whelanpress.com.

The Wood Engravers Network is the site for people interested in engraving, whether it is on wood or Resingrave. They host a yearly conference, publish a biennial newsletter, and

sponsor print exchanges. Go to **www.wooden-gravers.net**.

World Printmakers is a web site that serves printmakers by publishing articles about print-making, connecting printmakers and print collectors, listing exhibits and suppliers, and much, much more. You can spend a lot of hours roaming around this site, so beware! **www.worldprintmakers.com**

A Note About Materials in this Book

Most of the materials used to make the prints in this book can be found at your local art supply store.

Silkscreen materials may be harder to find. Ulano is a company that makes Rubylith® film and Sta-Sharp film, which are both good for creating stencils to use in the silkscreen process."

Andrew Saftel, *Water Hemisphere.* Woodcut, collage, monoprint on paper.

Printmaking Timeline

Diamond Sutra, China

Yi Ham, *Collected Works of Yi Munsun*, Korea (moveable metal type, Library of Congress)

9th century Beginning of flowering of Anasazi Pueblo cultures in American west, known for sophisticated basketry and ceramics.

860s Cyril, a Byzantine theologian, learned the Slavic language and devised the Cyrillic alphabet.

868 Death of the author al-lahiz, master of Arabic prose.

13th century Creation of the famous Japanese handscroll illustrating the *Night Attack on the Sanjo Palace.*

1241 End of the Middle Byzantine Period (863–1241), a period during which Islamic art influenced decorative motifs in Byzantine art.

c1250 Zimbabwe's great stone structures are built.

Bohemian School, *Holy Family's Rest on the Flight into Egypt*

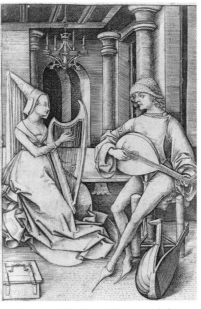

Meckenem, *The Lute Player and the Harpist*

Mantegna, *Madonna and Child*

c1406 Beginning of the period of activity (until 1444) of the great Flemish Renaissance painter Robert Campin.

1410 First publication (in Beijing), of the Tibetan and Mongolian Buddhist canons, the *Kanjur* and the *Tanjur*.

1423 Block printing used to print books in Europe.

1490–1493 Habshi Dynasty (Muslim Ethiopian), rules Bengal in India and builds many mosques and minars.

1490–1494 Albrecht Dürer's wanders years to learn under other artists: the Netherlands, Basel, Colmar, and then Basel again.

1495 First paper mill opens in England.

Dürer, *Knight, Death and the Devil*

Rembrandt, *Abraham's Sacrifice*

Piranesi, *The Giant Wheel*

1501 Italic type used in Europe for the first time.

1513 Niccolò Macchiavelli writes *The Prince*, his ode to a Renaissance dictator.

1513 Swiss artist Urs Graf produces what is possibly the first etching.

1640s First publication in China of the "Mustard-Seed Manual," a woodcut illustrated book meant to be inspiration for painters.

1660 Mezzotint process invented in Germany.

1691 First paper mill opens in the American colonies (Roxborough, PA).

1720-1750 The artist Torii Kiyomasu II, in Japan, produces hand-colored black-and-white woodcuts in the *ukiyo-e* style.

1728 Benjamin Franklin opens a print shop in Philadelphia, from where he issues "Poor Richard's Almanack."

1747 William Hogarth, in England, publishes the satirical series of engravings on virtue and vice entitled "Industry and Idleness."

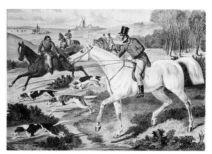

Hokusai, *The Great Wave at Kanagawa*

Currier and Ives, *Fox Hunting*

West, *Angel of Resurrection*

1796 Aloïs Senefelder invents lithography.

1800 Iron printing press invented.

1801 First edition of the *New York Evening Post* published.

1829 Embossed printing invented by Louis Braille.

1830 American poet Emily Dickinson born in Amherst, Mass.

1833 First "penny press" newspaper founded in New York, aided by improved lithography and wood engraving techniques.

1870 Étienne-Jules Marey first experiments with documenting the flight of birds using multiple exposures on a single photographic plate.

1870 Paper is now mass-produced from wood pulp.

1873 Morris and Company begins selling their wallpaper designs in Boston, initiating the Arts and Crafts movement in America.

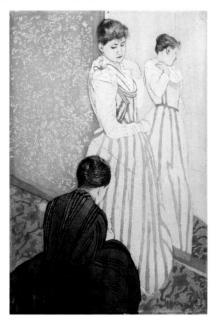

Cassatt, *The Fitting*

Toulouse-Lautrec, *Les Ambassadeurs:
Aristide Bruant*

Gauguin, *Noa Noa*

1890s Many American artists go to France and learn traditional printmaking techniques such as woodcut, etching, engraving, and aquatint.

1890 Mimeograph machine introduced.

1891 Creation of the first of Henri de Toulouse-Lautrec's music hall posters.

1892 Four-color rotary press invented.

1892 Master Mexican printmaker José Guadalupe Posada advertises his services to illustrate books and periodicals in metal, wood, and lithograph.

1892 Death of Tsukioka Yoshitoshi, one of the last of the great Japanese *ukiyo-e* woodblock artists.

1893 World's first movie studio completed by Thomas Edison in West Orange, New Jersey.

1893 World's Columbian Exposition opens in Chicago, exposing Americans to art from around the world, including Japanese *ukiyo-e* woodblock prints.

1893 Publication of "The White House," a collection of photographs of interiors of the executive mansion taken by photographer Frances Benjamin Johnston.

Picasso, *The Frugal Repast*

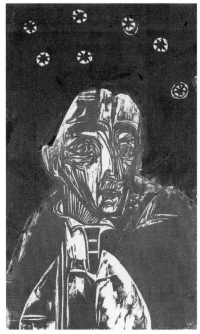

Kirchner, *Woman at Night*

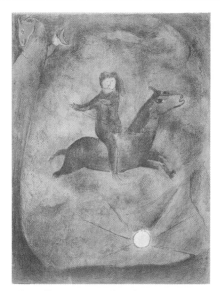

Chagall, *Mounting the Ebony Horse*

1904 Publication of *Japanese Art* by Carl Sadakichi Hartmann, the first book in the U.S. to explore the history of Japanese painting.

1904 Offset lithograph becomes commonplace; the first comic book is published.

1904 The Worcester Art Museum (Mass.) is the first American institution to hold an exhibition showcasing photography as fine art.

1919 In his essay "To All Artists, Poets, Musicians," German Expressionist printmaker Ludwig Meidner urges artists to ally themselves to the working class to achieve inspirational subject matter.

1919 African-American artist Horace Pippin returns from World War I, and hides his sketches of the French countryside and the horrors of the war. He does not take them out for ten years.

1919 First issue of the magazine/manifesto "Der Dada" appears in Germany and questions the validity of modern art at the time (Cubism, Expressionism, and Futurism).

1929 Founding of the Museum of Modern Art in New York.

1930 Alexander Calder visits Piet Mondrian's Paris studio, and the visit confirms his intention to produce art in the abstract.

1930 The master Japanese woodblock artist of the twentieth century, Yoshida Hiroshi, published the first of his famous series "The Inland Sea."

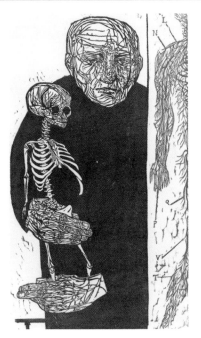

Baskin, *The Anatomist*

Lazzell, *Four Red Petunias*

Yampolsky, Photo of Elizabeth Catlett

1942 Exhibition of the winners from the National War Poster Competition takes place at the Museum of Modern Art, New York.

1945 In April, General Eisenhower inspects a store of stolen artwork hidden by the Nazis in salt mines in Merkers, Germany.

1945 Hopi artist Fred Kabotie receives the Guggenheim Fellowship.

1947 Phototypesetting is made practical.

1946 The first Tupperware is sold in department stores and hardware stores, but sales are not initially successful.

1946 Louis Reard's bikini swimsuit design debuts at Paris fashion show, the first showing of a bikini.

1946 The Philbrook Museum in Tulsa, OK, begins annual juried exhibitions of living Native American artists.

Avery, *The Edge of the Forest*

Bearden, *Slave Ship*

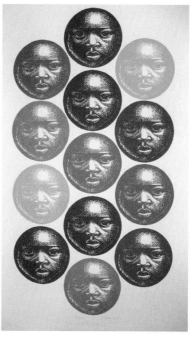

Elizabeth Catlett, *Girls*

1953–1956 Jackson Pollock, most famous of the "action painters" of Abstract Expressionism, returns to brush painting, retreating from his all-over abstract drip paintings.

1955 Edward Steichen's "Family of Man," an exhibit of 503 photographs about children, love, and death, is displayed at The Museum of Modern Art, New York. It becomes a traveling show thereafter for eight years.

1956 Richard Hamilton's collage, *Just what is it that makes today's homes so different, so appealing?* debuts, signaling the beginning of Pop Art.

1977 Xavier Viramontes and other artists create murals in the Mission District of San Francisco based on Star Wars characters.

1977 Greek archeologist Manolis Andronicos discovers the tomb of King Phillip II, father of Alexander the Great, at Vergina in Macedonia.

1977 First showing of *Untitled Film Stills* by photographer Cindy Sherman.

1985 The postmodern Neue Staatsgalerie in Stuttgart, Germany, is finished, based on designs by architect James Stirling.

1985 Although art exhibitions need official approval in China, the "new wave" movement begins where artists band together in groups to show their work unofficially to each other.

1986 Photoshop first written as 24-bit paint system by Thomas and John Knoll, working at Lucasfilm.

Seliger, *Untitled*

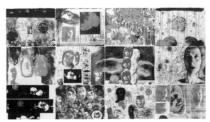

Smith, *Banshee Pearls*

Smith, *Peacock*

1987 The National Museum of Women in the Arts opens in Washington, D.C. Inaugural show: American Women Artists 1830–1930.

1987 Adobe Systems introduces Adobe Illustrator, a PostScript-based personal computer program for artists, designers, and technical illustrators.

1988 First International Symposium on Electronic Arts held in Utrecht, Netherlands.

1990 "The Decade Show" is held in three museums in New York featuring artists, mostly minorities and women, from outside the established "art scene" in the city.

1991 Production of Yoshimasa Morimura's photo series, *Playing with Gods,* in which the artist depicts himself as figures—male and female—from great western masterpieces.

1991 yBa (Young British Artists), video and installation art is on the rise.

1997 A museum dedicated to the late Georgia O'Keeffe is opened in Santa Fe, New Mexico.

1997 A monument to President Franklin Roosevelt, designed by sculptors Leonard Baskin and George Segal, is dedicated in Washington, D.C.

1997 The Sony Mavica digital camera is introduced. It is different from others, because it stores its images on a standard floppy disk that can be popped into a personal computer and printed.

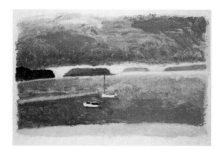

Kahn, *Bay with Boats*

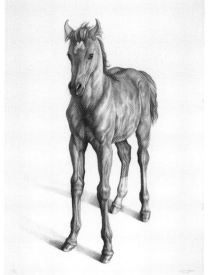

Bravo, *Potro*

1999–2001 "MOMA 2000" is a seventeen-month novel reorganization of the Museum of Modern Art's display of its permanent collection in three phases, each covering a forty-year range.

2000 A traveling retrospective, "Michael Mazur: A Print Retrospective," opened at the MFA in Boston, to which institution the artist donated many works in 2005.

2001 Digital: Printmaking Now exhibition opens at the Brooklyn Museum of Art.

2007 *Garden in Transit*, a public art exhibit of weatherproof painted flowers on New York City taxicabs done by children from schools and hospitals.

2007 Salander/O'Reilly Galleries in New York, one of the world's largest, are forced to close amidst lawsuits and scandals on the eve of a major Caravaggio exhibition.

2007 *Richard Serra: Forty Years,* retrospective of the sculptor's work opens at the Museum of Modern Art, New York.

2008 The Museum of Modern Art in New York held a retrospective of the work of Jasper Johns to celebrate the acquisition of new works on paper by the artist.

2008 Paernu, Estonia, celebrated the 20th anniversary of the Contemporary Music and Printmaking Festival that explores the connection between music and prints.

2008 *Lynda Benglis as Printmaker,* a thirty-year retrospective of her works on paper at the Carl Solway Gallery in Cincinnati.

2008 The de Young Museum in San Francisco held a retrospective of the prints of Martin Puryear to coincide with a retrospective exhibit of his sculpture at the San Francisco Museum of Modern Art.

Glossary

A

abstract art Art stressing the form of its subject rather
than its actual appearance. The subject is broken down into elements: line, shape, etc., not necessarily resembling the subject itself.

aquatint An intaglio technique in which an acid-resistant resin is used to achieve tonal effects. When the plate is dipped into an acid bath, the resin on the plate repels the acid, creating areas of light and dark.

artist proof A proof reserved by the artist for his own record or use, excluded from the numbering of the edition. They are marked A/P for artist proof.

B

baren A slightly convex domed and covered tool of Japanese origin. About 5 inches in diameter, used for burnishing the back of the paper to transfer the ink from the plate without using a press.

bench hook A device used to keep a block from slipping during cutting. It is made by fastening two cleats at opposite ends of a board so it will hook onto the table edge and remain steady.

bevel The filed edge of a stone or plate, at an angle with a sloping edge, so that the press rolls across the plate more smoothly.

blanket Rectangles of woven or pressed surgical felt used between the paper and the roller of an etching press. Usually three blankets are used—the starch catcher next to the paper, the pusher, and the cushion.

bleeded prints Prints in which the printed image extends to the edge of the paper.

body The relative density or viscosity of the ink.

block out In screenprinting, a substance that prevents the ink or paint from penetrating the screen.

blocking out Preventing lines and areas from biting or printing.

brayer A small one-hand roller used for applying ink to various printing surfaces.

bridge In silkscreen or stencil printing, a part that holds the island to the rest of the stencil.

burin A sharp tool with a V-shaped tip used to engrave a line into the surface of a plate.

burnish To rub the back of the paper to create the print, a tool such as a baren is used.

burr In dry point, the ridge of metal thrown up on each side of the linecut by a needle in the plate.

C

charge To cover or roll with printing ink.

Chicago post A metal post which comes in two parts, consists of the screw and base that holds the book together.

chine collé A technique for gluing smaller pieces of paper onto a print while you are printing it. Usually thin papers are attached to a heavier printing paper with this method.

chop An identifying mark or symbol impressed upon the paper, representing a particular artist. It is also used by workshops and printers.

classical The art of ancient Greece produced in the 400s and 300s BCE. Any art form influenced by ancient Greek or Roman examples.

collage Originally a picture made of paste papers, extended to include fabrics and other materials and objects. When heavily three-dimensional objects are included so that the work loses its flatness, it is called an assemblage.

collage print A print with collage elements incorporated by inking them or stamping down or transferring them photographically to the plate or print.

collagraph A print made from a plate composed of other materials—papers, fabric, lace, gesso—that are often glued to a support material such as cardboard or masonite.

colophon An inscription page used with a suite of prints with facts relative to its production: an identifying mark, emblem, or device used by a printer or publisher.

color separations A series or proof of a multicolor print showing each color on a separate sheet.

composition The act of organizing the elements of an artwork into a harmoniously unified whole.

continuity A state of flow between connected visual elements.

contour Line that creates boundaries or closed shapes and space, an outline.

counter proof A print obtained by offsetting a wet proof or print onto a clean dampened sheet of paper.

cross-hatching Shading created by crossed parallel lines.

D

deckle edge The regular untrimmed edge of paper, typical of handmade paper and sometimes produced artificially in commercial papers.

design The plan the artist uses to organize the art elements (line, shape, form, space, etc.) in a work of art to achieve a unified composition.

digital print A print created by digital imaging and printing processes.

direct transfer To transfer image directly from a flat or three-dimensional ink object onto the plate.

drypoint An intaglio process in which the plate is incised with a steel needle or other point. When ink is wiped and the plate printed the burr created by the cut of the needle provides a warm velvety line. It tends to break down in large editions.

E

edition The total number of prints pulled and authenticated by the artist for distribution. The eleventh print in an edition of fifty is numbered as follows 11/50.

elements of art Line, shape, form, color, value, space, and texture. The building blocks the artist works with to create an artwork.

embellishment A method in printmaking in which each print is unique because of added watercolors, pencils, or other additions.

embossing A relief or intaglio print in which the image appears raised from the surface of the paper.

engraving An incising method that utilizes burin and similar push-cutting tools on ingrain woodblock and metal plates. The print from said block or plate.

etching An intaglio process in which an acid resistant ground is applied to a plate, images are cut into the ground with a needle, and acid is applied to bite the image into the plate.

etching needle A blunt rounded steel point used to cut open the ground, when making an image on an etching plate.

extender A white or colorless pigment used in screen printing to add body to the ink and increase coverage.

F

felt side The printing side of paper that reveals a nap on the surface.

found objects Objects other than standard art materials that are incorporated into a workable art in any medium.

frottage Art technique of creating a visual image by transferring textured items to paper by rubbing methods.

G

gouge A tool used for cutting wood and linoleum. The two basic types are the V-gouge and the U-gouge.

H

hatching Shading using closely spaced, parallel lines; used to suggest light and shadow.

hickey An undesirable ink spot with a white halo, usually caused by dirt or skin in the ink.

hue The property of color that distinguishes one gradation from another and gives it its name.

I

impression The ink-transferred image on a piece of printing paper.

ink slab A fairly large piece of plate glass, marble, rigid plastic, etc., on which ink is prepared and rolled.

intagliate The cut or etched lines forming the design on an intaglio plate.

intaglio One of the four major divisions of printmaking in which an image is undercut or bitten by acid into a metal plate. Ink is forced into the lines of the image. The surface of the plate is wiped clean, and the print is made with the pressure of an etching press.

intaglio relief A print made by inking the surface rather than the etched or engraved lines in an intaglio plate.

intuitive The reliance on instincts, whether learned or innate, for natural sensing and feeling rather than a reliance on exact rules.

island In stencil printing, an area in the design like the inner circle of the letter Q that will be cut loose from the stencil, unless it is attached in some way (i.e., by a bridge).

K

kara-zuri A Japanese term for blind embossing; key block or plate—the block or plate that contains the master design with which all other blocks and plates are registered in multicolor printing.

knife A sharp cutting tool of various designs used to cut stencils for silkscreen and lines in woodcuts and linoleum.

L

lift To print properly, fed up being when it transfers properly from the inked stone, plate, or block to the paper.

light fastness Resistant to change caused by exposure to ultraviolet rays colorfast said a gain or paper.

linocut A relief print made from an image cut into a piece of linoleum, also known as linoleum cuts.

linoleum cut A relief print made from an image cut into a piece of battleship linoleum, also known as linocuts.

lithography One of the four major divisions of printmaking in which an image is created by using a greasy substance such as a litho crayon or tusche on a stone, paper, or metal plate. The plate is treated with a chemical, which causes the ink to be attracted to the greasy areas and repelled by the nonprinting areas.

M

make ready Preparation of the plate so that it will print evenly, may be accomplished by pasting layers of paper on the back corresponding to the low areas in the plate that failed to print.

medium (pl. media) The materials, such as oil, watercolor, etc., used to create an artwork; or a category of art such as drawing, painting, or sculpture.

mezzotint A method of creating an intaglio print that creates different tones or values in the print using a tool called a rocker to create a texture on the plate.

mixed media In printmaking, prints made by combining two or more processes—i.e., lithograph intaglio or by combining a print process with a different art form.

monoprint A print pulled from an etching, woodblock, or collagraph plate that has been altered, making it unique. For example, in the case of an edition of etchings printed in black, printing one in red ink would make it a monoprint.

monotype A print pulled from an edition of one from a painted plate that has no permanent markings on it, usually Plexiglas, glass, or metal.

montage The technique of combining in a single composition photographic elements from various sources and collage and frottage fashion.

motif A recurring subject theme idea or visual element in a composition that is the dominant feature.

multiple A work of art in any medium that exists in duplicated examples of which all are considered to be originals.

multiple block printing A printing process which can create an edition of relief prints that contain more than one color. Each part of the design that is a separate color is created on its own separate block.

N

negative An image in which the lines and areas normally or previously printed in black become white and those white become black.

nonobjective art Artworks that have no recognizable subject matter such as figures, flowers, buildings, etc.

O

offset printing A method of commercial printing in which the image is transferred from the plate to the roller of the press and onto the paper, rather than a letterpress printing directly from the plate to the paper.

open In silkscreen printing, a term describing the areas that will receive ink and create the image.

P

photo emulsion A light sensitive coating used in screen printing to fill the screen and get it ready for light exposure using a negative. The image washes out so that it can be printed.

photo silkscreen A method in printmaking that allows artists to use photographic images in their work.

planographic Printing method that transfers an image from the surface of the plate. Lithography and monotypes are forms of this process.

plate A surface made from various materials—including metal, wood, plastic, linoleum, limestone, plaster, cardboard, masonite, etc.—for the reception of an image that can be inked and printed multiple times.

plate mark The imprint of the edges of the plate on a copy of the print.

Pop Art An art style, also known as neo-Dada, developed in the 1950s. Pop artists depicted and satirized popular cultures such as mass-media symbols, comic strips, fast food, billboards, and brand-name products.

principles of design Unity, variety, emphasis, rhythm, movement, balance, pattern, and proportion. The effects that may result when the art elements are structured to achieve a successful composition.

process book A book created to show progressive proofs or the process of creating a multicolor print.

progressive proofs A set of color proofs showing the first color, then the first and second colors, then the first, second and third colors, and so on, with the next color added onto each successive proof.

proof An impression made at any stage of the work from the ink stone, plate, block, or screen. Not a part of an edition of prints. See artist proof, printers proof, cancellation proof.

pull To make a print by transferring the ink to the paper. The pulled edition refers to the entire printed body of prints containing a particular unique image.

R

rainbow printing The printing of several colors rolled simultaneously onto a plate from a single roller and blended together at the edges.

realistic art Artworks that show things just the way they are.

reduction print The most efficient process for making relief prints that contain more than one

color. The linoleum is cut away before the addition of the next color to the print.

register marks Hairline crosses or team marks placed in diagonally opposite margins of the paper as the guide to correct registration.

registration Placement of the paper when printing so that each succeeding color impression is made in the correct relationship to the first one. The print is said to be in register when the colors overlap properly and out of register or off register when they do not.

relief One of the four major divisions of printmaking in which the image is printed from the raised surface of the wood or linoleum block or other material, nonprinting areas have been cut away.

reproduction A copy of an original piece of artwork, such as a painting, that is printed, or reproduced many times by means of a commercial photographic process.

reverse image An image which prints backwards as seen in a mirror.

roller The tool used for applying ink. See also brayer.

rollup To ink a stone or plate.

S

seal Print a blind embossed print.

serigraphy A term originated by Carl Zigrosser for screenprinting as the fine arts process.

silkscreen A wooden frame on which a piece of silk or other meshed material is stretched.

slipped sheet A sheet of paper placed between prints when they are pulled to keep the ink from smudging.

squeegee A tool consisting of a flat wooden bar with a rubber blade used to apply the ink or paint in stencil printing.

state Variations of a basic printed image from the same single or multiple plate or block area, states within an edition are identified by Roman numerals following the title or states after the edition number, such as 1/10 state one.

stencil One of the four major divisions of printmaking in which paint or ink is forced with the squeegee through a silkscreen onto the paper. The non-image areas of the print are blocked out by applying a stencil to the screen; a paper stencil, glue, or other specially prepared products can be used as block out.

stencil knife A tool such as a utility or craft knife used to cut stencils in serigraphy.

struck off Printed the set of prints or an edition.

suite A group of original prints, usually related in theme sometimes issued in a portfolio containing a title page and colophon.

surface rolled Ink rolled on the surface of the plate, as for relief printing, and not in the grooves or cut away areas of the block or plate.

T

tack The pulling power of ink against the surface, stickiness.

tapping in Gently tapping on ink with your finger and then tapping the print with the ink to match the surface area and cover hickeys.

tap out Attests to ink color made by dipping a finger in ink and running it along a piece of paper so that it shows variations from full intensity to light.

tarlatan A stiff cheesecloth-like material used for wiping ink plates, mainly used in intaglio printing.

technique The craft or skill with which one employs particular tools and processes to achieve the desired result.

texture A real or illusionist presentation of tactile surfaces.

tooth The roughness or smoothness of paper.

trace transfer Technique of making a monotype by laying an existing drawing over dry printing paper on top of any smooth surface that has a thin layer of ink, then trace over the drawing lines with pen or pencil. The pressure will transfer ink to the reverse of the printing paper.

transparent base Substance that reduces the opacity of color and improves screening in serigraphy without changing the line correction.

trial proof An early proof of a block, plate, stone, or screen in collaborative work. A stabilized impression pulled by an artisan printer often indicates the artist revisions in color and in drawing.

tushe Grease in liquid or stick form used in making lithographic drawings; also used in serigraphy.

type-high Having the height of type used for letterpress printing 0.018 inches.

U

U-gouge A gouge named for the U-shaped cut it makes.

undercut When cutting a relief print, the area under some of the printed area is cut out causing the printing spot to collapse.

unity The oneness of a complex organic whole were of an interconnected combination of parts, harmonic are chaotic and nature.

V

V-gouge A gouge named for the V-shaped cut it makes.

value The quality of lightness or darkness of color or
neutrals.

veiner A cutting tool for wood or linoleum blocks. It consists of a metal rod with V- or U-shaped cutting tip and a pushing handle.

viscosity The glutinous nature of the high viscosity revert refers to very stiff short term and low viscosity refers to very oily. Long ink refers also to the particular processes of simultaneous color application to deep rich lights.

W

wood engraving A technique of relief printmaking in which a design is cut into the end grain of a wood block. Wood engravings contain more detail than woodcuts.

woodcut A technique of relief printmaking in which a design is cut into a block of plank wood with knives and gouges, leaving raised shapes to receive ink. A print is then made from the block.

working proof A trial proof with additions and corrections indicated on it. It is not part of the edition and is used by the artist or printer for feedback information only.

X

xylography Wood engraving.

Credits

Page 2: Fig. 1-1. Janet Fish, *Tropical Still Life,* 1992. Silk-screen, Edition of 75. Image: 36 x 42"; paper: 41 x 46". Courtesy of John Szoke Editions, NY. Art ©Janet Fish/Licensed by VAGA, New York, NY.

Page 5: Fig. 1-4. Jaune Quick-to-See-Smith, *Cahokia,* 1989. Lithograph, 30 x 22½". Mildred Lane Kemper Art Museum, Washington University in St. Louis. Gift of Island Press (formerly the Washington University School of Art Collaborative Print Workshop), 1989.

Page 6: Fig. 1-5. Albrecht Dürer, *Self-portrait at age 28,* 1500. Oil on wood, 26 x 19" (67 x 49 cm). Bridgeman-Giraudon/Art Resource, NY. Alte Pinakothek, Bayerische Staatsgemaeldesammlungen, Munich, Germany. Fig. 1-6. Kitagawa Utamaro, *Combing Hair,* c. 1800. Color woodcut. Courtesy Chazen Museum of Art, University of Wisconsin-Madison.

Page 7: Fig. 1-7. Albrecht Dürer, *The Rhinoceros,* 1515. Woodcut, 24.8 x 31.7 cm. ©The Trustees of The British Museum/Art Resource, NY.

Page 8: Fig. 1-8. Käthe Kollwitz, *Self-Portrait,* 1923. Woodcut. Collection of the Boston Public Library, Print Department, ©2003 Artists Rights Society (ARS), New York/VG Bild-Kunst, Bonn. Fig. 1-9. Ron Adams, *Blackburn,* 2002. Color lithograph, 63.2 x 88.7 cm. The Cleveland Museum of Art, John L. Severance Fund 2003.34.

Page 9: Fig. 1-10. Sir Eduardo Paolozzi, 7 *Pyramide in form einer achtelskugel,* 1967. Color screenprint. Image: 35 x 24" (88.9 x 60.96 cm); sheet: 40 x 27" (101.6 x 68.58 cm). Minneapolis Institute of Arts, The Herschel V. Jones Fund, by exchange.

Page 10: Fig. 1-11. Silkscreened T-Shirt. Collection of the author.

Page 11: Fig. 1-12. Kate Shepherd, *Baudelaire,* 2007. Aquatint and line etching. Paper: 17½ x 14½"; image: 10 x 9". Edition of 40. Printed by Pace Editions Ink. Printed by Pamplemousse Press. Screenprint. Courtesy of Pace Editions Inc., New York, NY.

Page 12: Fig. 1-14. Eldzier Cortor, *Carnival,* 1960. Woodcut. Library of Congress.

Page 13: Fig. 1-15. Sir Anthony van Dyck, *Lucas Vorsterman,* probably 1626/1641. Etching. Rosenwald Collection. Image courtesy of the Board of Trustees, National Gallery of Art, Washington, DC.

Page 14: Fig. 1-16. Andy Warhol, *Mick Jagger,* from portfolio of 10 screenprints, 1975. Screenprint, 43½ x 29" (110.5 x 73.7 cm). ©The Andy Warhol Foundation for the Visual Arts/ARS NY. Photo: The Andy Warhol Foundation, Inc./Art Resource, NY.

Page16: Fig. 1-18. Frank Stella, *The Butcher Came and Slew the Ox.* Hand colored and collaged with lithographic, linoleum block, and screen printings, 56⅞ x 53⅜" (144.5 x 135.6 cm). Gift of Ann and Robert L. Freedman, 2004-59. Photo by Richard Goodbody, Inc. The Jewish Museum, New York, NY. Photo: The Jewish Museum, New York/Art Resource, NY. ©ARS, NY.

Page17: Fig. 1-20. Hung Liu, *Narcissus 4,* 2007. Mixed media, 62 x 40½ Courtesy of the Nancy Hoffman Gallery, New York, NY.

Page 19: Fig. 1-21. *Ryman National Historical Landmark Ceremony,* 2001. Courtesy of Hatch Show Print and the Country Music Foundation, Inc. Fig. 1-22. *Duke Rayburn announcement,* 2007. Courtesy of Hatch Show Print and the Country Music Foundation, Inc. Courtesy of his parents.

Page 22: Fig. 1-25. Katsuyuki Nishijima, *Dyes in Kyoto.* Woodblock print. Courtesy of the author.

Page 24: Fig. 2-1. Henri Matisse, *Primavera,* 1938. Linocut on gessoed paper. Paper: 9 x 6¾" Courtesy University of Maine Museum of Art. Robert Venn Carr Jr. Collection.

Page 26: Fig. 2-2. *Peonies and Butterfly,* c. 1650. Chinese color print, 25 x 34 cm. Photo: Richard Lambert. Musee des Arts Asiatiques-Guimet, Paris, France. Photo: Réunion des Musées Nationaux/Art Resource, NY.

Page 27: Fig. 2-3. Edgar Degas, *Foret dans la montagne (Forest in the Mountains),* c. 1890. Monotype. Plate: 11⅞ x 15¹³⁄₁₆"; sheet: 12⅜ x 16⁵⁄₁₆". Louise Reinhardt Smith Bequest. The Museum of Modern Art, New York, NY. The Museum of Modern Art/Licensed by SCALA/Art Resource, NY. Fig. 2-4. Elizabeth Murray, *Untitled,* 1982. Screenprint, Composition (irreg.): 48⁷⁄₁₆ x 31¾" (123.3 x 80.6 cm). Sheet (irreg.): 48⁷⁄₁₆ x 31¾" (123 x 80.6 cm). Composition (total, irreg.): 48⁹⁄₁₆ x 31¾" (123.3 x 80.6 cm). Sheet (total, irreg.): 48⁹⁄₁₆ x 31¾" (123.3 x 80.6 cm). Given anonymously. 227.1983a–c. The Museum of Modern Art, New York, NY. ©The Museum of Modern Art/Licensed by SCALA/Art Resource, NY.

Page 30: Fig. 2-7. Rembrandt Harmensz van Rijn, *Six's Bridge,* 1645. Etching, 12.9 x 22.4 cm. Rijksmuseum, Amsterdam, The Netherlands. Courtesy of the Rijksmuseum.

Page 31: Fig. 2-8. Chris Brady, *Type A,* panel 24. Courtesy of the artist. Fig. 2-9. Ed Ruscha, *Your Space #1,* 2006. Sugar lift flat bite with hard ground etching, 25¾ x 29". Edition 30. Published by Crown Point Press. ©Ed Ruscha.

Page 32: Fig. 2-11. Edvard Munch, *The Sick Child,* 1894. Drypoint, roulette and burnisher on copper, 14 x 10½" (36.1 x 27 cm). ©The Munch Museum/The Munch-Ellingsen Group/ARS 2008.

Page: Fig. 2-13. Ed Ruscha, A *Columbian Necklace . . . ,* 2007. Four-color lithograph, 19½ x 15½". Edition of 35. ©2007 Ed Ruscha and Gemini G.E.L. LLC.

Page 35: Fig. 2-16. Margaret Adams Parker, *Winter Shadows,* 2007. Woodcut, 22 x 17". Courtesy of Washington Printmakers Gallery, Washington, DC. Fig. 2-17. Margaret Adams Parker, *Winter Stream,* 2007. Woodcut, 22 x 17". Courtesy of Washington Printmakers Gallery, Washington, DC.

Page 36: Fig. 2-18. Israhel van Meckenem, *Self-Portrait with His Wife, Ida,* ca. 1490. Engraving, 5¼ x 7⁷⁄₁₆" (13.3 x 17.9 cm). Philadelphia Museum of Art: Gift of Suzanne A. Rosenborg, 2002. Photo by Lynn Rosenthal.

Page 37: Fig. 2-19. Loïs Mailou Jones, *A Shady Nook, Le Jardin du Luxembourg, Paris,* 1991. Color screen print. Edition no: Artist's Proof 21/22. Image size: 27⅛ x 32⅜". Courtesy of the Harmon and Harriet Kelley Collection of African American Art.

Page 38: Fig. 2-20. Eldzier Cortor, *Dance Composition #35,* n.d. (early 1990s). One-color aquatint and line etching. Edition no: Artist's Proof. 23⅞ x 21⁵⁄₁₈". Courtesy The Harmon and Harriet Kelley Collection of African American Art. Fig. 2-21. Paula Rego, *Mr. Rochester,* 2002. From *The Guardians,* a suite of nine lithographs. Sheet: 33⅛ x 25", edition of 35. Published by Marlborough Graphics. ©Paula Rego, courtesy Marlborough Gallery, NY.

Page 39: Fig. 2-22. Claes Oldenburg, *Proposal for a Colossal Monument in Downtown New York City: Sharpened Pencil Stub with Broken-off Tip in Front of the Woolworth Building,* 1993. Etching. Paper Size: 32¾ x 22". Printed by Aldo Crommelynck, published by Pace Editions Inc. Courtesy of Pace Editions, Inc., New York, NY.

Page 40: Fig. 2-23. Sybil Andrews, *Racing,* 1934. Linoleum cut, composition: 10⁵⁄₁₆ x 13½" (26.2 x 34.3 cm); sheet (irreg): 11⅞ x 14¹⁵⁄₁₆" (30.2 x 37.9 cm). Publisher and printer: the artist. Edition: 60. Sharon P. Rockefeller Fund and General Print Fund. The Museum of Modern Art, New York. Digital Image ©The Museum of Moder Art/Licensed by SCALA/Art Resource, NY. Art© Estate of Sybil Andrews.

Page 41: Fig. 2-25. Kate Shepherd, *Rondeau,* 2005. Pigmented linen blownout on pigmented linen-cotton base sheet, 15½ x 12½". Edition of 15, published by Dieu Donné. Photo by Nick Knight, image courtesy of Dieu Donné.

Page 42: Fig. 2-26. Henri de Toulouse-Lautrec, *La Troupe de Mlle. Eglantine,* 1896. Photo: Erich Lessing/Art Resource, NY. Musee des Arts Decoratifs, Paris, France.

Page 46: Fig. 2-30. Red Grooms, *Dalí Salad II,* 1980. Print: 23 x 34" x 10" (58.42 x 60.96 x 225.4 cm); image: 26½ x 27½ x 12½" (67.31 x 69.85 x 31.75 cm). Minneapolis Institute of Arts, Vermillion Archival Collection, Gift of funds from The Northern Star Foundation and The Hersey Foundation.

Page 48: Fig. 3-1. Elizabeth Catlett, *Sharecropper,* 1952, published 1968–70. Linoleum cut, composition: 17⅝ x 16¹⁵⁄₁₆" (44.8 x 43 cm); sheet: 18½ x 18¹⁵⁄₁₆" (47 x 48.1 cm). Publisher: the artist, Mexico City and taller de Gráfica Popular, Mexico city. Printer: the artist, Mexico City and José Sanchez, Mexico City. Edition: A.P. before edition of 60. The Ralph E. Shikes Fund and Purchase. The Museum of Modern Art, New York. Digital Image ©The Museum of Modern Art/Licensed by SCALA/Art Resource, NY. Art ©Elizabeth Catlett/Licensed by VAGA, New York, NY.

Page 50: Fig. 3-3. Olowe of Ise, *Doors from palace at Ikere-Ekita.* Central panel depicts the reception by the king (Ogoga of Ikere) of Captain Ambrose, 1st British official to visit the area in 1895. Carved wood. Yoruba, late 19th c., Nigeria. British Museum, London, Great Britain. Photo: Werner Forman/Art Resource, NY.

Page 51: Fig. 3-4. *Vaishravana with attendants,* from Cave 17, Mageo, near Dunhuang, Gansu province, China, Five Dynasties, 947 CE. Woodblock print on paper, 40 x 26.5 cm. Gift of Sir Mark Aurel Stein, Inv: asia OA 1919.1-1.0245. One of the earliest dated examples of printing. ©The Trustees of the British Museum/Art Resource, NY. Fig. 3-5. Ozeki Konishiki, *Tegata Sumo Japan Wrestling.* Tegata handprint. Courtesy Gallery Ryogoku 603.

Page 52: Fig. 3-7. Vija Celmins, *Ocean Surface Woodcut,* 1992. Woodcut, composition: 8¾ x 11¹⁵⁄₁₆" (22.3 x 30.4 cm); sheet: 19⁹⁄₁₆ x 15⁷⁄₁₆" (49 x 39.2 cm). Johanna and Leslie J. Garfield Fund. The Museum of Modern Art, New York. Fig. 3-8. Mary Azarian, *Haying.* Woodcut, 10½ x 15". Limited edition 150. ©Mary Azarian, Farmhouse Press.

Page 53: Fig. 3-9. Albrecht Dürer, *Four Horsemen of the Apocalypse,* c. 1497–98. Woodcut, 40 x 28.8 cm. ©The Cleveland Museum of Art. Gift of the Print Club of Cleveland 1932.313. 54.

Page 55: Fig. 3-12. Lucas Cranach the Elder, *St. Christopher,* 1509. Chiaroscuro woodcut. ©The Cleveland Museum of Art. Gift of The Print Club of Cleveland 1928.633. Fig. 3-13. Thomas Bewick, *A Hound,* from "History of British Birds and Quadrupeds." Engraving. Private Collection/The Bridgeman Art Library International.

Page 56: Fig. 3-15. Pablo Picasso, *Young Pigeon,* 1939. Linocut. Fred Jones Jr. Museum of Art, University of Oklahoma, USA/©DACS/Richard H. and Adeline J. Fleischaker Collection, 1996/The Bridgeman Art Library International.

Page 57: Fig. 3-17. Samella Lewis, *I See You,* 2005. Linocut. Scripps College, Samella Lewis Collection of Contemporary Art. Gift of Samella Lewis. Image courtesy Scripps College. Art ©Samella Lewis/Licensed by VAGA, New York, NY. Fig. 3-18. Sareya Sedky, *Egyptian Mother and Child.* Linocut. Courtesy of the artist.

Page 58: Fig. 3-19. Margaret Taylor Burroughs, *Youth,* 1953. Linoleum cut. Image size: 12 x 10¾", framed: 21 x 19½." Courtesy of the Harmon and Harriet Kelley Collection of African American Art.

Page 62: Fig. 3-22. Karl Schmidt-Rottluff, *Mother (Mutter),* from the portfolio *Ten Woodcuts,* 1916 (published 1919). One from a portfolio of ten woodcuts; composition: 14⁹⁄₁₆ x 12⅛"; sheet: 24⁷⁄₁₆ x 19¹³⁄₁₆" Publisher: J. B. Neumann. Printer: Fritz Voigt. Edition: 75. Digital Image ©The Museum of Modern Art/Licensed by SCALA/Art Resource, NY.

Page 63: Fig. 3-23. Leonard Baskin, *View of Worchester,* 1953. Wood engraving, 10 x 8½". Collection of Eastern Michigan University Art Department.

Page 66: Fig. 3-26. Mary Azarian, *Round Bales.* Woodcut, 9½ x 11¾". Limited edition 200. ©Mary Azarian, Farmhouse Press.

Page 68: Fig. 4-1. Helen Frankenthaler, *Savage Breeze,* 1974. Woodcut, printed in color on cream and brown pink, smooth, laid handmade Nepalese paper (laminated). Composition: 29⅝ x 25" (75.3 x 63.3 cm); sheet: 31½ x 27¼" (80 x 69.2 cm). Digital Image ©The Museum of Modern Art, NY/Licensed by SCALA/Art Resource, NY. The Museum of Modern Art, New York.

Page 70: Fig. 4-2. *Hartlib's Alexander: Alexander Seated on Throne.* Germany, 15th century. Woodcut. The Cleveland Museum of Art. 1928.763.

Page 71: Fig. 4-3. Jim Dine, *The Woodcut Bathrobe,* 1975. Woodcut and lithograph. Composition: 33¹¹⁄₁₆ x 24⅝"; sheet: 36⁵⁄₁₆ x 24⅝". Edition: 80. Publisher: Petersburg Press Inc., New York. Printer: Graphicstudio, University of South Florida, Tampa. Gift of Gordon and Llura Gund. (245.1991). The Museum of Modern Art, New York. Digital Image ©The Museum of Modern Art/Licensed by SCALA/Art Resource, NY.

Page 72: Fig. 4-5. Francesco Clemente, *Untitled (Self Portrait),* 1984. Color woodcut print on Tosa Kozo paper. Inv. E.427-1985. Victoria and Albert Museum, London, Great Britain. Photo: Victoria & Albert Museum, London/Art Resource, NY. Fig. 4-6. Katsushika Hokusai, *South Wind, Clear Sky (Gaifu kaisei) (Red Fuji),* from the series "Thirty-Six Views of Mt. Fuji" (Fugaku sanju-rokkei). Color woodblock print. ©The Trustees of the British Museum/Art Resource, NY.

Page 73: Fig. 4-7. Suzuki Harunobu, *Drying Clothes,* c. 1767–68. Color woodcut, 10⅞ x 8⅛" (27.6 x 20.6 cm). Philadelphia Museum of Art: Gift of Vera White, 1955. Photo by Lynn Rosenthal.

Page 74: Fig. 4-8. Elizabeth Catlett, *Sharecropper,* 1952. Color linocut on cream Japanese paper, 450 x 431 mm (block); 544 x 513 mm (sheet). Restricted gift of Mr. And Mrs. Robert S. Hartman, 1992.182. Reproduction, The Art Institute of Chicago. Art ©Elizabeth Catlett/Licensed by VAGA, New York, NY. Fig. 4-10. Milton Avery, *Birds and Sea,* 1955. Woodcut on paper, 9⅝ x 24" (24.6 x 60.9 cm). Photo: Smithsonian American Art Museum, Washington, DC/Art Resource, NY.

Page 75: Fig. 4-11. Sol LeWitt, *Distorted Cubes (B)* from "Distorted Cubes (A-E)," 2001. Linoleum cut. Composition: 28⅜ x 35⅞" (72 x 91.1 cm); sheet: 34¹³⁄₁₆ x 42⅜" (88.5 x 107.7 cm). Publisher: Pace Editions, Inc., New York. Printer: Watanabe Studio, Brooklyn, NY. Edition 50, Virginia Cowles Schroth Fund. the Museum of Modern Art, New York. Fig. 4-12. Ethel Spowers, *Birds Following a Plough,* 1933. Linocut. Private Collection ©The Fine Art Society, London, UK/The Bridgeman Art Library International. Fig. 4-13. Pablo Picasso, *Nature Morte au verre sous la lampe (Still Life with Glass under the Lamp),* 1962. Linoleum cut, printed in color. Plate: 20⅞ x 25⁵⁄₁₆"; sheet: 24½ x 29⅝". Gift of Mrs. Donald B. Straus. The Museum of Modern Art, New York.

Page 79: Fig. 4-16. Stephen Alcorn, *Isabella Bird, Rockie Mountain Explorer,* 1991. Relief-block print (reduction print), 14 x 20"; image, 17 ½ x 23". ©The Alcorn Studio & Gallery.

Page 82: Fig. 4-19. Elizabeth Catlett, *Malcolm X Speaks for Us,* 1969. Linoleum cut. Composition: 34¹³⁄₁₆ x 27³⁄₁₆" (88.4 x 69.1 cm); sheet: 41⁷⁄₁₆ x 30¹⁄₁₆" (104 x 77.9 cm). Publisher and printer: the artist, Mexico City. Edition: 40; plus X A.P. Gift of the Artist. The Museum of Modern Art, New York. Digital Image ©The Museum of Modern Art/Licensed by SCALA/Art Resource, NY. Art ©Elizabeth Catlett/Licensed by VAGA, New York, NY. Photo of the artist: Mariana Yampolsky, *Portrait of Elizabeth Catlett (La escultora Elizabeth Catlett, Cudad de México),* 1959. National Portrait Gallery, Smithsonian Institution/Art Resource, NY. ©Fundación Cultural Mariani Yampolsky, A.C. México.

Page 84: Fig. 5-1. Chuck Close, *Keith,* 1972. Mezzotint and roulette; printed in black; plate: 44¹¹⁄₁₆ x 35⁵⁄₁₆"; sheet: 50¹⁵⁄₁₆ x 41¹³⁄₁₆". John B. Turner Fund. Digital Image ©The Museum of Modern Art/Licensed by SCALA/Art Resource, NY.

Page 86: Fig. 5-3. Lucas van Leyden, *Christ Presented to the People,* 1510. Copperplate engraving, 28.8 x 45.2 cm ©The Trustees of the British Museum.

Page 87: Fig. 5-4. Käthe Kollwitz, *The Outbreak (Losbruch),* 1903. Etching, 50.7 x 59.2 cm. Photo: Joerg P. Anders. Photo: Bildarchiv Preussischer Kulturbesitz/Art Resource, NY. Kupferstichkabinett, Staaliche Museen zu Berlin. Fig. 5-5. Dürer, Albrecht, *Women's caps.* Engraving. Musee des Arts Decoratifs, Paris, France. Photo: Snark/Art Resource, NY.

Page 88: Fig. 5-6. Pablo Picasso, *Portrait of Fernande Olivier.* Drypoint, 16.2 x 11.8 cm. Worcester Art Museum, Worcester, MA, Sarah C. Garver Funds and Anonymous Gifts.

Page 89: Fig. 5-9. Damien Hirst, *Global-a-go-go for Joe* from "In a Spin, the Action of the World on Things," Volume 1, 2002. One from a portfolio of 23 etchings, aquatints, and drypoints. Sheet: 35⅞ x 27½" (91.2 x 69.9 cm). The Paragon Press, London. Hope (Sufferance) Press, London. The Associates Fund. (171.2003.8). The Museum of Modern Art, New York, NY. Digital Image ©The Museum of Modern Art/Licensed by SCALA/Art Resource, NY. Fig. 5-9. Albrecht Dürer, *Melancholia*, 1514. Engraving. Inv. B.74-II. Photo: Joerg P. Anders. Kupferstichkabinett, Staatliche Museen zu Berlin, Berlin, Germany. Photo: Bildarchiv Preussischer Kulturbesitz/Art Resource, NY.

Page 90: Fig. 5-10. Edward Savage, *Liberty, in the Form of the Goddess of Youth: Giving Support to the Bald Eagle.* Stipple engraving on cream laid paper, 24¼ x 14⅒" (62 x 37.9 cm). Worcester Art Museum, Worcester, MA. Gift of Mrs. Kingsmill Marrs. Fig. 5-11. Louise Bourgeois, *Spiraling Arrows,* 2004. Engraving on paper. 18 x 24" (45.7 x 60.9 cm). Courtesy Harlan & Weaver, New York. Photo: James Dee. Art ©Louise Bourgeois/Licensed by VAGA, New York. Fig. 5-12. Louise Bourgeois, *M is for Mother,* 2003. Drypoint on paper. 15 x 17" (38.1 x 43.1 cm). Courtesy Harlan & Weaver, New York. Photo: Christopher Burke. Art ©Louise Bourgeois/Licensed by VAGA, New York, NY.

Page 92: Fig. 5-14. Giorgio Morandi, *Il Poggio al mattino (Hillside in the Morning),* 1928, probably printed in the early 1940s. Etching. Plate: 9⅝ x 9¾" (24.5 x 24.8 cm); sheet: 13½ x 17" (34.5 x 43.3 cm). Digital image ©The Museum of Modern Art/Licensed by SCALA/Art Resource, NY.

Page 93: Fig. 5-15. Rembrandt Harmensz van Rijn, *St. Jerome in a Hilly Landscape,* c. 1653. Etching and drypoint, in part sulphur etching on Japanese paper, 25.9 x 21 cm. Photo: Foto Marburg/Art Resource, NY.

Page 94: Fig. 5-16. Rembrandt Harmensz van Rijn, *Self Portrait: Rembrandt drawing,* c. 1648; 1st state. Etching, retouched with dry point, 16.1 x 13 cm. Photo: Gérard Blot. Photo: Réunion des Musées Nationausx/Art Resource, NY. Louvre, Paris, France.

Page 95: Fig. 5-17. Rembrandt Harmensz van Rijn, *Self Portrait at a Window.* Etching and drypoint. Photo: Art Resource, NY. Fig. 5-18. Dox Thrash, *Abraham,* c. 1937. Etching and drypoint, image size: 4⅞ x 4"; framed: 15½ x 13½". Image courtesy the Harmon and Harriet Kelley Collection of African American Art.

Page 96: Fig. 5-19. Francisco de Goya y Lucientes, *El sueño de la razon produce monstruos (The Sleep of Reason Produces Monsters),* first published in 1799. Plate 43 from the series "Los Caprichos." Etching, 21.4 x 15.1 cm. ©The Trustees of the British Museum/Art Resource.

Page 97: Fig. 5-21. Jim Dodson, *Faded Glory,* 1984. Etching. Courtesy of the artist. Fig. 5-22 Susan Rothenberg, *Boneman,* 1986. Mezzotint, printed in color. Sheet: 30 x 20⅛"; plate: 23⅞ x 20⅛". John B. Turner Fund. The Museum of Modern Art, New York. Fig. 5-23. Philibert Louis Debu-

court, *La Promenade Publique.* Mezzotint, aquatint, etching and engraving with roulette, 35.5 x 58.4 cm. Worcester Art Museum, Worcester, MA. Gift of Mrs. Kingsmill Marrs.

Page 98: Fig. 5-24. Carol Wax, *The Oliver,* 2004. Color mezzotint engraving, printed from three plates, 18 x 18" (45.7 x 45.7 cm). Courtesy of the artist. Fig. 5-26. David Crown, *Trio of Pears,* 2002. Four-plate color mezzotint, 9 x 12". Courtesy of the artist.

Page 99: Fig. 5-26. Mary Cassatt, *Portrait of the Artist,* 1878. Gouache on wove paper laid down to buff-colored wood-pulp paper: 23⅝ x 16¹³⁄₁₆" (60.1 x 41.2 cm). The Metropolitan Museum of Art, Bequest of Edith H. Proskauer, 1975 (1975.319.1) Image ©The Metropolitan Museum of Art. Fig. 5-27. Mary Cassatt, *The Letter.* Color drypoint and aquatint on cream laid paper, 34.5 x 22.7 cm. Worcester Art Museum, Worcester, MA. Bequest of Mrs. Kingsmill Marrs.

Page 102: Fig. 5-29. Trenton Doyle Hancock, *Harmony from the Ossified Theosophied,* 2005. One from a portfolio of eight etchings and aquatints. Plate: 11¹⁵⁄₁₆ x 17¹⁵⁄₁₆" (30.3 x 45.6 cm); sheet: 19½ x 25" (49.5 x 63.5 cm). Publisher: James Cohan Gallery, New York and Dunn & Brown Contemporary, Dallas. Printer: Harlan & Weaver, New York. Edition: 35. Maud and Jeffrey Welees Fund. The Museum of Modern Art, New York. Photo of artist: Art:21—Art in the Twenty-First Century. Production still of Trenton Doyle Hancock 2003. ©Art21, Inc. 2003.

Page 104: Fig. 6-1. Red Grooms, *Deli,* 2004. Color 3-D lithograph, 29⅜ x 28 x 9¾". Edition of 50.

Page 106: Fig. 6-3. James Rosenquist, *Light-catcher,* 2005. Lithograph in 10 colors. 37½ x 37½". Edition of 48. Published by Universal Limited Art Editions. Art ©James Rosenquist/ULAE 2005/Licensed by VAGA, New York, NY.

Page 107: Fig. 6-6. Käthe Kollwitz, *Self-Portrait.* Print. ©Copyright ARS, NY. Photo: Art Resource, NY.

Page 108: Fig. 6-7. Lorenzo Quaglio, *Portrait of Senefelder,* 1818. Lithograph on paper, printed from two stones, 284 x 228 mm (image), 520 x 366 mm (sheet). Restricted gifts of Katherine Kuh, Mr. and Mrs. Edwin Eisendrath, Arthur Meeker, D.T. Bergen, Mr. and Mrs. Charles C. Cunningham and the Print and Drawing Club. 1966.360. Reproduction, The Art Institute of Chicago. Fig. 6-8. Théodore Géricault, *The Flemish Farrier,* 1821. Lithograph ink on paper. ©The Trustees of the British Museum.

Page 109: Fig. 6-9. Cesare della Chiesa di Benevello, *Spontaneous Combustion of a Forest near Colterra in 1829* (detail). Lithograph: crayon and brush with spatter and scraping, 46 x 38.5 cm (18⅛ x 15³⁄₁₆"); Legacy dimension: 18⅛ x 15⅛". Museum of Fine Arts, Boston. Katherine E. Bullard Fund in memory of Francis Bullard, 1995.213. Fig. 6-10. Cesare della Chiesa di Benevello, *Spontaneous Combustion of a Forest near Colterra in 1829.* Lithograph: crayon and brush with spatter and scraping, 46 x 38.5 cm (18⅛ x 15³⁄₁₆"); Legacy dimension: 18⅛ x 15⅛". Museum of Fine Arts, Boston. Katherine E. Bullard Fund in memory of Francis Bullard, 1995.213.

Page 110: Fig. 6-11. William Blake, "Little Lamb who made thee . . ." *Songs of Innocence.* Lithograph. Private Collection. Photo: Fine Art Photographic Library, London/Art Resource, NY. Fig. 6-12. Eugène Delacroix, *Faust and Mephistopheles Galloping on the Night of the Witches' Sabbath,* 1826–27. Crayon lithograph with scraping, on thin paper mounted during printing. Early proof with marginal lithographic sketches, sheet: 32 x 48 cm (12⅝ x 18⅞"). Museum of Fine Arts, Boston. Lee M. Friedman Fund, 63.1012.

Page 111: Fig. 6-13. Joshua Cristall, *Apollo and the Muses,* 1816. Pen lithograph, image: 30.8 x 45.4 cm (12⅛ x 17⅞"), sheet: 34.9 x 54.6 cm (13¾ x 21½"). Museum of Fine Arts, Boston. Lee M. Friedman Fund, 1983.506. Fig. 6-14. David Gamble, *Ysolina,* 1996. Lithograph. Courtesy of the artist.

Page 113: Fig. 6-15. Jean Louis André Théodore Gericault, *The Sleeping Fish Merchant,* 1820. Pen lithograph, printed on stone paper, sheet: 27 x 42 cm (10⅝ x 16⁹⁄₁₆"). Museum of Fine Arts, Boston. Frederick Keppel Memorial Bequest, 1913. M23502. Fig. 6-16: Jean Baptiste Chometon, *The Artist's Mother and Sister,* 1819. Crayon lithograph, sheet: 31.5 x 24.3 cm (12⅜ x 9⁹⁄₁₆ in.). Museum of Fine Arts, Boston. Gift of W.G. Russell Allen, 38.303.

Page 114: Fig. 6-17. Erich Heckel, *Dancers,* 1911. Lithograph, comp: 9¾ x 7⅜". Publisher: unpublished. Printer: the artist, Dresden. Edition: fewer than 10. Gift of Victor S. Riesenfeld, 1948. The Museum of Modern Art, New York. Digital Image ©The Museum of Modern Art/Licensed by SCALA/Art Resource, NY.

Page 116: Fig. 6-21. Elizabeth Catlett, *Black Girl,* 2004. Lithograph, 18 x 12⅜". Image courtesy M. Lee Stone Fine Art Prints. Art ©Elizabeth Catlett/Licensed by VAGA, New York, NY. Fig. 6-22. Francisco de Goya, *Dibersion de Espana (Spanish Entertainment),* from "Bulls of Bordeaux," 1825. Lithograph on wove paper (edition impression printed by Gaulon in Bordeaux in 1825). Gift of W.G. Russell Allen, image courtesy of the Board of Trustees, National Gallery of Art, Washington, DC.

Page 117: Fig. 6-23. Charles White, *Hasty B,* 1970. Lithograph, 21 x 27" (53.4 x 68.6 cm). Photo: Smithsonian American Art Museum, Washington, DC/Art Resource, NY.

Page 118: Fig. 6-25. Grafton Tyler Brown, *Map of Comstock Lodes Extending Down Gold Cañon, Storey Co. Nevada,* 1868. Paper, lithography ink, 9 x 18." Collection of California African American Foundation. Courtesy of the California African American Museum.

Page 119: Fig. 6-26. Grafton Tyler Brown, "Willow Glen Ranchero," *Residence of T.W. Moore, Pescadero, San Mateo County, California,* c. 1800s. Lithograph with hand-coloring. Image size: 12¼ x 26¼". Image courtesy the Harmon and Harriet Kelley Collection of African American Art.

Page 120: Fig. 6-28. Luis Jimenez, *Howl,* 1977. Color lithograph on paper. Smithsonian American Art Museum, Washington, DC.

Page 121: Fig. 6-29. Emmi Whitehorse, *Jackstraw.* Lithograph on white Thai mulberry paper. Image courtesy the artist and Chiaroscuro Contemporary Art.

Page 122: Fig. 6-31. John Woodrow Wilson, *Elevated Streetcar Scene,* 1945. Lithograph, Sheet: 14⅛ x 17⅜" (35.9 x 44.1 cm). Image: 11¼ x 14¾" (38.6 x 37.5 cm). The Metropolitan Museum of Art, Gift of Reba and Dave Williams, 1999. (1999.529.198). Image ©The Metropolitan Museum of Art. Art ©John Wilson/Licensed by VAGA, New York, NY. Fig. 6-32. George Bellows, *Dempsey and Firpo,* 1924. Lithograph, 18⅛ x 22⅜". Abby Aldrich Rockefeller Fund, 1951. Digital image ©The Museum of Modern Art/Licensed by SCALA/Art Resource, NY.

Page 123: Fig. 6-33. Romare Bearden, *Louisiana Serenade,* from the "Jazz Series," 1979. Color lithograph on cream wove paper, 62 x 86 cm. Edition 4 of 10. Brooklyn Museum of Art, Brooklyn, NY. Art ©Romare Bearden Foundation/Licensed by VAGA, New York, NY.

Page 124: Fig. 6-34. David Gamble, *Terra de Mer,* 1995. Hand-colored lithograph in five colors. Courtesy of the artist.

Page 125: Fig. 6-35. Robert Rauschenberg, *Breakthrough II,* 1965. Lithograph. Composition (irreg.): 44 x 31⅛" (111.8 x 78.9 cm); sheet: 48½ x 34⅛" (123.2 x 86.6 cm). Edition: 34. Gift of the Celeste and Armand Bartos Foundation. Art ©Estate of Robert Rauschenburg and U.L.A.E/Licensed by VAGA, New York, NY. Published by U.L.A.E.

Page 126: Fig. 6-37. Edvard Munch, *Geschrei (The Scream),* 1895. Lithograph. Sheet: 48.3 x 38.8 cm (19 x 15¼"). Rosenwald Collection. Image courtesy the Board of Trustees, National Gallery of Art, Washington, DC.

Page 130: Fig. 6-39. Beauvais Lyons, *Planche X.* Lithograph. Courtesy of the artist. Photo by Shaurya Kumar.

Page 132: Fig. 7-1. Blanche Lazzell, *Petunias II,* 1922. Color monotype, 35.5 x 30.5 cm (14 x 12"). Smithsonian American Art Museum.

Page 134: Fig. 7-2. Romare Bearden, *Zach Whyte's Beau Brummel Band,* 1980. Oil monotype with paint on paper. Garth Fagan. ©Romare Bearden Foundation/Licensed by VAGA, New York, NY. Fig. 7-3. Jules Olitski, *After the Fire,* 2004. Monotype print on rag paper, 14¾ x 14⅞". Courtesy of Jules Olitski Warehouse, Marlboro, VT. Art ©Estate of Jules Olitski/Licensed by VAGA, New York, NY.

Page 135: Fig. 7-4. Maurice Prendergast, *Six Sketches of Ladies,* 1891–94. Color monotype and pencil printed on buff-colored Japan paper, 15 x 11¹⁄₁₆" (395 x 281 mm). With a pencil sketch of similar lady at upper right. Signed with the monogram in the plate, once in each upper subject. Clark/Mathews/Owens 1583. Private Collection.

Page 136: Fig. 7-6. William Blake, *Newton,* 1795/c. 1805. Color print finished in ink and watercolor on paper, 46 x 60 cm. Photo: Tate, London/Art Resource, NY. Tate Gallery, London. Fig. 7-7. Edgar Degas, *Landscape with*

Rocks, 1892. Pastel over monotype in oil colors, 10⅛ x 13³⁄₁₆" (25.7 x 34.4 cm). High Museum of Art, Atlanta; Purchased with High Museum of Art Enhancement Fund, 2000.20.

Page 137: Fig. 7-8. Maurice Prendergast, *Orange Market,* 1900. Monotype, printed in color. Compostition: 12⁷⁄₁₆ x 9⅛"; sheet: 15¹⁵⁄₁₆ x 11." Abby Aldrich Rockefeller Fund. Digital Image ©The Museum of Modern Art/Licensed by SCALA/Art Resource, NY.

Page 142: Fig. 7-12. Edgar Degas, *Dancer,* 1878–80. Monotype. Platemark: 27.9 x 23.4 cm (11 x 9³⁄₁₆"); sheet: no margins. Museum of Fine Arts, Boston. Helen and Alice Colburn Fund, 56.109. Fig. 7-13. Edgar Degas, *The Path Up The Hill,* 1877–79. Monotype, platemark: 11.9 x 16.1 cm (4¹¹⁄₁₆ x 6⅜"); sheet: 14.8 x 18.1 cm (5¹³⁄₁₆ x 7⅛"); mount: 22.3 x 31.4 cm (8¾ x 12⅜"). Museum of Fine Arts, Boston. Fund in memory of Horatio Greenough Curtis, 24.1688.

Page 143: Fig. 7-14. Edgar Degas, executed in collaboration with Ludovic Napoléon Lepic, *The Ballet Master (Le maître de ballet),* c. 1874. Monotype heightened and corrected with white chalk or wash, plate 56.5 x 70 cm (22¼ x 27⁹⁄₁₆"); sheet: 62 x 85 cm (24⁷⁄₁₆ x 33⁷⁄₁₆"). Rosenwald Collection, Image courtesy of the Board of Trustees, National Gallery of Art, Washington, DC.

Page 144: Fig. 7-16. Paul Gauguin, *Two Marquesans,* c.1902. A monotype. ©The Trustees of the Bristish Museum.

Page 145: Fig. 7-17. Paul Gauguin, *Ia Orana Maria (Ave Maria),* 1894. Watercolor monotype on thin cream Asian paper. Original sheet: 22.3 x 14.5 cm (8¾ x 5¹¹⁄₁₆"); mounting sheet: 38 x 28 cm (14¹⁵⁄₁₆ x 11"). Museum of Fine Arts, Boston. Bequest of W.G. Russell Allen, 60.365.

Page 146: Fig. 7-19. Gail Ayres, *Mason Jar.* Monotype. Image courtesy the artist. Fig. 7-20. Anne Moore, *In Memoriam.* Monotype. ©Anne Moore, www.annesprints.com.

Page 147: Fig. 7-21. Michael Mazur, *Wakeby Day II,* 1982. Monotype triptych, 182 x 111 cm. Image courtesy Brooklyn Museum of Art. Art ©Michael Mazur.

Page 150: Fig. 7-24. Samella Lewis, *Mother and Child,* 2005. Monoprint, 26 x 34". Courtesy of the artist. Art ©Samella Lewis/Licensed by VAGA, New York, NY.

Page 152: Fig. 8-1. Andy Warhol, *Untitled* from *Marilyn Monroe (Marilyn),* 1967. One from a portfolio of ten screenprints, composition and sheet: 36 x 36". Gift of Mr. David Whitney. The Museum of Modern Art, New York, NY. Digital Image ©The Museum of Modern Art/Licensed by SCALA/Art Resource, NY.

Page 155: Fig. 8-2. El Hortelano, *Citizens,* 1983. Serigraph, 100 x 70 cm. ©ARS. Photo: VEGAP/Art Resource, NY.

Page 156: Fig. 8-3. Henri Matisse, *Icarus: Plate 8,* from "Jazz" series. Lithograph from paper cutouts, published by Teriade 1947, in an edition of 270 copies. Twenty pochoir

plates, each double sheet 42.2 x 65.1 cm. © Succession H. Matisse, Paris/ARS, NY. Photo: Erich Lessing/Art Resource, NY.

Page 157: Fig. 8-4. Henri Matisse, *Le Buffet,* 1929. Color pochoir (hand-colored stencil print) after a painting, 500 impressions for Florent Fels' Henri Matisse, published 1929 in Paris by XXe Siecle, 16.3 x 20 cm. Courtesy Spaightwood Galleries, Upton, MA.

Page 158: Fig. 8-6. Shahzia Sikander, *Afloat,* 2001. Screenprint. Composition and sheet: 34¾ x 23¹³⁄₁₆" (88.3 x 60.5 cm). Publisher: Editions Fawbush, New York and Diane Villani Editions, New York. Printer: Axelle Editions, New York. Edition: 35. Virginia Cowles Schroth Fund. (2542.2001). The Museum of Modern Art, New York. Digital Image ©The Museum of Modern Art/Licensed by SCALA/Art Resource, NY. Fig. 8-7. Kenzo Okada, *Morning Glories,* 1975. Screenprint, Paper Size: 30 x 32⅝", Image Size: 23⅝ x 26½". Edition of 175. Courtesy of Pace Editions, Inc., New York, NY.

Page 159: Fig. 8-8. Sam Gilliam, *T Shirt,* from the portfolio "Equal Employment Opportunity is the Law," 1973. Serigraph on paper, 22 x 30" (55.8 x 76.2 cm). Smithsonian American Art Museum, Washington DC. Photo: Smithsonian American Art Museum, Washington, DC/Art Resource, NY. Fig. 8-9. Jacob Lawrence, *The 1920's . . . The Migrants Cast Their Ballots,* 1974. Silkscreen print, 30 x 25." Collection of the Newark Museum, 75.227. The Newark Museum, Newark, NJ. Photo: The Newark Museum/Art Resource, NY. ©ARS, NY.

Page 160: Fig. 8-10. Larry Stewart, *Tribute to Annie Oakley.* Silkscreen. Collection of the author. Courtesy of the artist.

Page 161: Fig. 8-11. Yayoi Kusama, *A Pumpkin (BT),* 2004. Silkscreen. 17¹³⁄₁₆ x 15" (45.3 x 38.1 cm). Museum of Fine Arts, Boston. Edward S. Morse Memorial Fund, 2006.1821. Fig. 8-12. Roger Jackson, *North Gay Street Viaduct.* Silkscreen. Collection of the author. Courtesy of the artist.

Page 162: Fig. 8-13. Andy Warhol, *Self-Portrait,* 1966. Silkscreen ink of synthetic polymer paint on nine canvases; each canvas, 22½ x 22½"; overall: 67⅝ x 67⅝". Gift of Philip Johnson. ©The Andy Warhol Foundation for the Visual Arts/ARS, NY. The Museum of Modern Art, New York.

Page 164: Fig. 8-14. Victor Vasarely, *SIKRA-MC,* 1968. Screenprint. The Cleveland Museum of Art. Gift of the Print Club of Cleveland 1968.276. Fig. 8-15. Roy Lichtenstein, *Wallpaper with Blue Floor Interior,* 1992. 5 panel, 9 color screenprint, 10 x 152½". Edition of 300. ©1992 Roy Lichtenstein and Gemini G.E.L.

Page 165: Fig. 8-16. Ben Shahn, *H Bomb Poster,* 1960. Color serigraph, 42½ x 29¼". Gift of Mr. And Mrs. Harry Baum in memory of Edith Gregor Halpert. Photo: Smithsonian American Art Museum, Washington, DC/Art Resource, NY. Art © Estate of Ben Shahn/Licensed by VAGA, New York, NY. Fig. 8-17. Andy Warhol, *Bighorn Ram,* Endangered

Species Series, 1983. One from portfolio of ten screenprints and colophon, 38 x 38" printed on Lenox Museum Board. ©The Andy Warhol Foundation for the Visual Arts/ARS. The Andy Warhol Foundation, Inc./Art Resource, NY. Fig. 8-18. Donna Anderson, *Expectation.* Silkscreen. Courtesy of the artist.

Page 167: Fig. 8-20. Keith Haring, *Untitled,* 1985. Silkscreen, 23½ x 31½" (60 x 80 cm). Edition: 150. ©The Keith Haring Foundation. Fig. 8-21. Michael Mazur, *Serpentine with Orchids,* 2005. Four-color screenprint on Rives BFK, 18 x 22" Edition of 50. Courtesy of the artist.

Page 168: Fig. 8-22. John Douglas, *Top Gun,* T-Shirt design. Image courtesy the artist.

Page 172: Fig. 8-24. John Douglas, *An Orange Sunday,* 1989. Serigraphy, paper stencil, and tusche. Courtesy of the artist.

Page 174: Fig. 9-1. Miriam Schapiro, *Frida and Me,* 1990. Color lithograph, fabric, and color Xerox, 41½ x 29½". Image courtesy the Norton Museum of Art.

Page 176: Fig. 9-2. Robert Rauschenberg, *Cardbird Door,* 1971. Cardboard, paper, tape, wood, metal, offset lithography, and screenprint; 203.2 x 76.2 x 27.9 cm (80 x 30 x 11"). Gift of Gemini G.E.L., Image ©2009 Board of Trustees, National Gallery of Art, Washington., DC. Art ©Estate of Robert Rauschenburg and Gemini G.E.L./Licensed by VAGA, New York, NY. Fig. 9-3. Manolo Valdés, *Perfil I,* 2006. Etching with color collage. ©Manolo Valdés, courtesy Marlborough Gallery, NY. Fig. 9-4. Edvard Munch, *Vampire II,* 1895-1902. Lithograph. Munch Museum, Oslo, Norway. ©Munch Museum/Munch Ellingsen Group/BONO (or ARS) 2008. Image courtesy Munch Museum.

Page 177: Fig. 9-5. Kara Walker, *Confederate Prisoners Being Conducted from Jonesborough to Atlanta from Harper's Pictorial History of the Civil War (Annotated),* 2005. One from a portfolio of fifteen lithograph and screenprints. Composition (irreg.): 27⅟₁₆ x 33⅜" (68.7 x 84.8 cm); sheet: 39 x 53" (99.1 x 134.6 cm). Publisher and printer: LeRoy Neiman Center for Print Studies, Columbia University, NY. Edition: 35. General Print Fund and The Ralph E. Shikes Fund. (956.2005.11). The Museum of Modern Art, New York, NY. Digital image: The Museum of Modern Art/Licensed by SCALA/Art Resource, NY. Fig. 9-6. Dieter Roth, from *6 Piccadillies* [title not known], 1970. Screenprint and off-set lithograph on paper, print. Presented by Klaus Anschel in memory of his wife, Gerty 1997. ©Tate London 2009. Fig. 9-7. Terry Winters, *Graphic Primitives,* 1998. A portfolio of nine woodcuts printed on Japanese Kochi paper, 18 x 24". Courtesy of the artist and Two Palms, NY. Fig. 9-8. Sarah Sze, *Day,* 2005. Offset lithography, silkscreen. Image: 38¼ x 71¼"; sheet: 39 x 71¾". Edition of 27, 8APs. Publisher and printer: The LeRoy Neiman Center for Print Studies, Columbia University, New York. Edition: 10. Patricia P. Irgens Larsen Foundation Fund (40.2003). Digital Image ©The Museum of Modern Art. Licensed by SCALA/Art Resource, NY.

Page 178: Fig. 9-9. Robert Rauschenberg, *Estate,* 1963. Oil and silk-screened inks on canvas. 96 x 69 ¹³/₁₆" (243.8 x 177.3 cm). Gift of the Friends of the Philadelphia Museum of Art, 1967.

Philadelphia Museum of Art, Philadelphia, PA. Photo: The Philadelphia Museum of Art/Art Resource, NY. Art ©Estate of Robert Rauschenberg.

Page 181: Fig. 9-14. R. Lee Hebert, *Love Letter to Christophe Galfard,* 2008. Serigraph, detroyed block SINTRA relief print with embossing. Photo: Erwin Thamm. Courtesy of the artist.

Page 182: Fig. 9-15. Louise Nevelson, *Dawnscape,* 1978. Cast paper pulp. Fine Arts Museums of San Francisco, Anderson Graphic Arts Collection, gift of Harry W. and Mary Margaret Anderson Charitable Foundation, 1996.74.330.

Page 183: Fig. 9-17. Bill Shinn, plate for *Lost in Leisure.* Courtesy of the artist. Fig. 9-18. Bill Shinn, *Lost in Leisure.* Collograph. Courtesy of the artist.

Page 186: Fig. 9-22. Anselm Kiefer, *Grane,* 1980–93. Woodcut; printed in black with paint additions; irregular composition: 9' 1⅟₁₆" x 8' 2½" Purchased with funds given in honor of Riva Castleman by the Committee on Painting and Culpture, the Associates of the Department of Prints and Illustrated Books, Molly and Walter Bareiss, Nelson Blitz, Jr. with Catherine Woodard and Perri and Allie Blitz, Agnes Gund, The Philip and Lynn Straus Foundation, Howard B. Johnson, Mr. and Mrs. Herbrt D. Schimmel, and The Riva Castleman Endowment Fund. Digital Image ©The Museum of Modern Art/Licensed by SCALA/Art Resource, NY.

Page 188: Fig. 9-23. Kiki Smith, *Pool of Tears 2 (after Lewis Carroll),* 2000. Etching, aquatint, drypoint and sanding with watercolor additions. Plate: 47½ x 71¾"; sheet: 50¹³/₁₆ x 74½". Publisher and printer: Universal Limited Art Editions, West Islip and Bay Shore, NY. Edition: 29. Gift of Emily Fisher Landau. (1529.2001). The Museum of Modern Art, New York, NY. ©The Museum of Modern Art/Licensed by SCALA/Art Resource, NY.

Page 189: Fig. 9-24. Michael Mazur, *Pond Edge V (Reflections),* 2007. Aquatint, woodcut, and silkscreen, 31¾ x 36⅝". Edition 16 of 50. Signed, titled, and numbered on reverse. Image courtesy of Barbara Krakow Gallery. Fig. 9-25. Michael Mazur, *Lake I,* 2004. Etching, aquatint, wood relief, and engraved plexiglass. Image size: 17½ x 16." Edition 11 of 15. Signed, numbered, and titled on back. Image courtesy of Barbara Krakow Gallery.

Page 192: Fig. 9-28. Sue Coe, *Doctor Giving Massage to Patient with AIDS,* from The New Provincetown Print Project, 1993. Linoleum cut and monotype with ink additions from a portfolio of four prints. Publisher: The New Provincetown Print Project of the Fine Arts Work center, Provincetown, MA. Printer: Michael Mazur, Provincetown. Impression: unique. The Ralph E. Sikes Fund (707.1955). Digital Image ©The Museum of Modern Art/Licensed by SCALA/Art Resources, NY.

Page 200: Asante People, Adinkra cloth. Stamped cotton, 213 x 343 cm. Museum of International Folk Art, Santa Fe, NM. Image ©Davis Art Images.

Page 211: Andrew Saftel, *Water Hemisphere.* Woodcut, collage, monoprint on paper, 46 x 25". Image courtesy the artist.

Index

W

Z